IN THE WAKE OF A DEADAD

In the Wake of a Deadad
by Andrew Kötting
Copyright 2006 Andrew Kötting

for more information see www.deadad.org

Published in 2006 by

university college
for the creative arts
at canterbury, epsom, farnham
maidstone and rochester

Publication ISBN 1-870-522-451

The Deadad project is part funded by

Arts & Humanities
Research Council

design by Julien Lesage: www.brett-lesage.com
typeset in Caslon and News Gothic

CONTENTS

CHAPTER ONE 5
Of my dad dying and wondering what to do about it

CHAPTER TWO 9
Of the table set out (introduction)

CHAPTER THREE 17
*Of summing up my deadad's life and my life
in an attempt at making a comparison*

CHAPTER FOUR 21
*Of a lost request and then inviting 65 people to respond to
4 photographs of my deadad in order that something might come of it*

CHAPTER FIVE 215
*Of making an effigy of my deadad, discovering a new family in the
Faroe islands and then making a pilgrimage with both my deadad
and my deadad's deadad to places of significance*

CHAPTER SIX 331
Of a discovery, pornography and digital decoupage

CHAPTER SEVEN 363
*Of pondering on hislifemylifeourlives, Madagascar, Mexico
and how the deadad became the Bigman*

CHAPTER EIGHT 431
Of the made plain (conclusion)

Acknowledgements 440

To

Ronald Walter Kötting 1935 - 2000

Dedicated with sincere feelings of esteem for his private worth, family services and eminent psychological influences and disturbances.

CHAPTER ONE

*Of my dad dying and wondering
what to do about it*

The son refused to look.

The son refused to look.

The son refused to look.

He was dying now.

He could no longer fend death off.

One roll of 35mm black and white scala reversal stock using an Olympus Trip camera and the death of a father from two hours after his passing right up until two weeks later when his frozen remains were presented to me in a Chapel of Rest.

There is the sound of footsteps and the ringing of bells on a soundtrack, which were recorded in the church where my mother and father used to pull bells together when they were very young.

B is for Burial, which I would prefer
(Anglo-Saxon – birgan – to conceal)

The photograph is born precisely of the bewilderment and amazement experienced in the face of existence, when the mechanical eye succeeds in stopping the mattered flow of life and transforming it into a petrified vision. It manages to freeze on the surface an immemorial existence normally receding and moving out of focus in time, and becomes a permanent and unencompassable revelation: a lived image that can no longer return to nothingness.

GERMAN CELANT *Photography between flesh and Spirit*

Don't be afraid of death
When you are old
and about to be eaten
by a coffin,

> **don't**
> **be afraid**
> **of death.**

Naa.

RICHARD BRAUTIGAN
(The Edna Webster Collection
of undiscovered writings)

CHAPTER TWO

Of the table set out
(introduction)

I hear a wasted violin
playing in a small café,
hear a wasted violin
playing in a dark café.
It says your journey's over,
It's time to sail away

ANTONIO MACHADO, from *Portrait,* translated by Robert Bly

Life is nothing without a measure, without a frame against which to measure its fleeting glories. Before the worm or the fire or the beaks of broad-winged birds, the jaws of certain beasts, traffic provides such a frame. The stepping out. Into a sordid and all too frequent means to the inevitable passing. Another aide-memoire is a visit to www.deathclock.com "Welcome to the death clock, the internet's friendly reminder that life is slipping away, second by second. Like the hourglass of the Net, the Death Clock will remind you just how short life is." Entering primary information, it soon became apparent that "your personal day of death is June 6, 2041. The seconds countdown inexorably taunting: 1,115,702, 900 seconds. So that's all there is... But there is an option:

"delay your date of death & say ALOHA to heart disease".

Thus the mood was set. Groundwork for the job in hand. Only seconds remaining, and some of them would be spent in reflection on Kötting and his attempts to dodge the scythe.

The essence of Idealism is the application of the imagination to realities; it is not a play of fancy, a golden vision arbitrarily projected upon the clouds and treated as if it had an objective existence. Goethe, who had such a vigorous hold upon the realities of existence, and who had also an artist's horror of mere abstractions, touched the heart of the matter when he defined the Ideal as the completion of the real.

In this simple but luminous statement he condensed the faith and practice not only of the greater artists of every age, but of the greater thinkers as well. In the order of life there can be no real break between things as they now exist and things as they will exist in the remotest future; the future cannot contradict the present, nor falsify it; for the future must be the realisation of the full possibilities of the present. The present is related to it as the seed is related to the flower and fruit in which its development culminates. There are vast changes of form and dimension between the seed and the tree hanging ripe with fruit, but there is no contradiction between the germ and its final unfolding.

HAMILTON WRIGHT MABIE

As with all times, if one looks at this period, this month, this week, in a certain light, it can seem that mortality is the all-pervasive weather. Not simply in the endemic and endless fact of passing, but in the social, cultural and political manifestations of the terminal. The worrying seam of headlines, tabloid and otherwise. And in all strata, from the biosphere to the familial. Butterflies failing, vanishing, evidence of vast ruptures. A whale trapped in the Thames, drawn into the city only to end, with crowds watching from the shore (a perverse real-world echo of the dominant motif in Bela Tarr's darkly luminous parable 'Werckmeister Harmonies'). Roofs collapsing in Poland, snow with its white weight buckling the steel. Birds crossing the continents with the germs of international collapse among their feathers. An uncle waking up to die, and processed out of sight in a production-line send-off, plastic name flower mounts piling, colour drained, in the crematorium car park. And Iraq, Darfur, the Congo, where civilians find themselves interminably inside violence as we might in a job or coupling gone sour.

Death falls from the air as storm and lands as fire. It issues from the ground beneath the misplaced foot. It passes from hand to hand, mouth to mouth, like a terrible greeting, a bleak rumour made real in the telling. And it spreads through the body like spilt ink across a page, it stains the living and still it spreads and spreads. Trying to keep up with the words written about itself.

They go, they come, they trot, they dance - of death no news. All that is fine. But when it comes, either to them or to their wives, children or friends, surprising them unprepared and defenceless, what torments, what cries, what frenzy, what despair overwhelms them! Did you ever see anything so dejected, so changed, so upset? We must provide for this earlier; and this brutish nonchalance, even if it could lodge in the head of a man of understanding - which I consider entirely impossible - sells us its wares too dear. If it were an enemy we could avoid it, I would advise us to borrow the arms of cowardice. But since that cannot be, since it catches you just the same, whether you flee like a coward or act like a man - let us learn to meet it steadfastly and to combat it. And to begin to strip it of its greatest advantage against us, let us take an entirely different way from the usual one. Let us rid it of its strangeness, come to know it, get used to it. Let us have nothing on our minds as often as death. At every moment let us picture it in our imagination in all its aspects; thus did the Egyptians, who, in the midst of their feasts and their greatest pleasures, had the skeleton of a dead man brought before them, to serve as a reminder to the guests.

MICHEL DE MONTAIGNE *That to philosophise is to learn to die*

There is nothing to say about anything.
So there can be no limit to the number of books.

E.M. CIORAN *The Trouble with Being Born*

Dead Man Walking

SOME THOUGHTS ON A PROJECT AND ITS PROCESS

I am he as you are he as you are me and we are all together.
JOHN LENNON AND PAUL MCCARTNEY, from *I Am the Walrus*

Desire, loneliness, the wind in the flowering almond; surely these are the great, the inexhaustible subjects.
LOUISE GLÜCK

Whether in his film, gallery, publishing or explicitly cross-platform projects, Andrew Kötting has never sought an easy, simply-decked monotone to his idiosyncratic meditations on family, place, social ritual and the artesian threads of narrative, rumour, custom and sometimes dubious tradition that link such territories. An often melancholy humour, an absurdist physical pranksterishness has carried, informed and even shaped the most personal of material. The awareness behind this attitude - that the lusting, entropic vessel of the body and its prime cargoes (the restless intellect with its wide roving eye and the anxious, rifted heart) somehow seem to survive, to ward off, through the application of a particularly perverse will and a constantly creative call-and-response, vast swathes of what by reasonable assumption they should not - is what makes his work so refreshing, engaging and rewarding.

This prankster - denying the hourglass rush of this life with jokes, sex, hands-dirty labour and clock-spiting endeavour on all fronts - finds his imperatives manifest perhaps most keenly in his latest cross-media exploration. In the Wake of a Deadad, seeded by the passing of Kötting's father, is at once an elegy to, autopsy and exorcism of a troubling essential presence, as recalled and reimagined through inflated, installational engagements with topography; pornography and the associative reflections of others close and removed. Acknowledging and embedding the central qualities of memory - especially when such remembrance is felt in the body - namely, its provisionality and elusiveness, the project tellingly concentrates on the body of the father and those bodies that he remotely desired or rather, called into the orbit of his desire through consumption. (Even when the texts created by others are considered, it is important to note that they were initiated by the mailing out of photographs of the dead father, with his physicality the leading aspect of those images).

The prime organising structure of this project is around the conceit of the trinity, most obviously Kötting, his deadad and his deadad's deadad. Such a numerical ordering is not essentially religious, although it is worth noting that the father, son and holy ghost (here, perhaps memory, a collective sense of the deceased) of In the Wake of a Deadad are not so far in their ambiguous relations from the more widely known grouping.

The trinities here, however, continue, from the material manifestations - filmed 'inflations' of larger than life avatars of his father and grandfather, pornographic decoupages and writings - to the intellectual triangulations. In the Wake of a

Deadad is built around the tangled relationship between place, the body and what we might call (aesthetic) re-memory, the public incarnation of memory in an artefact. Similarly, the sense of sitings (sightings), the body as a zone in its own right, the positioning of that body (whether Kötting's deadad, the artist himself or his inflated creations) in a landscape or environment and the final location of the resultant work, in the gallery or simply public consciousness by any means, serve further to underline how the triangulation of emotion generated by the material is encoded directly into the means of its representation.

And yet, despite the persistence of this schema, perhaps it is more accurate to describe the inter-relation as closer to that of the single surface of a möbius strip. In the twisted continuum of such a model, one finds the deep indivisibility of self from family, of generations from each other and of artistic form from content clearly encapsulated.

This way of conceiving fundamental associations is also helpful in considering how Kötting, yoking together what might seem disparate strains - inflations in 65 significant familial and thematically charged locations, treated 'found' pornography and the textual contributions - seeks to test the limits and tensions in his source material, whatever its scale (the fact that he finds or places himself, actually or digitally, in this material provides a crucial 'embodiment' of the point to be made). Indeed, it might at first appear that the opposite of the Faroes (the most geographically removed site) is the wardrobe where his father's 'glamour' magazines were found, or that the counterpoint to Mexico's Day of the Dead (exotic ritual of a major moment) is a 1970s three-piece suite.

Instead, examination reveals that such seeming oppositions, such measurements of his project's parameters, are much closer than first appears. It is in this proximity that the lasting and wider resonance of this autobiographical installation lies. For, at its heart, In the Wake of a Deadad looks to investigate, and ultimately to celebrate, whatever its emotional fallout or legacy, the power of aura (what we might call the Narnia wardrobe charge), the potency of certain people and things and their impact on others and, by association, the remarkable fact of being alive, of being sensually perceptive, in the phenomenal world.

Indeed, this fecundity of attraction extends throughout the territories, so that the project also becomes a retrospective visitation of countries and regions essential and newly essential to Kötting, from Britain and southern France to Madagascar, Mexico (in his relationship to death, he has always been Mexican) and now, through the discovery of unknown, extended family histories, the Faroe islands.

Whether it is the map's edge, the Ultima Thule, the visceral, even fearful thrill of encountering previously unknown co-ordinates and islands, or the similar intimation of overwhelming vistas that open to an adolescent male on first viewing (and never forgetting) the iconic promise of the sexual as captured in the permanent imminence of pornography, and especially the anticipation within

its thin narratives, what works in common is the profound charge all afford. Offering a kind of Blakean immersion in the physical moment of viewing, the heightened materiality of the ostensible subject (here realised via the devices of larger-than-life inflation and découpage) and in the often emotive writings of colleagues, family and friends, the work seeks to collapse the distance between these apparently challenged elements to reveal a single intensity that flows möbius-like between all components in the puzzle, one revealed (à la 'Magic Eye' patterning) by a concentration of looking, an appreciation that seeks revelation and connection.

The fact that such aims are realised simultaneously in conceptual, organisational, aesthetic, material and thematic ways makes In the Wake of a Deadad a genuinely rewarding and stimulating initiative. An ambitious experiment in creating prismatic auto/biography, it exhorts its audience to make incursions into their own multihued psychologies and (family) histories; to live inside a death so rigorously that it becomes the vessel of a keener future. In doing this, it follows less in the wake of the gone protagonist; rather it generates its own passage forward into fresh, deep waters, and the wake it offers is not a following but a call out of stupor and into vivid appreciation of the moment now. Of all the living still there to be done.

The idea that the soul will join with the ecstatic just because the body is rotten – that is all fantasy. What is found now is found then. If you find nothing now, you will end up with an apartment in the city of death.
KABIR

Gareth Evans

16

CHAPTER THREE

*Of summing up my deadad's life and my life
in an attempt at making a comparison*

18

He was born in Highgate, London on January 31st 1935. He was educated at the Grammar School – 'The Glass School'- just off the Sidcup Bypass. He went to work at a factory in Wuppertal in Germany in 1953. He learnt his father's mother tongue whilst he was there and then returned in 1955 to start work in his father's business in Regents Street. He got married to my mother Rita in 1957 and moved into a Bungalow in Sidcup. His first son Peter, was born in 1958 and I was born in 1959. He did some rally driving with his brother Leslie as navigator. In 1960 he bought a mock Georgian house in Elmstead Woods and my sister Leesa was born in 1961, followed by Mark in 1964 and then Jonathan in 1966. He had his first heart attack in 1977. He continued to work his father's business selling belts and braces. He moved home with my mother in1980 to Beckenham. They lived there together where he grandfathered Eden, Billie, Oscar, Etta and Albertine. On December 14th 2000, after years and years of heart attacks, diabetes and the occasional rage he died.

My life

I was born in Farnborough, Kent in 1959. I was educated at St Dunstan's College, Catford. In 1978 I went to work in a factory in Finland and then in Sweden. I learnt very little Finnish and not much Swedish. By 1983 I was in love with Leila. In 1984 I graduated from 'The Art College'- Ravensbourne, Bromley - with a first class degree in Fine Art. I moved into a council flat on the Pepys Estate, Deptford in 1985. I painted, decorated and travelled for a living until 1988 when I graduated with a Master's Degree in Fine Art from The Slade, University College, London. In the same year my daughter Eden was born to Leila. In 1988 I moved into a house with my brothers' Mark and Jonathan and my sister Leesa in the French Pyrenees. I made a feature film in 1996 and another one in 2001. I teach at a University College for the Creative Arts and continue to work as an Artist and Film-maker. In 2004 I moved to St Leonards-on-Sea. In 2005 I married Leila and I am an uncle to Billie, Oscar, Etta and Albertine and have had the occasional rage.

An observation which to my great regret, is always verifiable: only those are happy that never think, or rather, who only think about life's bare necessities, and to think about such things means not to think at all. True thinking resembles a demon who muddies the spring of life or a sickness which corrupts its root. To think all the time, to raise questions, to doubt your own destiny, to feel the weariness of living, to be worn out to the point of exhaustion by thoughts and life, to leave behind you as symbols of your life's drama, a trail of smoke and blood – all this means is you are so unhappy that reflection and thinking appear as a curse causing a violent revulsion in you.

E.M.CIORAN *On the Heights of Despair*

CHAPTER FOUR

*Of a lost request and then inviting 65 people
to respond to 4 photographs of my deadad
in order that something might come of it*

My dad is dead.
Lost.
So I took some of the photographs I had made of him in the chapel of rest and
photocopied them into a
Lost
Request.

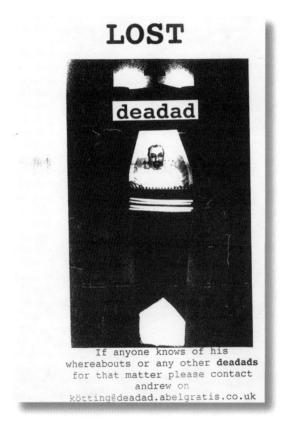

There were 65 of them
One for each year of his life
And my mother, his wife, would not have been impressed,
So I scattered them along the Thames footpath from my home on the Pepys Estate to
where he used to work late,
When I was a child
In Regent Street

And nothing came of it

SO...

...I went to meet with a spiritualist

She lived near Charlton Athletic Football Club and she set about word painting a portrait of my deadad through the various apparitions that came to her during our meeting.

Portraits of a Deadad as seen through the eyes of a spiritualist

"All the time we've been sitting here talking I've had a gentleman with you who is not as tall as you, quite a stocky gentleman and he actually reminds me very much of my own father, a hands on man, I think he went with a condition of the chest, right? Suddenly in the end, he was quite fussy about his hair, and I would have said that he was quite smart in his appearance, he might not have liked that you don't polish your shoes, which you don't all the time and he keeps looking at your feet. Well I think he could have been on one level quite strict and abrupt but on another level he could have been quite funny and he's touching his stomach now, so I don't know if he thinks you've become a little bit of a paunch there or what. I think you had a lot of unexpressed feelings together, I think perhaps he didn't need to say, you knew and he knew, you could read each other pretty well but I think he wishes he had said more, but there's another gentleman with him, he's a bit greyer, a different shape really although, I think if your father was strict with you as a child then it was because he wanted you to have the benefits he had and I think there is definitely a Ted somewhere and I'm positive that there is a George as well, now funnily enough also I had a John very clearly, I know that Mary is a lady's name that's in the family, somebody called Arthur and I'm positive that there is somebody called Bill or William, is there a David on the planet? Ooh somebody just shouted out Frank very clearly, was there a lady called Winifred? And he's also given me, right in front of me, Violet, so I think there must have been a lady called Violet, I think you'll have to check some of these if you don't know who they are and he just said Thomas very clearly, is there an Irish connection as well? "There's also a Margaret, I would think there is a Jean and I think really what you're going through now at the minute is a spiritual evolution or revolution, and it's almost like the demise of your father has given you a gigantic push to find out what it's all about. Right?"

(There is an old aunt, long dead, called Winnie and my father's sister, still living, is called Margaret, however all other names being shouted out had little or nothing to do with the family. Unfortunately.)

So I invited 65 people to reflect
on who he was and what he might have been.

That to philosophise is to learn to die.
MICHEL DE MONTAIGNE

Andrew Kötting 52 Bence House Pepys Estate London SE8 5RU England BADBLOODANDSIBYL@UKONLINE.CO.UK

INVITATION

This is an invitation to participate in a work provisionally entitled
In the wake of a dad dying

At the top of the following page are four photographs of my dad, who is now dead. He was born on 31st January 1935 and died on 14th December 2000. The first is a photograph of him as a young boy the second is of him as a man, the third is of him as a middle-aged man and the last one is of him as an older man, (dead).

I am interested in trying to compile a portrait of him through the words or marks of other people. To this end I would be very pleased if you could spare the time to provide me with 'something' about my deadad. Some of you will know him, some of you will know about him and some of you will not know him at all. Some of you won t even know me. Whilst writing about my deadad I would like you to consider a series of questions, (consider them but disregard them by all means).

Hence some of the questions might be : What do the pictures tell you about him ? What was his point of view ? What did he use to do ? What did he want to say but didn t ? What gave him pleasure ? What were his principles ? What was his greatest fear ?

Confabulation is encouraged and there is no prescribed length or size to the work generated.

I d like to apologise in advance for any inconvenience caused and will not take umbridge should any of you decide not to participate. There is no particular deadline or pressure to respond but I'd like to be kept a breast. This will be a self-negotiated project and to this end is self-funded. A pencil is enclosed as a somewhat peppercorn token of my appreciation for your time and possible energy.

Yours sincerely

Andrew Kötting

Below is a list of those invited to participate for your perusal should it be of any interest. One for each year of his life

Ken Arnold Paul Auster Clio Barnard Mark Bourne Dave Calhoun Dinos Chapman John Cheetham Adam Chodzko Matthew Collings Michael Copeman Ben Cook Laurence Coriat Mark Cousins Alex Cromby Rodgers Chris Darke Alnoor Dewshi Sian Ede Gareth Evans Robert Farrar Jem Finer Lizzie Francke John Gange Nick Gordon Smith Tony Grisoni Nicky Hamlyn John Hardwick Garry Henderson Susan Hiller Ben Hopkins Barry Isaacson Nick James Mike Jay Christy Johnson Emma Kay Conor Kelly Simon Lebe James Lever Janna Levin Joanna Lowry Sean Lock Jacqueline Lucas Jackie McCannon Andrew Mitchell Judith Palmer John Penfold Mark Peranson Sophia Phoca Vito Rocco Jonathan Romney John Roseveare Howard Schuman Nat Segnit Kerri Sharp Ian Sinclair Kiki Smith Frank Stanton Dudley Sutton Heiko Van der Ploeug Dan Weldon Fay Weldon Richard Wentworth Ian White Louise K Wilson Janni Wisman Ben Woolford

**Seen through photographs,
people become icons of themselves**

SUSAN SONTAG *Portraits in Life and Death*

In the wake of a dad dying

In the wake of a dad dying.

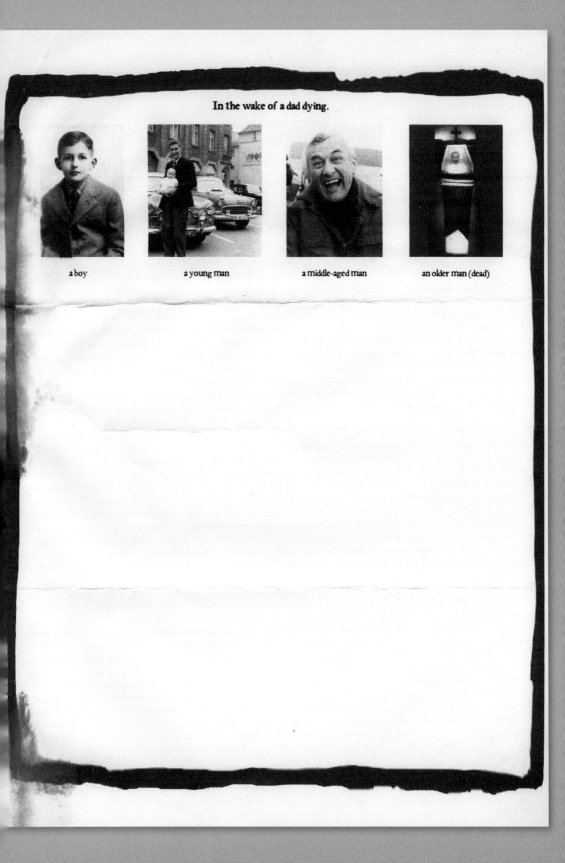

a boy a young man a middle-aged man an older man (dead)

Those invited

Ken Arnold Paul Auster Clio Barnard Mark Bourne Dave Calhoun Dinos Chapman
John Cheetham Adam Chodzko Matthew Collings Michael Copeman Ben Cook
Laurence Coriat Mark Cousins Alex Crombie Rodgers Chris Darke Alnoor Dewshi
Sian Ede Gareth Evans Robert Farrar Jem Finer Lizzie Francke John Gange
Nick Gordon Smith Tony Grisoni Nicky Hamlyn John Hardwick Garry Henderson
Susan Hiller Ben Hopkins Barry Isaacson Nick James Mike Jay Christy Johnson
Emma Kay Conor Kelly Simon Lebe James Lever Janna Levin Joanna Lowry
Sean Lock Jacqueline Lucas Jackie McCannon Andrew Mitchell Judith Palmer
John Penfold Mark Peranson Sophia Phoca Vito Rocco Jonathan Romney
John Roseveare Howard Schuman Nat Segnit Kerri Sharp Iain Sinclair Kiki Smith
Frank Stanton Dudley Sutton Heilco Van der Ploeug Dan Weldon Fay Weldon
Richard Wentworth Ian White Louise K Wilson Janni Visman Ben Woolford

In the wake of a dad dying continued

'No need to elaborate works - merely say something that can be murmured in the ear of a drunkard or dying man.' E.M.Cioran

1 | KEN ARNOLD, Curator and writer

I've never met or even heard you talk about your dad Andrew, but he had a pretty remarkable son and I like the look of him in these pictures - the young, tentative (is he completely comfortable in that jacket?) but quietly confident boy; the new father elated, but a bit scared (another jacket; the middle-aged laughter (finally, in a jacket he is comfortable in!); and then, dead dad shrinking into the technology and symbolism of death. So I'm part intrigued and part moved. And I like this project.

So what does all this make me think of? Well I have two young boys who half-break-through formal photographs themselves; and I stood outside a Victorian Hospital six and nine years ago thinking is this going to be the best or the worst thing I've ever gotten into; and I have a dad who is dying, all too slowly. Inevitably, I guess, these pictures become reflections and refraction's of my life, my relationships, and me with the closest men in my life at their various stages.

And what else? Well if I let myself go dozens of different ideas and questions come rushing. What was he like? And did his life continue smoothly across these pictures, or were there four or even forty different people who were your dad at different stages in your life? What's your mum like? Is that baby you? And what buttons do these pictures press in you? How is the far right picture constructed (looks sort-of like a collage), and what is the glassy top bit? When did you get the idea for this? I kept hold of my mother's ashes for ages before I finally sprinkled them in a river she loved. My dad had Parkinson's disease for over 15 years, and I think of him dead already, but also I know that when he finally goes it will be a shock. I also half-think that he is going to outlive me. What am I going to do as a memorial for my dad? A year after my mum died (fairly quickly, when she was still young) I organised a talk to be given by a close friend of hers about Madagascar (where she and my dad lived for ages) in the village where she died for an audience of 50 of her friends ad acquaintances, and I much enjoyed the idea of the memory leading onto new ideas and activities- from death to life. I wonder if your dad and my mum would have made anything of each other (are they up there now making each others acquaintance?), or my dad for that matter. And what does happen to us when we die?

Heaven / Hell?

Nothing but molecules and atoms being recycled?

Rebirth?

From death into life…

I shall never understand how we can live knowing that we are not
– to say the least! – eternal.

E.M. CIORAN *The trouble with being born.*

2

No reply

HOLLY AYLETT, Writer and film-maker

Dead Dad

Tension and Play

Staring at these four photos without blinking four people are afloat, on top, beside, in and out of focus, with beginnings and ends only in parenthesis. And today is the birthday of my own Dead Dad.

In the first, I see a boy. Displayed one time on table or mantelpiece? Cleansed behind the ears, kempt, the loose crease of a quality, tailored jacket, big enough to grow into, and the sense of huge expectation looking out beyond the palaver and false grin of the photographer. A clear energy, warmth and softness. And yearning. Where was your Dad, the man with the German-sounding name? Was he there to see him, or a soldier lost abroad.

Then, look! There's Andrew. Luminous, and on display. Dad weighing the future. Proud with the warmth of a son against his chest. Long, angular body, high forehead and Elvis hair swept back. Smartly casual with this plump, machine-washed baby in front of the chrome shine and brazen promise of the fifties. Was this your car, Dad, or a backdrop borrowed for the smell of leather and horsehair padding from the trim shop? Nappies, bottles, creams and tissues somewhere out of sight. I wonder were you ever in the back with Andrew on your lap? Perhaps most comfortable feeling the spin and control of the wheel between your large, capable hands.

The days of touring at an end and Dad in middle age. The only photo where son and father are aware of the same moment. Now I write to you and not to Dad. Aware that he has grown in your image, learnt himself through the tension and play of father – son exchange. You're big enough to share the joke and see the grimace, which Dad's laughter often hides. 'Not a nice face' my live Mum commented. But Dad's a man who tried to square up, his soul would out and he'd communicate. Well-prepared too. Dressed to keep the neck warm and the wind out. A man who knew the damp chill of island weather. Did he listen to The Duke, to Elvis, tango, rock or Shostokovich? Those younger dreams

- of loving a woman, of being Dad, proud in front of those fifties cars - now lived through, not quite tamed perhaps but accommodated. There's a passion reawakened, audible when you meet again; bonds as clear and intangible as the laugh trapped in the frame. But like the boy, his eyes still focus slightly beyond. Where is the ambivalence of his expression carried in the homage you give to him? Was it Dad who gave you the smell of the outdoors, the sense of history lined in his own face, the desire to gallivant? And where in this snapshot is Mum?

Now look what you have done. Sent Dad swaddled into another world, still facing life – just. Strapped, boxed, plinthed and crossed, yet Dad will out - he pixels out in mezzotint. You've built your own shrine, a place to focus those flash moments shuffled in the pack. Not many make or carry a portrait of Dead Dad. Berger sketched his father's face, felt the lines and traced them in pencil. The sketch is pinned, unframed to his wall. A place of encounter. The Elders resound within us. Even the younger ones, like my sister, drowned deep. Were you there when living stopped? Dad, my Dad, is the only person I have seen and held and smelt across the road from life to death. Confounding. 'See what you mean?' said the ambulance man in the early morning, awkward in the presence of dead Dad's huge frame, now pale and stiff, diagonally on the bed.

Big hands. Big deeds. Big heart. 'See what you mean' he tried again. What did I mean? Or any of it? And what might be the epithet for those coming after? Dad was born, lived and died in London. Became a surgeon at war. In his ledger, I counted 44 operations on one day – legs, innards, shrapnel. Where was your Dad aged between 28 and 36? How did it shape him? Where was he from or to – Norfolk, the North? What did he do? A teacher? Water engineer? And who came after? These basic questions, which keep the hearth warm, and help place lives within and for their fraternity. Life after all is rugged and used as a hand-me-down, those ones which keep us warm, dated and self conscious, sometimes on the day of wearing.

Ronald was from Sidcup but we used to think that he should go and live in 'Bexley', which was just down the road.

3 CLIO BARNARD, Film-maker

When Andrew's dad died his spirit entered the body of my unborn child.

They cut me with knives and he was ripped from me with steel tongs, leaving me wretched, tattered and torn.
The baby had a filthy scream and a foul temper.
So I abandoned him.

He was found in the public toilets near Greenwich Park by a girl who lived in Erith, in a high rise block with a stunning view of the Dartford Crossing. She jiggled and juggled the little foundling as he bellowed and squealed. She was patient beyond belief.

She named the baby Erith. One day, when Erith was two or so, she packed up a bag for them both and hit the road. She didn't want the baby to be taken away. She had heard of a place in the marshes at Seasalter where no one would bother them. They lived in a small makeshift shack hidden by the reeds, surrounded by the abandoned detritus of the trailers and caravans that once occupied this strange landscape. Erith and his mother foraged for their survival. They feasted on oysters they found in the Estuary and sea spinach that grew wild on the beach. They would take the left-overs from the bins at the back of the pub to feed to the piglet that they'd stolen from it's pen, ripped from his mother as he suckled. They fattened up the pig and slaughtered her when she was big enough to eat.

Erith discovered he had a way with animals. He took to sheep rustling. He'd slaughter them and cook them over an open fire, waiting until the early hours so that they wouldn't get caught. Then he began dog-napping. First he took Issit, a bitch, and then Innit a male, and he began breeding Jack Russells. He went with his Mum to Dartford Fare to sell the puppies. Erith began to make a tidy profit. He extended his repertoire and began breeding Lurchers, which he also sold at the Fare. Erith became known as a skilled dog handler. His reputation grew and so did his income. He became involved and entwined with the Hare Coursing community. Erith met a girl, Swanley, and fell in love. He and his mother and his new wife moved to a piece of wasteland in Dartford where there was plenty of room to keep and breed his dogs. Erith and his wife had a child. They named him Meopham (pronounced Meh-pam). Meopham was a feisty little boy. He struggled and fought to get exactly what he wanted. A strong willed child with a huge lust and passion for life and for living. Nothing could hold him back. He and his father came to blows. His mother would try to intervene but to no avail. They rolled around the wasteland, wrestling and spitting and cursing at each other. Finally Meopham took off, ran away.

That was when we met, quite by chance. He was 15, I was old enough to be his Nan. In fact I was his Nan but at the time neither of us knew it. We met in a pub in Woolwich one sleepy afternoon. My local, an empty, dusty pub on the edge of nowhere. I was awash with the syrupy stench of Special Brew. I'd

followed my usual tins with several brandy chasers. The door swung open and the dusty old pub was transformed by the glittering, late-afternoon autumn sunlight. This golden boy stood tall and proud, silhouetted in the doorway. I beckoned him over and ordered him a double brandy. He sat beside me and we were as broad and as rude and as bad as each other. We drank until we were ready to drop, until we were thrown out of the pub. We spent that first night by the side of the Thames. I admit that I lusted after that boy but I swear I didn't lay a finger on him.

I took him in and treated him like a son. I even stopped boozing quite so much and I got food for him. (I had to get Nancy in the pub to tell me what to buy and how to cook it.) He was like a precious bird to me and I didn't want him to flit away. I wanted to keep him, so I tried my best to please him. I didn't tell him what he could and couldn't do. He came and went as he pleased. I don't know what he got up to and I didn't ask. I didn't want him to know my trade because I thought he might not like me for it. I'd been on the game for years. I waited until he was out of the way before I put my red light bulb in. Then the gentlemen would come calling. I was always scared in case he came back when I was in the middle of giving relief. I'd always have half an ear for the door. One time he did come back when I was with old Amos. We was in the bedroom. I finished him off quick, tidied me self up and pretended like everything was normal. Amos came out buttoning his flies. Meopham came over all knowing and he winked at me. Amos gave me my money. I was dying of shame. But Meopham didn't judge me, he just laughed and laughed, and showed me a new telly he'd got for us.

And so we went on. We were happy, us two. But then his father came calling. Of course I didn't know he was Meopham's father, no more than I knew that Erith was my son, the little fella I'd abandoned all them years back. He was a brute of a man. In every way that Meopham was good, his father was bad. They were flip sides of the same coin, them two. Meopham didn't judge where his father did. The two of them were built the same, like brick shithouses, but where his Dad was vicious Meopham was kind and generous despite himself. He played it tough and hard but you could see he was a caring lad. His Dad came calling, attracted like a particular kind of moth to my red light. Him and Swanley weren't at it no more. She blamed Erith for the fact that Meopham had run away and Erith liked to do funny stuff that Swanley didn't like. Erith wanted to do the funny stuff with me, but to me it wasn't that funny. I'd been on the game for years. I liked funny stuff and on top of that he was offering good money. He wanted me to dress up like a medic and there was some medical equipment he'd bought with him that he wanted to put up inside me.

Now this time when Meopham came home (with a DVD player and some other electrical goods) he went mad. He knew it was his Dad as soon as he saw that funny medical equipment. It turned out Erith had forced his wife Swanley to have the equipment inside her against her wishes and Erith had been so forceful it had meant they couldn't have any more children. It made Meophams blood boil. He went for him. It was like a dog-fight in me own front room.

Luckily the younger one won, in this battle between father and son. His father went limping off into the night and we heard no more about it.

The years passed and Meopham became a man. He set up in business, selling tellies and DVD's, and eventually he left my home. But he'd come back and he'd care for me, giving me money and gifts, keeping me company as I got older and unable to trade.

He moved me into a new place, a trailer that he'd set in a field on Sheerness. One day Meopham came and he said that his father was ill and he was going to die within the year. Meopham was a good man and despite the wrongs his father had done he helped his mother take care of the old man who needed bathing and feeding. He said his father had begun talking about how he was a foundling, a bastard, illegitimate, how he'd never known his real mother. His dying wish was to find his real mother. He accepted that more than likely she'd be dead, but he wanted to know who she was. When his adoptive mother died she had given him something that was sewn inside the babies clothes.

As he told the tale I went cold, all the warmth had run into the ground beneath me and was holding me there, like a frozen block.

I'd sewn it there myself. I told Meopham that what was sewn into the baby's clothes was a lock of my very own hair, (a bit soft of me maybe but I felt bad abandoning that child.)

Then it was Meopham's turn to be frozen like a block, as I watched the warmth drain out as the wretched news sank in.

He stuttered and spluttered and said out loud part of what was going through my own head. His dad had paid for perverted sex with his own mother. Meopham was angry, and he fled, forgetting about the good news, that I was his Nan.

I was broken hearted and I turned back to drink. My trailer became a stinking hovel and I hoped to rot to nothing, such a mess I'd made of it all.

One day I saw a figure approaching across the field. I never had no visitors apart from Meopham. I was excited and nervous that it might be him, I tried to clean myself up as he approached. But it wasn't him, it was his mother, Swanley. She'd come to ask me to the bedside of Erith, who was asking for me. I was full of shame and horror at having been with my own son, but I did want to make amends and explain the past. It had made me sad abandoning that child and I'd drunk to forget him. He was the bastard child of one of my clients and I was only 15 at the time. I thought I had nothing to offer a child, but Meopham had proved me wrong. That was why I felt so bad that he had left me.

Swanley was a good woman and she knew the human heart. She told me I'd been a good Nan to Meopham and that he loved me. She told me to come to Eriths' bedside.

And so I went.

He spat in my face. He'd gone to all that trouble just so he could spit in my face. He told me I was a dirty whore and it was me that had made him bitter and perverted. Swanley tried to quiet him but that was it. He died. That's when Meopham turned up. He was all matter-of-fact. The bastard was dead. Here was his mother who he loved and his new found Nan. Between the three of us we organised a burial. We put Erith's body in my stinking trailer on the marsh and we burnt it. Then the three of us moved into tower block with a stunning view of the Dartford Crossing. We were happy and lived peacefully.

The spirit of Erith is elsewhere, living another life. Though sometimes I look at our little Jack Russell puppy and I wonder whether a more contented Erith might be lurking there.

4 | MARK BOURNE, Sculptor, landscape gardener and writer |

Mark Bourne was first to write back,
His time is also running out.
He builds a garden of miniatures,
Italian grandiose magnificence,
A garden that I want to live on forever.
Inspiration hewn into the Welsh Slateside.
This is a man I wished my Deadad might have been.
This is what he left,
This is his hasbeen.
This is why I wanted his words.
And
These are the words he gave.

```
            D E A D A D

         (for   Andrew   Kotting)

   What can be said of him?   Unmet, unknown,
   save for a clutch of photos;  and, of course,
   a son;  that living trace of him, perforce
   now asking us, the world -  make something of him.

   Just like a wand, a baton, comes a black
   inscriber, pleading silently - write, write;
   a pencil sharpened ready, lead as bright
   as spear to toss against our ignorance.

   But in the wake of death what phrases can
   encompass even a slender shade of him?
   Unmet, unknown, save for a son abrim
   with the flashing of ideas.   Amen.
```

I am hoping to publish a booklet which may contain these 'portraits' as well as other works pertaining to the project. To this end I would ask for your written permission, agreeing that I might use some or all of your words or marks.

I agree to the abovementioned.

Signed : Date : 11 JULY 03

Mark Bourne

OBITUARY

Mark Bourne

It was with some surprise that we heard on 12th January of the death of long-standing member Mark Bourne, at the age of 82. We were aware that he was not well, and was expecting to go into hospital for an operation, but nevertheless he was still active in the area it seems, only days beforehand.

Mark was one of those unforgettable characters that one encounters rarely in life. He originated from Essex but after war service, settled at Garth, Machynlleth to keep chickens and sell eggs and one day old chicks. It is many years since I have seen such chicks huddling around a heater in a straw lined box awaiting transport by rail, being carefully tended by station staff. I expect that such trade - if it still takes place - now goes by road.

Mark was also something of a journalist, producing articles for a number of publications including railway enthusiast magazines, Country Quest, The Lady and The Guardian over a span of several decades. His items in the latter describing Corris characters were particularly notable - talk about painting pictures with words! The characters positively leapt to life off the written page, but unfortunately virtually all these characters have by now passed on.

Mark was one of the first members of the newly formed Corris Society in 1967, and as his property now boasted a camp site, the first contact experienced by the poorer early Society members with a local resident was Mark. Mark also had an interest in the ancient civilisations and being something of a handy man, he turned his interest into reality by producing fine large scale models of the notable ruins of Greece in his grounds. His camp site was not one which you would readily forget!

In 1976, Mark gave up the Garth and moved to Garreg Lwyd, Corris, high on the hillside between Corris and Upper Corris. By now his interest had moved on to Italy, and a number of structures appeared in the garden there based on buildings in Venice and such places. This led to something of a run-in with the Snowdonia National Park because none of the work had planning permission. Mark had no time for such bureaucracy, and the Park escaped by ruling that as long as the height of any structure did not exceed 3 metres, he could carry on. I suppose it depended exactly from where you measured the 3 metres! While he always welcomed visitors to look at his handiwork in his garden, the Park were concerned that he should not advertise them as an attraction, as the only practical access to the site was along a steep public footpath or by 4 x 4. Then again, there was no real room to turn around there! We therefore had to be careful how we mentioned his handiwork in the village trail leaflets we produced around 1980!

In 1978, the Society sponsored a Job Creation Gang to improve the infrastructure of the railway in and around Corris. The main work undertaken was the start of the work which created what are now the Corris United Football Club changing rooms in the old stables under the Museum, knocking the internal doorways through within the Museum, improvements to the then heavily rutted track and drainage giving access to it and Glanyrafon, and the repair and construction of walls and drains past the Church and in front of Maes y Ilan. For this, Mark became one of the cheque signatories, and would visit the gang several times a week to present the Society's face to them, taking photographs, arranging deliveries and dealing with the paperwork, and handing out the (cash) wage packets and collecting time sheets as necessary. We would not have been able to undertake this work without him! Liaison was by 'phone or by dropping items in his mail box at the bottom of his drive.

Although strictly retired, Mark was very active, and could be seen most days driving his small 4 x 4 with trailer in tow, fetching materials from Machynlleth with which to carry building materials up the mountain to build another folly. Although very small and slight of stature, he packed quite a punch - as his neighbour found out to his cost! Over many years he kept donkeys, building small sheds for them in the field below the house, which were affectionate company to the elderly couple living at Penrhos - Meinir's Nain and Taid.

Mark and wife Muriel - who he met on a train tour in Austria - would always stop and pass at least a few words, with Mark's distinctive laugh-cum-chortle (not too dissimilar to the vacuum pump on a GW loco!) to the fore. It was around Christmas time when we last exchanged such words, Mark pausing on his way to visit the Doctor in the Surgery to get news of his impending operation, while I was topping up with sweets from the Museum with which to feed the office. Little was I to know that I would not see him again.

Not being a religious man, Mark's cremation service at Aberystwyth was as distinctive as he was - unusual to say the least. However it was truly as it was described - a celebration of his life and full of colour. It was very fitting of such a colourful character, of whom I can say with pride that I knew.

Our commiserations extend to Muriel, his very kind and tolerant wife, in her loss.

DKC

(Mark Bourne died last year, two years after his reply so I made a pilgrimage to his garden in Wales and photographed it, the same garden in which I had made a film called SELF HEAL)

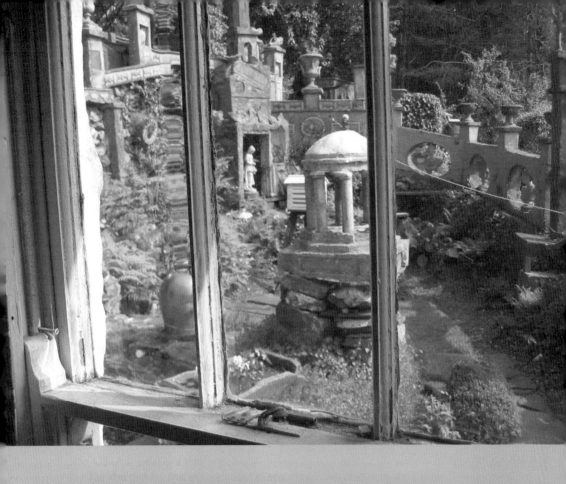

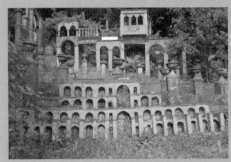

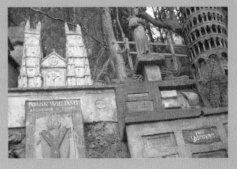

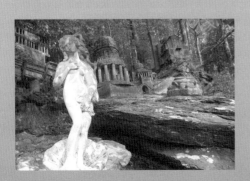

5 | DAVE CALHOUN, Writer and editor |

Hi Andrew - I'd love to contribute still, but I lost the form you sent me when I moved flat and was too embarrassed to admit my sloppiness!

Do you think you could send me another one and then I will fill it in when I get it? You could send it to me at home: London NW1

I hope everything is going well for you. x

"badbloodandsibyl" on Tuesday, June 28, 2005 at 12:50 pm +0000 wrote:

>Dave – I can see from your regular missives scattered throughout the time
>of out publication that you are busy - but was chasing the last few
>stragglers vis a vie the DEADAD project – if you think you might be
>sending something then great – if not then could you send me an irate
>email instead which I might then include under the Calhoun section – ps
>the editor made me do it!
>Andrew
>x

6 | DINOS CHAPMAN, Artist |
No reply

7 | ADAM CHODZKO, Artist |
➜

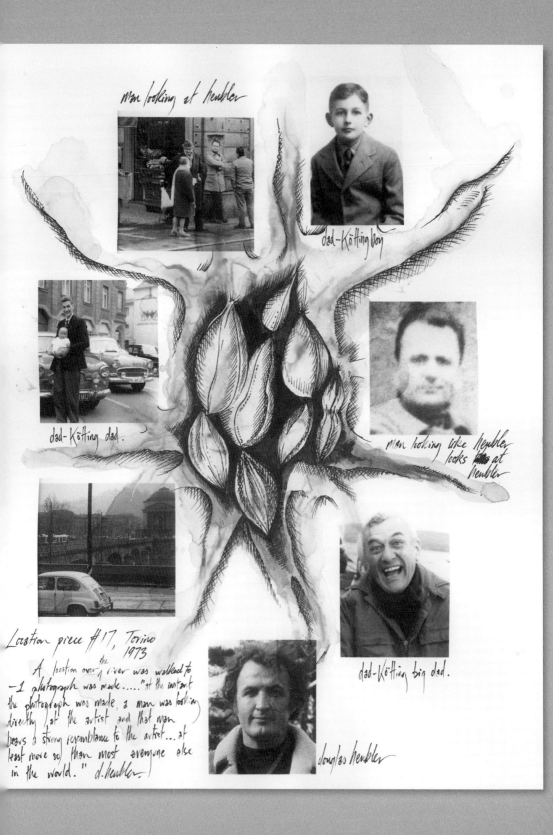

man looking at heubler

dad-Kötting boy

dad-Kötting dad.

man looking like heubler looks ~~like~~ at heubler

dad-Kötting big dad.

douglas heubler

Location piece #17, Torino
1973

A location over the river was walked to
—1 photograph was made....."at the instant
the photograph was made, a man was looking
directly at the artist and that man
bears a strong resemblance to the artist... at
least more so than most everyone else
in the world." d.heubler

I shall be reconciled with myself only when I accept death the way one accepts an invitation to a dinner: with amused distaste.

E.M. CIORAN *Drawn and Quartered*

8 | JOHN CHEETHAM, Writer and would be ambulance driver |

➔

In the wake of a dad dying.

a boy

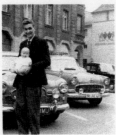

a young man

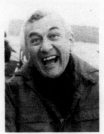

a middle-aged man

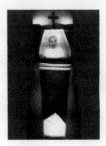

an older man (dead)

Interior. Friendly - a diner. Uncertain location. On a sunny day.

It is a brunch crowd. A little more than multicultural and more like a meeting of the United Nations. There is a Masai herder drinking coffee with a very hot and bothered looking Inuit lady, in a booth by a window that looks out onto a busy car-park. In the next booth are two much more ordinary looking men.

The older one, in his mid-sixties is white. DEADAD, holding four photographs and looking at them in turn. Opposite him is a young man dressed in a suit. Close up we can see that ANGEL is really a very big guy with terrible posture.

<div align="center">

ANGEL
Can I see those?

</div>

Deadad puts the photos on the tabletop and slides them over to Angel.

<div align="center">

ANGEL
Are they all of you?

</div>

Deadad nods.

<div align="center">

DEADAD
I think so.

ANGEL
You don't know? Don't you remember taking them?

DEADAD
I like this one.

</div>

In the wake of a dad dying continued

He takes one of the pictures and looks at it. The image looks like Deadad but it looks like it has been made of other photographs. It shows Deadad asleep in the ground with a cross above his head.

DEADAD
My son made it…Actually I was cremated.

ANGEL
It is morbid.

DEADAD
It isn't morbid, it's got a sense of something traditional. There is not enough room to bury everyone, in England anyway. There are too many people.

He has a quick look around at the other diners.

ANGEL
Call it what you like, it is morbid that you carry a picture of yourself dressed a corpse.

DEADAD
No you don't understand, it's a real photo. I am dead. My son is an artist.

Angel is staring at a Russian businessman looking through his pockets for the keys to his Toyota Marino out on the lot.

DEADAD
Where is this place. Is it a Little Chef?

ANGEL
It's a Friendly.

DEADAD
Never heard of it. It feels familiar though. Have I been here before?

In the wake of a dad dying continued

ANGEL
It's a chain. They're all the same. You may find little differences
in the menu to cater for local tastes and a slight variation in the
prices depending on whether you are in Sakai City or on the Jersey
Turnpike, but basically the same, wherever you go.

DEADAD
So you know where you are.

ANGEL
That's right. That is why we always use these places.

DEADAD
Do you do many of these...meetings?

ANGEL
A lot. This is not a seasonal business, it's twenty-four seven,
three hundred and sixty five days a year from now until forever....
So don't even talk to me about over-time.

Angel is not joking.

DEADAD

Well maybe we should get on with it. I don't want hold you
up...You clearly a busy man.

ANGEL
Have you looked at the menu?

Deadad looks at the Friendly menu in the rack.

ANGEL
Maybe you could start things rolling by taking a look at the menu.

Deadad studies the menu.

DEADAD
It's all a bit heavy isn't it. Do you think I can just get a cup of tea?

ANGEL
You're here to select your afterlife. Your fate for all eternity will
be the outcome of your choosing right now, so consider it
carefully. A cup of Dahrjeeling might not be exactly what you are
looking for.

Deadad's wonderfully sympathetic face-acting says "I'm thirsty".

In the wake of a dad dying continued

DEADAD(reading)
Hell. Spit-roasted by flaming Berbers to the sound of an over
excitable Schubert string ensemble… Do people actually get it up
for this kind of thing?

ANGEL
Winning the object of your heart-desire is not always a blessing
my friend, especially when it is forever. Please do not be over-
hasty.

DEADAD (reading)
Reincarnation…I think I'm having a deja-vu…Just kidding.
God, I don't know. Nobody ever told me that it what going to be
this complicated.

ANGEL
You have a menu to choose from, how complicated can it be?

DEADAD
I think I liked it better when it was all decided for you. If you were
good then you went to heaven and if not you went to hell.

ANGEL
Have you any idea how much manpower is involved in watching
every human on Earth from cradle to grave, not to mention the
administration and the very credible possibility that somebody
somewhere might just make an error of judgement, on which there
can be no going back you understand me.

DEADAD
Alright then, I'll go to heaven please.

ANGEL
Heaven's closed…Except for the VIP lounges, for which you do
not qualify, but mostly it is full.

DEADAD

Shit.

ANGEL
There is a colony in a galaxy fairly close to our own where
scientists have created a simulacrum of heaven. Its very like the
original but it is less crowded and the shops are open twenty-four
hours a day. But get in quick because it is filling up fast.

'No need to elaborate works - merely say something that can be murmured in the ear of a drunkard or dying man.' E.M.Cioran

Deadad closes the menu.

 DEADAD
Can't I just die? Now that I am dead. Just let it be the end of it.

 ANGEL
Yes, but what are you going to do?

 DEADAD
Nothing. Absolutely nothing at all.

 ANGEL
That's a bit boring isn't it?

 DEADAD
But it's death isn't it. Death isn't supposed to be fun. It isn't
supposed to twenty four hour shopping and big tvs.

 ANGEL
Alright, alright. You obviously appreciate a little retro-chic. Have
you thought about being a ghost. You can choose your own
patch…within reason of course.

 DEADAD
I'm retired, or at least I was. And I liked it. Being a ghost would
be like going back to work all over again. No.

 ANGEL
Alright, alright. What do you like to do?

Deadad shrugs.

'No need to elaborate works - merely say something that can be murmured in the ear of a drunkard or dying man.' E.M.Cioran

In the wake of a dad dying continued

ANGEL
You like a pint with your mates, am I correct?

DEADAD
Occasionally.

ANGEL
What are you like in a fight?

DEADAD
It has been a while but still a bit tasty I would say.

ANGEL
What about Valhalla?

DEADAD
Valhalla? I didn't see Valhalla on the menu.

Angel opens the menu.

ANGEL
It's here, look. They call it a Viking Buffet.

DEADAD
Oh, yes. Feasting and drinking and fighting with Nordic warrior
ancestors. Bring your appetites, not for the faint hearted. No
chics. Alright, I'll have it.

ANGEL
Are you sure?

Angel beckons the waitress.

ANGEL
One Viking Buffet.

He sits back in his seat, satisfied.

DEADAD
So what do I do now?

ANGEL
You see that door over there?

DEADAD
To the loo.

'No need to elaborate works - merely say something that can be murmured in the ear of a drunkard or dying man.' E.M.Cioran

ANGEL

When you walk through that door you will enter a large hall. At the far end of the hall their will be a table. There will be a place for you at that table. Go right in and join the party my friend.

DEADAD

It's as simple as that?

ANGEL

Yes it is…Do you have a hat or a scarf? It might be cold in there…Nevermind, you won't even notice once you are in the swing.

Deadad stand up.

DEADAD

Thank-you.

He shakes Angel's hand. Taking one last look around Denny's he can't help smiling as he walks towards the door of the gents.

DEADAD

Valhalla… Bloody result.

He opens the door and walks in.

I am hoping to publish a booklet which may contain these 'portraits' as well as other works pertaining to the project. To this end I would ask for your written permission, agreeing that I might use some or all of your words or marks.

I agree to the abovementioned.

Signed : Jonathan Cheetham Date : 29/8/03

John Cheetham

9 | MATTHEW COLLINGS, Writer and artist |

No reply

10 | BEN COOK. Programmer and writer |

No reply

11 | MICHAEL COPEMAN, Writer and council worker |

Andrew,

Sorry this took so long. I hope it's not too late - here you are anyway.

How little pictures tell us; and how much they point to other things.

Of death a picture tells least of all. Should it be shocking? Of the others: is he smiling through the pain? Does love show in laughter? Father is what we call someone, not who we are. We fathers are still, always, sons. The lost father is always an absence. I imagine your family is a rock on which you all can lean, but these pictures are of something distant, something I do not quite understand.

I never met my father. He could have made himself known to me and I am angry that he did not. The man I called dad was kind, and much loved. When I was twelve he was ill and I realised he might die. My world turned cold with fear that there would be no-one to answer when there was something I didn't know. But in the end I thought he'd betrayed me by loving me as a boy and not a son. My childhood is far too far away for my children to care about, but somehow, I wish they would.

I think your pictures mean love.

Andrew,

I've just posted you something for in the wake of a dad dying, but I fiddled around with what I wrote and now I wish I'd sent it straight- can you chuck the other sheet? I had your pictures - and Prince whatsit's stamp - on my desk all summer.

First I wrote:

I imagine your family as a tribe, and a rock on which each of you leans.

I never had a family like that. I think that it would choke me with cords of obligation.

The man I called Dad was kind, and much loved.

When I was twelve he was ill and I realised he might die. My world turned cold fear that there would be no-one answer when there was something I didn't know. But in the end I thought he'd betray me by loving me as a boy and not a son.

Perhaps I chose to stay in the cold.

I don't want to plant seeds of bitterness.

I think my children see my childhood as far too far away for them to care about, but for some reason I wish they would.

I love them more than life.

Then, later I wrote:

How little pictures tell us.In death least of all
Should it be shocking?
Do we smile through pain?
Does love show in laughter?
No
Father is what we call
Someone not who
We are
Always a son
The lost father
Always an absence.

 LAURENCE CORIAT, Writer and film-maker

In the wake of a dad dying.

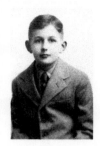

a boy

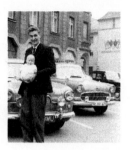

a young man

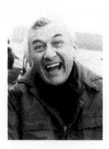

a middle-aged man

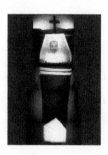

an older man (dead)

WHEN I LOOK AT PICTURES OF YOUR FATHER, I THINK OF MY FATHER. PERHAPS BECAUSE IT FEELS I KNOW AS LITTLE OF HIM (WHO WAS MY FATHER) AS I KNOW OF YOURS WHO I NEVER MET.

SO HERE ARE SOME PHOTOS OF MY DAD WHO DIED WHEN I WAS 16.
HE WAS BORN ON 2nd OF FEBRUARY 1914 (!) IN RELIZANE IN ALGERIA AND DIED ON JULY 1975 IN AIX EN PROVENCE, FRANCE.
I WISH I HAD KNOWN HIM LONGER AND BETTER.

SAMUEL CORIAT
NOT LONG BEFORE
HE DIED

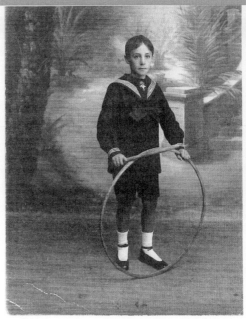

SAMUEL CORIAT
A BOY (ALGERIA)

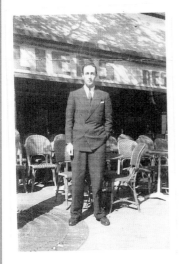

SAMUEL CORIAT
A~~YOUNGER~~ MAN
YOUNG
(PARIS)

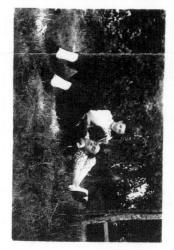

SAMUEL CORIAT
IN LOVE
(NORMANDY)

WHAT WAS YOUR FATHER'S NAME
I WONDERED?

L.C

I am hoping to publish a booklet which may contain these 'portraits' as well as other works pertaining to the project. To this end I would ask for your written permission, agreeing that I might use some or all of your words or marks.

I agree to the abovementioned.

Signed : _____ Date : 26/07/2003

Laurence Coriat

13 | MARK COUSINS, Writer and film maker

ANDREW'S DAD:

Why is Andrew doing this? I don't know. Because he loved me I suppose. He has sent you, somebody I never met, somebody who doesn't even know my name, four pictures of me and asked you to conjure something out of them. To stare at them and try and work out things about me.

I don't envy you the task, Mark. What can pictures tell?

MARK:

This is strange, hearing your voice in my head. You are the nice looking man I'm staring at. Andrew asked me to think about you but I didn't hear my thoughts. I heard yours.

Or, to be honest, a mixture of yours and my own dad's. He died before you- in 1996. From a heart attack. In minutes. With Only Fools and Horses on the TV. After eating a big plateful of my mum's Irish stew. Which came up after the attack. 56 years old. You were 65, exactly retirement age. Like him, you look as if you were having a laugh up until the end, which I hope I can ask you about. I wonder would you have liked him? You could have gone for a pint. Did you get very, very proud of Andrew after a few pints? Did you get that flint in your eye like a Rembrandt painting when you talked of him in the pub? My dad did with me.

ANDREW'S DAD:

Most men like your dad and me kept things to themselves. I look like a clown in the third picture Andrew sent you, as if I'm performing for everybody, but there were loads of things I didn't say. Far more than those I did. The thing about life is that emotions mature inside you. Men like us let them do so. We didn't talk about them as soon as they started to form. We waited to see. And then when they had formed, it was too late because you can't talk about something as complicated as that.

That's what took me by surprise about Andrew's film Gallivant. I saw my feelings about my family up there on the big screen where I saw John Wayne films as a boy.

MARK:

My girlfriend and I drove to India from Scotland and at our going away party we showed Gallivant on the big screen. My dad was dead by then but he would have loved it. My mum loved it. She'd never seen a film like that but it was so like a real family to her that I heard her talking out loud in the pictures during it.

If these were moving pictures or videos Andrew ad sent me about you, I could have seen the way you moved or talked or interacted with you r family. But no. All I have are these. Shall I tell you what I see in them?

ANDREW'S DAD:
Go on then, give us a laugh.

MARK:
In the first, your ears are quite big...

ANDREW'S DAD:
All my friends noticed...

MARK:
But they are smaller, or more pulled back, in the clown picture. Maybe life pushed them back like the wind does the wing mirrors in my clapped out campervan. Your nose also got a lot bigger, but that's what happens. Noses keep growing even though the rest of us stops.

Your face was so sweet. A shy face, drinking in more than you were giving out- back to that again- but your mouth was quite bold.

In the second picture, how you are holding the child- Andrew I guess- really makes me laugh. It's how photographers hold their inch square cameras. You've got some of the perky uncertainty of a new dad. I suppose this was in the Mid 50's?

ANDREW'S DAD:
About then. Look how clean the cars were, how polished the chrome. And me in my white shirt and dark tie. It was just normal to be presentable then. There wasn't really any such thing as casual.

MARK:
Looks like you're on holiday to me. That sign on the building behind you looks French or Belgian or German. Northern European. As do the buildings. The car beside you was maybe yours but the one behind it looks European too. I've go my face about an inch from the photographs as I write this. Wish Andrew had sent some clearer ones. A French writer I like, Roland Bathes, invented the word "punctum" to describe what I'm looking for in these photos of you. He explained: "A photograph's punctum is that accident which pricks me (but also bruises me, is poignant for me)." We are getting to the bruising bit, the fact that you who are so alive or, rather, who is coming alive before my eyes as I look and hear your voice and type, are no longer alive. That is big time bruising. I can feel it coming.

ANDREW'S DAD:
I've already been though that, Mark. I had long enough at the end to feel the loss of my own life. I had time to realise that all those rich emotions I mentioned earlier which I somehow always felt I could put to some good- and I did do with my family- what was left of them would die for me. They were unspent money in the bank. I didn't get a chance to use them fully. That was a bruise. Still feels like one now.

MARK:
I think about that nearly every day. My dad was insured to the hilt and paid lots of money into pensions and he didn't get to spend a penny of it. As a result of standing at the edge of the precipice after his death, I decided not to make the same mistake and to live life now. Sounds like I'm criticising him, I know, and I suppose I am in a way. But my approach is to be a clown now, like you are in the third picture.

ANDREW'S DAD:
What was his name?

MARK:
Nat. Nathaniel.

You know when you were talking about the bruise, I remembered this: At the end of a film called Gertrud by a Dane, CT Dreyer, a woman who once had a great affair asked herself "Am I still living?" Do you know what her answer is? "No, but I have loved." I can tell by the way that you are holding the child in the second picture that you have loved.

ANDREW'S DAD:
Of course. A lot.

MARK:
And then there's the last picture of you in your coffin. Looks like five pictures to me, taken from overhead. Did Andrew d find some way of climbing onto the ceiling and looking straight down?

ANDREW'S DAD:
I was lying there thinking, "some things never change".

MARK:
The picture really moved me. In our house we have a traditional Irish wake. Coffin open. Whiskey bottles too. Conversation flowing. My dad lying in the middle of it all.

The picture of you moved me for another reason as well. It reminded me of the ending of yet another Dreyer film. This one is called Ordet - The Word. In it, a woman is lying in her coffin, like you are. The décor in the room is very simple, as it is in your picture. Then a man says that he can call her back to life. People say he is mad. But he does.

It makes no sense. I don't believe in such things. I know that you are dead and that's it, only your influence-which I think was huge- will remain. Yet I look at this final picture of you and then or Ordet and wish.

I wish I'd met you, my friend. We could have talked like this.

If you talk about death you save a part of yourself.

E.M. CIORAN *On the heights of despair*

14 | ALEX CROMBIE RODGERS, Set builder and artist |

Numerous text messages about wanting to reply but ultimately no reply

15 | CHRIS DARKE. Writer |

No reply

16 | ALNOOR DEWSHI, Film-maker and writer |

Andrew,

it's impossible for me to make a genuine response to the death of your father knowing that these are intended for the public stage. it feels like an exercise.

despite this, i'll put it in writing; my heart goes out to you and your kin for your bereavement.

good luck with your piece,

Love

Alnoor

In the wake of a dad dying.

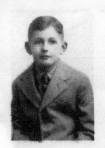
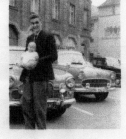
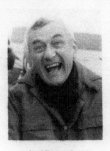
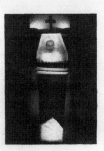

a boy a young man a middle-aged man an older man (dead)

A BOY

Skinny boy, arms like twigs. Ate insects for money. His Dad was a magnet. Magnetic he was, a Magnetic Man.

His Mum had an iron lung.

Arms like twigs, legs like toothpicks, the boy's business was eating insects for money. Sixpence for a spider, 15 for a fly.

Never got picked on, never got bullied...

Would you try it on with a nutter like that?

A YOUNG MAN

A young man, full of fire, went into a shop and asked for two jammy doughnuts.

And the shopgirl said,

"What?"

He looked around and he saw that he wasn't in the baker's but in Freeman Hardy Willis.

So he said,

"I meant a pair of plimsolls, and make 'em good 'uns."

He smiled sorry as she sized him up.

"Don't you normally work in the baker's?"

But she said that she didn't and he thought to himself all shopgirls look the same.

When he went into the baker's, there she was again. So he told her,

"They fit alright, but the left one squeaks."

And the shopgirl said,

"What?"

Because it wasn't her, but another one.

So he explained that he meant to ask for two jam doughnuts, and sorry about that and he gave her a smile.

Nine months later, a shopgirl gave him a baby. But he never found out which one. All shopgirls looked the same.

A MIDDLE-AGED MAN

A man in the middle had iron in the blood.
 Magnetic he was, a Magnetic Man.

AN OLDER MAN

An old man said to the corpse growing inside him,
 "You win, Joe."
 And with that came a smile.
 And Joe took his place on the stage.

I am hoping to publish a booklet which may contain these 'portraits' as well as other works pertaining to the project. To this end I would ask for your written permission, agreeing that I might use some or all of your words or marks.

I agree to the abovementioned.

Alnoor Dewshi

Signed: Date: August 2005

Physicists, experimenting on materials, discover things about a particular metal alloy when they subject it to extreme heat, extreme pressure or extreme radiation and the like. I think that, put under extreme pressure, people give you many more insights into their innermost being and tell us about who we really are.

WERNER HERZOG

17 | SIAN EDE, Writer |

No reply

18 | ROBERT FARRAR, Writer |

No reply

19 | JEM FINER, Artist and musician |

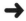

2/2/2005

Hi Andrew,

Here, at last, is my dead dad
offering, I hope it's OK.

All the files are on the cd - it's been laid
out using Adobe InDesign.
The idea is a right hand page

has the backs of the photos +
"sammy fne" etc text
overleaf, ie on turning the page, on the
the side of that page, are the fronts of
the photos. They're nearly lined up,
maybe need a slight nudge.
The text - what little there is, the names +
dates - I want to do in typewriting. I'm
just trying to find an old typewriter. In the
meantime the font is courier something or
other. The .psd files are there in case
the designer needs to tweek the shadows.
I went to great lengths to leave the

shadows around the seams but make
the bits outside the photos + shadows
go as white as the background.
Anyway this gives you the gist. I can
change stuff if need be.
Bye for now you shanghai beatnik

Jen x

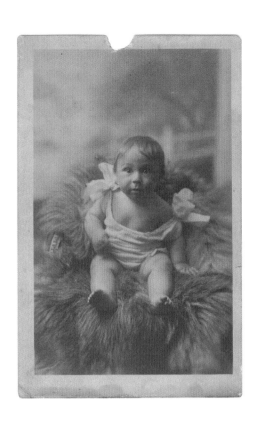

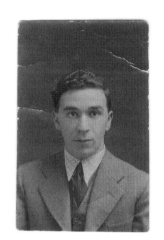

20 LIZZIE FRANCKE, Writer and producer

From: Lizzie Francke
Sent: 25 July 2003 11:43
To: 'badbloodandsibyl ******@'

Dear Andrew

I was so touched to receive your invitation to take part in your project 'in the wake of a dad dying'. It has the makings of something very rich. I will get going on it soonish. Bizarrely I dreamt about the project last night - and what I would say about the final picture. The dream included a conversation with Tracey Emin and Will Self (not a good sign I know), while I also lost a very very small baby - contact lens size (I dropped it, and couldn't find it and hoped that the parents wouldn't miss it).

Anyway I will give it all due care and thought (unlike the baby in my dream).

Much love to you, Lelia and Eden. I would love to catch up sometime.

Lizziexxx

21 JOHN GANGE, Visual theorist
No reply

22 JANE GILES, Programmer and curator

Dear Andrew,

Thanks for inviting me to take part in this. My dad was born in 1937 and also died of a heart attack, so has (had?) something in common with yours. But in my case, the death was a huge shock because he'd never had heart problems before. I went to see his body laid out because I didn't want to regret not having done so. But I didn't like what I saw- all the clothes were true, it both was and wasn't him, he looked smaller than life, and as though he was trying to be good- and I'm still coming to terms with that. In the last six months I've gone through various phases of glimpsing "him" in a crowd, seeing men of a similar age and wondering why they get to be still alive, and so on. It would be hard for me to seek out negative sides of my Dad's personality and life, but I admire your interrogation of your father because I'm sure it helps in moving forwards.

The first two photographs of your Dad are very similar to some of those in our family album- the studio shot of a smart little boy with sticking out ears and a side parting; the wonky snapshot of a nervously grinning young man in blazer and tie about to drop a baby. But the third picture is very different- did you take it? He looks manic. Does he look like you? Something reminds me of you in this picture. I find it hard to look at the last picture- there was much I didn't understand about seeing my own father in a box, and in this case I don't understand why yours is tied down, why he looks so naughty and what's with the devilish goatee.

Who knows if our fathers ever passed each other on the street, or whether if they'd struck up a chance conversation, they'd have got on. Probably not. But we move on.

In return for all the information you'd given me, I'd like you to have the following, which is what I said at my Dad's funeral and goes nowhere near describing the entirety of who he was and where he came from, but is a snap shot of sorts.

Best wishes,

Jane

When my dad died aged 67 on October 11th 2003- unexpectedly, of a heart attack- my mother, brother Mark and I sat down to work out the funeral that he would've appreciated. Mark wanted me to say something about the meaning of sport in Dad's life [he was a PE teacher in a new town comprehensive school]. Not easy for me as a non-believer in the religion of sport, but here goes.

Among my father's greatest loves were cricket and rugby.

One of my earliest memories is of sitting on a blanket during Dad's local cricket matches every Sunday in summer over several years. No doubt some runs were made and a few balls caught, but our most dramatic incident of this time was Dad's collapse while cricketing on Sunday in the early 1970's. Mum thought he'd had a heart attack. But no, not yet. Not yet. It was just the snapping of his Achilles tendon.

A later memory is of freezing in a rain-lashed winter field when Dad took me to watch muddy men with cauliflower ears shoving each other. The appeal of rugby is even less comprehensible to me than that of cricket, but Dad was equally passionate about it and won awards for his coaching of school teams, including the England Under-16's.

I think Dad loved these team sports because they embody the ideal of what a group collaborating in (we hope) friendly opposition. Dad loved to be part of a team with a shared endeavour. And he knew how to be oppositional, thanks not least to his life-long, left-leaning principles.

Cricket probably doesn't have a hymn associated with it, but rugby does and this hymn- 'Guide Me, O Thou Great Redeemer' or 'Bread of Heaven' as Dad always called it- was his favourite. Written more than 250 years ago by the itinerant Welsh minister William Williams, it's original title was 'Strength to Pass through the Wilderness'. It's sung by Welsh supporters at rugby matches and always moved Dad to tears. For although he had the body of an Englishman, some of us have long suspected that my father's soul may be Welsh.

I'm sad that Dad will not get to Cardiff Arms Park this winter. But I am so thankful that he lived through this beautiful summer's cricket season, in the village he loved, with Mum watching.

Jane Giles

20 October 2003

22 TONY GRISONI, Writer

Dear Andrew,

Thank you for inviting me to trample on hallowed ground

Tony

The Boy was very afraid of certain things; for example, of men who laughed too much or blew their noses too loudly, he was also afraid of magicians and ventriloquists. His mother indulged him in his hypersensitivity. His father had come to this country as a very young man to work as a pastry chef in a big hotel. To erase a previous life of unnamed sins he had assumed a new name. And so he worked all the hours and watched his son gradually take on the appearance of a child from another family and another class altogether.

There were times when the boy would visit the hotel - for the Christmas party or just because there was nowhere else to go. His father would often collar him and find an excuse to send him down into the basement where one of hell's portals was. The Head Kitchen Porter ruled the basement. The Porter had been in the First World War as a young man. During one battle he had dropped a shell on his foot. The resulting explosion wiped out his entire gun crew. But he survived. He would roll up his trouser leg and make the boy feel his shin. Through the paper-thin skin the boy could feel every break in the dry old bones. The porter believed in reincarnation. He liked to tell the boy his sincere hope was to return as a filthy virus so he could go round infecting everyone. The boy couldn't catch a cold without thinking of the terrible old man.

In rare idle moments, the boy's father would fantasise about hitting his son. He amused himself by dreaming the most exquisitely drawn out tortures

culminating in humiliating death. All for his son. Those were the times when he felt moved to ruffle his son's hair as he had seen other fathers do. Because that was the truth - he was acting a part. But so was everyone else back then.

The boy, sensing the terrible suppressed violence around him, left home as soon as a child could. He moved to another city and hoped his father would never find him. It meant that if you looked closely you could detect fear at the back of his eyes. It was a kind of space into which the boy dreaded his father might one-day walk; even after he died. The young man went to see his father in the Chapel of Rest. They had done a good job on him. Too good. It was difficult to believe the man in the coffin was really dead.

The ventriloquist act started as a joke one Christmas. He had had a few and just picked up a relative's baby in his arms and made it talk knowingly about the cost of living. There was something very Dan Leno about the act; "The moment he capers on, with that air of wild determination, squirming in every limb with some deep grievance that must be out-poured, all hearts are his... incarnate of the will to live in a world not at all worth living in..." That was Leno and that was the young man's act.

The ventriloquist act didn t last. People talked. Anyhow, at that time, talking dummies were rapidly being seen as passé. Time to move on. Which is why he began teaching himself magic tricks. He invented an entirely new persona for himself and named him, Harry. Harry was a card. Harry would like to be a womaniser. Harry hid deep dark fears that he might be found out. But most of all, Harry was an entertainer. Harry was fun.

The car crash didn't end Harry's career in show business, but it did lead to heavy drinking. It was the pain in his smashed legs that did it. More and more he felt an intense need to HAVE FUN. He became impossible - demanding others to HAVE FUN too. Everything had to be a joke. He ridiculed any sombre or serious thoughts or opinions. He began to scorn the living whilst praising the dead. Houdini was raised to the status of god, contempories were deemed charlatans. One assistant after another left, complaining of exhaustion and enforced jollity. Pretty soon the punters began staying away. Then the bookings stopped coming. It was a tragedy because Harry had been preparing a new act.

He was not surprised when no one showed. People had long stopped coming to hear his latest gags. It didn't deter him. He hired a hall in a local working man's club, which was due for demolition and where the membership had shrunk to seven. He installed a box- Harry's box. He climbed in and shut the door. He peered out through the window at the peeling wallpaper and stained carpet and nicotine brown ceiling. Then he held his breath and concentrated every ounce of his willpower- which was considerable. He prepared to transport himself. He stayed like that – breath held, muscles tensed, mind concentrated... then in a revelatory moment, it occurred to him that everything was a ridiculous joke. And that's how he stayed - in a state of exquisite suspension - crucified between fear and joy for eternity.

So you witnessed old age, pain, and death and told yourself that pleasure is
an illusion and that the pleasure seekers do not understand the inconstancy of
things. Then you shunned the world, persuaded that nothing will endure. "I will
not return", you proclaimed, "before I have escaped, birth, old age and death".

E.M. CIORAN *On The Heights of Despair*

Dear Andrew —
Oona produced this
in response to the pics
of your dad.
Best, Ben Grisoni

OONA GRISONI, Artist

for friends

A/P A Schmitt 05

A book is a postponed suicide.

E.M. CIORAN *The trouble with being born*

23 | NICKY HAMLYN, Film-maker and writer |

From: Nicky Hamlyn [nicky.hamlyn****@]
Sent: 13 March 2004 14:11
To: badbloodandsibyl@****
Subject: Text

Dear Andrew,

Here's a draft of my text, which you can take as a mark of my definite commitment to do something! I will almost certainly want to tweak it, and there will be a photo to go with it as well, best wishes,

Nicky.

PS I enjoyed your talk. It takes some guts to discuss your adolescent practices in front of a room full of strangers, although if we'd been sat around a table with the lights on, it would have been harder...?

Dead Dad.

Why did I find it so difficult to meet your request for a piece of writing that would respond to four pictures of your late father? My initial answer was that they fall into the vast genre of anonymous family snaps that function as momentos. As such they are indistinguishable from all the others that have a meaning, a special meaning, only to the people to whom they are directly connected. Indeed, the knowledge that they have that significance for someone else seems to reinforce the fact that they seem to mean nothing to me, beyond what one can infer from the manic grin in one of the pictures.

Yet a connection to the pictures I have of my own father recently occurred to me. Mine died when I was four, so I can say I never knew him, at least in so far as I don't remember him. When I was nineteen I learnt that he had committed suicide. Thirty years later, increasingly preoccupied with the need to know the precise circumstances and method of his death, I was told that he had taken a large overdose of anaesthetic after a job interview had gone badly. (He was probably an undiagnosed manic-depressive).

So, apart from manic perhaps, there is after all a melancholy affinity between the pictures I have of my own father and those I have of yours: I never met your father and I never got to know my own. Two different kinds of non-familiarity.

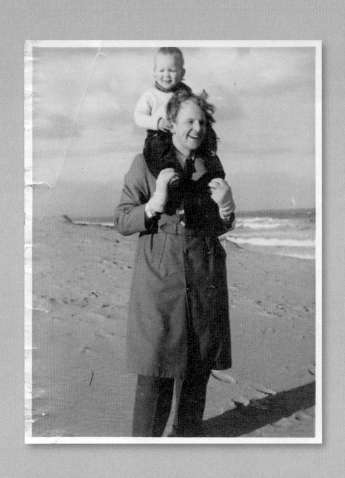

By the mark of something, the photograph is no longer "anything whatever". The something has triggered me, has provoked a tiny shock, a satori, the passage of a void (it is of no importance that it's referent is insignificant).

ROLAND BARTHES *Camera Lucida*

Kurt Kobain(1967-1994) shot himself leaving a suicide note ending with the words 'I love you, I love you'

BENJAMIN NOYS *The Culture of Death*

The GENERAL SUICIDE Agency

Amongst other benefits, the GSA at last offers a reputable method of passing away, death being the least excusable of moral failings. That is why we organised an Express Burial service: meal, viewing by friends and relations, photographs (or death masks if preferred), distribution of effects, suicide, placing in coffin, religious ceremony (optional), transport of the body to the cemetery. The Gsa pledges itself to carry out the last wishes of its esteemed clients.

N.B. – In the event of the establishment not being close to a main thoroughfare, the corpse will be conveyed to the morgue in order to ensure the peace of mind of those families who so desire it.

Price List

Electrocution 200 fr

Revolver 100 fr

Poison 100 fr

Drowning 50 fr

Perfumed Death (inclusive of luxury tax) . . 500 fr

Hanging. The suicide of the poor.
(the rope is charged at 20 fr per metre,
plus 5 fr for every additional 10 cm.) 5 fr

JACQUES RIGAUT *The General Suicide Agancy*

(Committed suicide and thus Died in 1929 after having exhausted all the reasons for living a man can afford himself)

In the wake of a dad dying.

a boy

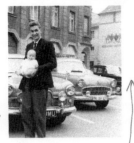

a young man

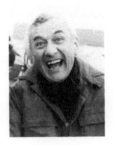

a middle-aged man

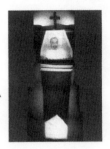

an older man (dead)

It occurs to me that your dad looks like / is redolent of different films at different times in his life. Something like this :

Les Quatre Cents Coups (Truffaut)

À bou de Souffle (Goddard) ~Spelling?~

OR

I'm Alright Jack

.... I can't decide

The Long Good Friday (Mackenzie)

Gertrud (Dreyer)

...... clearly, your filmmaking path was beaten for you.......

Aren't you big in the young man's arms though. And sound. like a football with a head.... it _is_ you isn't it?

Sorry, I found this process all rather upsetting Actually, the truth is, I was on the bus from Cork to Glengarriff and pothole + ballygowan = moistness?

'No need to elaborate works - merely say something that can be murmured in the ear of a drunkard or dying man.' E.M.Cioran

So I was talking to a pal about dead dads – mostly yours – and he told me that when he (my pal) was a youngman, he went to see a punk group play a punk gig at a punk venue. Apparently they were a 'Seminal' act (this punk band) but my friend is now senile and cannot recall their name. Anyway, he did recall that the singer stopped the show halfway through to announce that his dad had died a few days ago and that he (the singer) would like to perform a ~~recently~~ freshly written tribute to his dad. Apparently it went like this:

(very fast, very shouty)

1234 Dead Dad Dead Dad Dead Dad Dead Dad Dead Dad Dead
Dead Dead Dead Dead Dad Dad Dad Dead Dead Dead ...
... Dad Dad Dad Dead Dad Dead Dad Dead Dad Dead Dad
Dead Dad Dead Dad Dead Dad Dead Dad Dead Dad Dead Dead
Dead Dad Dad Dad Dead Dead Dead Dad Dad Dad ...
.... Dead Dad Dead Dad Dead Dad Dead Dad Dead Dad Dead
Dad Dead Dad Dead Dad Dead Dead Dead Dad Dad Dad
.... Thank you.

I am hoping to publish a booklet which may contain these 'portraits' as well as other works pertaining to the project. To this end I would ask for your written permission, agreeing that I might use some or all of your words or marks.

I agree to the abovementioned.

Signed: *John Hardwick*

Date: September 2nd 2003

John Hardwick

25 | GARRY HENDERSON, Dabbler-writer |

No reply

26 | SUSAN HILLER, Artist |

Dear Andrew

I just got back to Berlin and note some of your films are playing here.

My father died a fortnight ago and I've been in the States. Will try to send you something but am feeling rather flat at the moment.

All the best,

Susan

PS: Have not seen Janni for ages and I was very glad to have news of her. I will read her book(s).

Dear Andrew

I was away last week, yes Berlin is changing so fast that soon it will look just like anyplace else. I have a DAAD until January, am working on a huge project that is really getting on top of me, and due to recent emotional disturbance(s) I am feeling truly uncreative. Unable to confront the death of my own father, unlikely to come up with a good contribution for your project… so perhaps best now not to count on me unless there's a lot more time to think/feel/

Etc etc ….

All the best,

Susan

No more masterpieces

ANTONIN ARTAUD

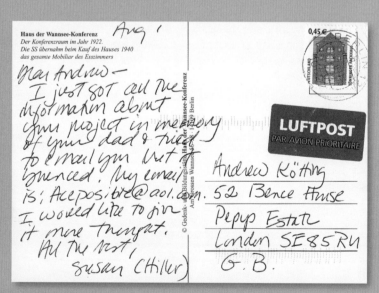

27 | BEN HOPKINS, Writer and film-maker

In the wake of a dad dying.

a boy

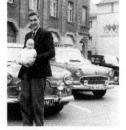

a young man

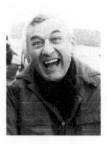

a middle-aged man

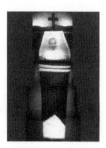

an older man (dead)

kötting, forgive the typography rather than the peppercornpenciloption, but i have forgotten how to write in the traditional fashion, or rather, it makes my hand hurt

response to you in the stylie of our email correspondence wot has been going on for some years now, innit; i'm most aware now we've known each other in bits and pieces now for 8 years odd, or 8 odd years indeed, and at times in our meats we've talked about the deadad, and maybe my livedad, and wot i have now about the deadad is fragments, and i'm sure that many of the fragments refer not to the deadad, but to the deadgrandad, who is, mefinks, deader than deadad

i think it was the deadgrandad who was a kraut in england at the time of the war, and some kind of military he was, and as they didn't trust the devious köttingkraut, they posted him on the faroes where he would watch the grey sea for uboats, and, i suppose, wonder what strange path had led him there, from deutschland to england to this funny island with its own language, somewhere farflung in the grey sea, where they like nuffink better than to tuck into a whale yum yum taste the blubber on that

doing the maffs and stuff i reckon that you were born around 1960, so your deadad was probably, like my livedad, born before the war, but too young like, to fight or nuffink and have them cockneys in his brigade call him "the Kraut" and stuff like that.. a bit obvious, what with the umlaut and that.. not much you can tell from that boyphoto, except that's how they liked the portrait in those days, formal and without expression, like my deadgrandad who, when the camera was pointed at him, would "compose himself", stop wot he was doing wot was interesting, and turn himself into a blank page

gloves? was it gloves your deadad retailed? he was a gloveretailer was he not? or a wholesaler? or a saler? a young man with a natty cheap suit and cream in his hair, moving around postwar britain with his glove samples, peripatetic and a'wandering like later his gallivanting idiot son,

drumming up a business? or he had a shop somewhere in sarf london, where youkötting grew up.. but i fink it was gloves he did sumfink with *a shop somewhere in sarf london* *(is wot is says there, alright?)*

and here's another fing; i don't know if you are the primogeniture, or the secondo, or even a terzo scherzo on your dad's part, for i know you are one of many brothers, but know not the order of your deadad's spermatozoic splatterings, the sequence of eggs from which you sprung

but there he is, the young man, with the babby which could be you, allowing himself a bit more expression there, maybe still a bit self-conscious (stand over there, deadad, and hold up the babby, not there you plonker, there.. left a bit, right a bit, the other right deadad, now hold the babby aloft, well look pleased with it man, smile goddamnyou deadad, ah that's better, click).. but then why is he looking – it would appear to me here in the semidarkness of my write – so far off camera? has a heron launched into the sky in the carpark there? is the star Wormwood falling from the sky as it were a lamp? or is it a shy moment (deadad: fuck i hate posing for these things, i feel like a prick.. my, look at that fantastic heron).. it could be many of fings, but there he is in middle-age, looking most relaxed, happy even, probably cos that fuckson andrew's left home and stopped fucking abaht with the lightfittings and that, and he's probably on a beach there, or somewhere near water, and what with the nautical blood of deadgrandad (his soul still staring over the grey sea of the Faroes) he feels a release, and gives this photo a bit of welly (say cheese deadad.. Deadad: fuck you i'll say "waaay" instead)

in this photo i say two fings -1: he looks like someone i've seen before. mefinks it's an actor in one of the many german expressionist silents i've seen and it could be max schreck without the nose, and 2 – maybe he is happy now cos he's sold a lot of gloves and exchanged them for children and a house and fings and shame about that fuckson andrew but the others have turned out alright innit

then in the next photo he's dead, which he was always going to be at some point, just the sad thing is, we never know when, but there it is

what did he give you, the deadad? he gave you a name with an umlaut, which is a major bequest, of which i am most deadenvious. wot would i give for an umlaut, to be höpkins.. o twould be an marvellous thing to be sure. for as you know, i know that fing that few brits know, namely that kraut-fings are the best fings around. the best fings in the world are the krautmusic, the krautwordsmithery, and the krautfinking. ok, maybe a great shag may be better, but that but lasts minutes, whereas the krautsounds/words/foughts last for ever. and indeed, i like this memorialising fing you're doing for your deadad, albeit in the köttingish way wot you do fings, for it's good to memorialise the dead, like the kaddish sung by the jews on the deadad, deadmum, deadwife's anniversaries, to keep them in the mind of the living. good luck with the deadad, and may he last forever in his krauty-sarflondon amalgam and in your köttingish work

you must see the umlaut here to catch my drift ↗ DRIFT

love from me

von Höpkins

I am hoping to publish a booklet which may contain these 'portraits' as well as other works pertaining to the project. To this end I would ask for your written permission, agreeing that I might use some or all of your words or marks.

I agree to the abovementioned.

Signed : *Benjamin Höpkins* Date : *2/8/03*

Ben Hopkins

Umlaut. The mark (¨) placed over a vowel in some languages such as German, indicating modification in the quality of the vowel.

28 | BARRY ISAACSON, Film producer and schoolboy friend

I never knew Andy's father, yet I saw Andy every day for eleven years. I'm so sorry he died and I'm going to try to construct an impression of him from these photographs and from qualities, which I have a hunch he may be genetically responsible for in his son:

- Funny
- Cockney
- Handsome
- Mad
- Hard
- Unconventional
- Practical
- Impractical
- Faithful
- Athletic
- Hates to lose (especially backgammon, to my wife)
- Physical
- Mental
- Non-materialistic
- Non-political
- Non-plussed
- Plussed
- Political
- Conventional
- Non-conventional Cheeky
- A GOOD FATHER (was I close?)

Love,
Barry.

Andy,
Will you send me the booklet?
-Barry

29 NICK JAMES, Writer and editor

Dear Andrew

I though I'd sent you this weeks ago. Hope it's still of use. Forgive the presumptions.

Nick.

In the wake of a dad dying.

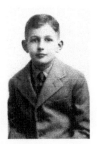
a boy

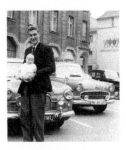
a young man

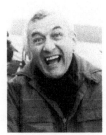
a middle-aged man

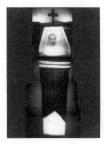
an older man (dead)

GROOMED

Dreamy and passive and well-turned-out – clean behind those ears. Some sense of knowing. The jacket's big enough to grow into. Fear-free candour for those whipping days in the eyes. Might have been a hypnotist but the look's far-away for him, not you. Is there a sparrow's frame under that cloth? Has hobbies. They all did then. I'd build him a den for his two friends.

GANGLY DANGLER

Big and drapey and delighted – it's all come quick for him, though he won't be left holding the baby. A bit of hankophile chrome and ducks' arse. A county town it seems he's man about. Always a bit Ted but looks after his own. The grin is something – wide, goony, unquestionable. But he doesn't know how to handle the baby (Andrew, I guess). It's like he's showing off his prize marrow.

GEEZER

Kindly but Barking. The eyebrow apostrophes dancing. Mad, up for it, you'd say, but a trace of strain in the gleam in the right eye. Some bleak Brit coast behind. A bit worn out with entertaining. Enough gas for another half hour of loon before some odd reverie. Lives to tease. Likes to challenge. Doesn't like to be on his own. Wants plenty more where that came from. This is the one that makes me envious. (Had a very bad dad myself)

FREEZER

Now he is Mesmer as Christ as Martin Scorsese (or is that the son's wish?). Looks like he'd rise again at the local Hippodrome instead of the organ. Now you have to spot the traces of dad in yourself – a real haunting you don't get exorcised for.

30 | MIKE JAY, Writer |

As I mentioned when we discussed Dead Dad, my main thought was the perverse one of how little you can tell from photos. How their meaning would change as soon as more information was attached to them - e.g. that he was a Communist, or a fascist, or a war hero, or a child molester. You mentioned that other people had voiced this thought so I imagine you have it covered? It's kind of obvious I guess.

 bon voyage et vacances to you all, and yes, I'd love to catch up for a drink or a feed on your return

m
=======
Mike Jay

31 | CHRISTY JOHNSON, Artist and lecturer |

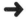

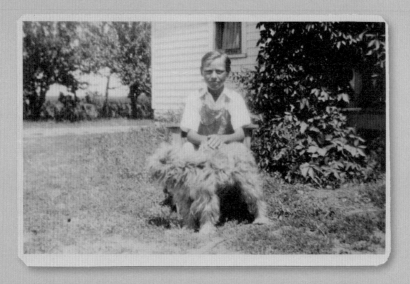

another boy & bowser

1

another young man & me

2

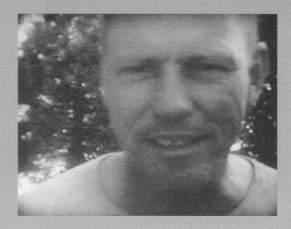

another middle-age man & *sequoiadendron sempervirens*

3

another older man (fell) & new england elevator

4

VICKY JUNG, Social worker and script editor

Letter to a living artist

Dear Andrew

I didn't know your dead dad. I can only imagine the traces he left in your life. I expect he was a HUGE MAN, as you are, a man who filled the room with his presence.

I too have a dead dad. He occupied a big space in my personal landscape. He made everything feel safe and his death left a gaping wound in my 13-year-old world. I spent a large part of my teens and adult life trying to fill the hole. An endless search for father figures, the fear of abandonment, and still a difficulty with endings...

I envy you. You seem to have found a better way to deal with all that.

So poignant to see the time line in the photographs; the young boy who dreams of the future becomes an old man with only a past. Are you the baby he holds in the second picture, a little uncertainly but with pride? His young man's smile, photo fixed, almost a grimace, shifts in middle age to one that appears much less self-conscious, less controlled. Was he a joker, or a maniac? Was that great joy on his face or a mask for deep pain?

How is your time line shaping up?

I can see the likeness between you in the third image; the energy, the 'joie de vivre', the wildness, the large frame. Did you take the picture? Are you laughing too?

The final image doesn't seem to belong to the family album set. It looks like a still from a gothic horror movie. I know you took this picture. Did you find this macabre portrait strangely comforting - black humour he would have shared? Or was it a joke at his expense - kick the old man when he's down? The coffin could be lying on its back or standing on end. Is he safely tucked up or about to rise up and haunt you? Did his containment leave you feeling diminished or more powerful? Who's the daddy now!

Did seeing your dead dad, change the way you live your life?

How does it make you feel about your own mortality?

I didn't see my dead dad. I stayed home and made an apple crumble. Did it make it any easier for you? Short cut the grieving process? I heard my father looked 'very peaceful'. Perhaps those are the only words you can say to a child.

Would your dead dad have approved of being served up as art? Being stared at by strangers? Having no control over his image? Or would he have found it funny, a last great laugh? Flattered to be the centre of attention? Is this a celebration of his life or an exorcism of his role in your life?

Your invitation posed some questions. Here's what I want to know:

What is YOUR point of view?

What do YOU want to say but haven't?

WILL DOING THIS HELP YOU SAY IT?

What are YOUR *principles?*

What is YOUR greatest fear?

I look forward to your reply.

Love as always

V x

P.S. Would you like to see some pictures of my dead dad?

32 | EMMA KAY, Artist

No reply

33 CONOR KELLY, Artist and musician

Tuning for six string guitar:

D E A D A D

LESLIE KÖTTING, Businessman and deadad's brother

Memories of a life lived in ten percents!

The first 10% yield's few and only hazy memories and dependency on Mother and the family.

The second provides a host of adventures and learning within the constraints of World War. Striving for independence from Mother and family!

The third sees the achievement of independence, sexual experimentation and serving ones country!

The fourth – adulthood, fulfilment and a partner for life.

The fifth – responsibility and the next generation.

The sixth – achievement to support one's issue and the realisation of just what your Mother had to put up with for the first twenty percent of your life!

The seventh – consolidation for self, wife and family.

The eighth – freedom from the yoke of the last thirty percent. Travel and the world at your feet.

The ninth – trying still to be in the prime of life but with middle age nibbling away at ones vitality.

The last – Grandparenthood - fulfilment once again - but the nibbling away is consuming. Would that one could enjoy a full 120%!

He had names for his five children
PETER was PUGALUGS
ANDREW was ANGE
LEESA was BONZ
MARK was MARKY PARKY
And
JONATHAN – (JOEY) was JOSEPHINE
We were like pets and then we got older

PETER KÖTTING - PUGALUGS, Businessman and deadad's son

Andy:

Stay safe in Columbia - I know that it isn't very safe there at this time - many kidnappings and murders of foreigners - that's one place I would never have chosen to visit at this juncture but then again your decision.

From my perspective Ronald was a very complex individual that I wouldn't wish to recollect on a personal level - but he was certainly a study in contradictions.

Grounded yet aloof

Dominant yet insecure

Generous with money yet Tight with emotions

Effusive in nature yet depressed/secretive in character

Politically correct yet socially irresponsible

A Big man in his small world

A Legend in his own mind..............

Nataliya and I are doing well and she is going to Vladivostok in May for three weeks. We have dissolved the relationship with Becky in the gallery and she is once again concentrating on school etc.

Love Peter

ANDREW KÖTTING - ANGE, Artist, film-maker and deadad's son

The first photograph was taken of Ronald in London when he was a boy.

The second photograph shows Ronald in Germany with my older brother Peter in his hand.

The third photograph was taken in the Faroe Islands by my sister Leesa. She was on holiday up there with my father and mother.

The fourth photograph is a composite, taken by myself in the chapel of rest two weeks after his death in Beckenham, Kent. He was very cold when I pushed my forehead against his to tell him that I would miss him with all my heart and I was left with a smudge of flesh coloured makeup that stayed with me all the way home.

And of the last photograph

He's no longer there, not barely alive,
Not freshly bathed, nor freshly talced,
Not fresh as a daisy but just gone and died.

And I'd parted his hair in the wrong direction,
And she's all a dither at his discombobulation but laughs;
His wife my mother,
All a fluster
at the imminence
of this
his very own disaster.

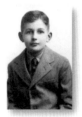

LEESA KOTTING - BONZ, Mother and deadad's daughter

A Regular Time

My Daddy

Preparation.
He walked into the bathroom in his loved mules, his feet moulded into the soles with them well manicured by his local professional chiropodist. Scissors put upon the bathroom side. He lent over the bath - purple two-tone in colour. Kneeling in his underpants with a towel wrapped around his shoulders waiting. I carry a chair into the bathroom and place it onto the tiles centrally placed. The bathroom mat, the toilet mat and the bidet-mat are all put onto the laundry basket.

The wash.
I mix the water to get the temperature just right. Washing the circumference of his head where his hair was. He liked a hard rub. Rinse and up. Feeling giddy, he would fall onto the chair in the middle of the bathroom floor.

The cut.
"How short?" I would enquire. The usual Bonz, (short for Bonny that then became Bonny knees that then became Bonz).
The usual depth was a fingers distance away from his scalp.
Around I would go, wondering which side the parting went. I would always ask…
"Which way does it go?" and snip away. If the front island was too short it would stand up on end. If it wasn't kept long enough it would bush like a hedge.
Snip, snip, snip. Hand-over scissors and away I would go.
The towel grasped tight around his neck, heavy breathing.
And questioning. Private questioning, memories buried.
Deep.
Held tight on the chest.
Extractor fan going.

Dead.
Every time I cut his hair.
Which I had done for donkeys' years.
I would think.
Is this the cut he would take with him to his coffin?
Is this the last one?
Has this one got to be the best one?
When will he die?
How will he die? On this chair, in the bed, crossing the road, slumped over his needle-point.
Admiring his china cups and plates.

Hair-cut finished.

thyme thyme

English Herb Garden

dill dill

chive chive

bay bay

sorrel sorrel

basil basil

Beard.
Snip, snip, snip all over his face; hair flying everywhere. I would side saddle the wooden chair
And my dad.
Him in his underpants.
We were close. Closer in body than most forty year olds would get to their father. He would make a spitting sound when tiny bits would fly between his thin lips. Grey and black Brillo-pad hair would move through the air like darts. Into my eyelids, into my hair, into my clothes and into every corner of the bathroom.
My hand would tremble it always did, shake, shake, shake, shake.
Along the lip-line.
Beard finished.

Eyebrows.
He would wet his fingers and smooth them straight. I would cut off the hairs that refused to obey.
Eyebrows done.

Nostrils.
A few strays merge with his beard snip, snip, snip.
Shake, shake.
Nostrils sorted. Spit splutter.
OK.

Ear holes.
Check, snip. Check snip.

All over check
Back of the neck- scarring. Boils in the past.
Scissors over comb.
Finished.
All-round Check.

There you go.

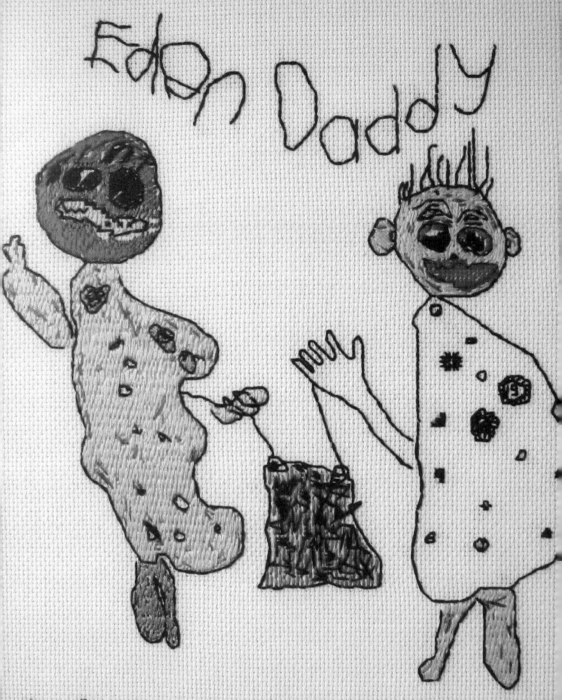

Eden Daddy

For Leila with my love and thanks for bringing Eden into my life. Taken from a 1998 drawing by Eden and now worked by her Gr... Ronald Költing.

Brush down.
We would carefully gather the towel up, from around his shoulders and he would carry it with the contents of hair to the balcony and then shake it all over everyone that lived below.
And off into the wind it would fly.
Through with his vigorous shake. Snap went the towel.
Snap, crisp hard shake. There would always be natural grease in his hair that would stick to me like glue.

I would get the dustpan and brush and sweep up.
Father would return. I would look for bits that I had missed.
Team work.
I would carry the chair back to the kitchen. Father would shower.
He would return to mother with the finished result.
I would look at it and think, was that it? Was that the last cut? And continue to wonder, would he die before the next?
When?
Where?
How quickly or slowly, easily or painfully, and what a bummer it must have been for him to have had all those heart attacks which reduced him to the life he now leads.

Back to the armchair in the lounge stretching his arms out for his glasses.
Grasping his needlepoint, gaining breath. Cut off from the world around him.
Off he would go again for a very fine endurance test, every stitch neat and in its place. Every cast-off immaculate.

The beast.
The man.
The spirit.
My dad.
Sadly missed with pain.

1999

MARK KÖTTING - MARKY PARKY, Black cab driver, writer and deadad's son

I'll tell you all I know about Daddy.
Nothing. In writing terms that's a whole lot of white space.
He liked to bear hug and tussle your hair.
His clothes were nice, neat, line down the middle of the jeans, a belt on top.
A gut raising up over a straight shirt.
Daddy boy, six foot tall, standing strong. I once saw him push a copper. A
little one, middle of his chest. He told him he wasn't big enough to be a
copper and that he should get out of the force or grow. My Dad fancied
himself when he got near a Bobby, he'd once been mistaken by an ice cream
man for C I D, he liked that. The man was shaking so much he gave dad a
free cone. "And what about my boys?" Dad said. The man nodded, Dad came
back with one for all the boys. We watched the Sweeny after that. God my
Dad could drive. Drive real well, he'd tell you as he was doing it.

"Daddy, Daddy's home."
We'd never run to say that. Hide more like. I hid in a cupboard, with sheets
on top, shaking like a dog, with a brother's breath in my ear.
We lived on a hill. That hill would bring him home in a foul mood. I inherited that.
His little gift to his third boy. Lucky old me. Luck running in threes.
But this isn't about me it's about him. He'd talk differently when a stranger
was about. He had a reserved-for-strangers-smile.
There were seven of us, the magnificent seven. We'd write it on our
Christmas cards, Mum and Dad did, I didn't write Christmas cards.
Dad was a quiet one, a foul one. Oh, he could shake a smile once in a while.
But you never knew if it was coming with a whack.
I'd make sure I was gone before he got up. I was a newspaper boy, shoving
papers through a box. I did it to get away from him.
I'd time that round, so I'd see his smoking, departing back, as I turned the
corner with my paper sack.

"Daddy works hard, don't you forget that. Now go do your paper round."
"Yes Mummy." I replied.
Daddy worked hard and Mum liked to be called Mummy, it showed her
respect.
Dad carried his briefcase up and down the smokers, heart attack hill. Many a
warrior had already died. These war children had gone soft inside. That case
was always stuck under his arm. I went in it once. It started something.
You had to be careful, he was a neat man, if you took something, you put
it back. And I mean back, right spot back. I went in to get a sweet, I knew
there'd be some. There always was, all wrapped sugar tight, waiting for me.
I checked my shoulder. No one there, then I noticed a book, a drawing book.
We had them at school, red. I took it out, turned a page. Black pen, scribble
lines, turning into porn. Women. Women. Bent over, opened up inside. High
heeled, slitted, slatted stockings.
Daddy was a drawer, an artist I'd just found out. Nipples pointing skyward,
women with holes in pants. He was an artist.

Dad was young, with too many kids, so he swore at night. A man with no
mind, fuck, fucking-cunt a lot. Winter rage, all at sea. Mum would be shaking
inside. She could take a hit, a cut lip, black eye. But you put bloody in there,
or that word cunt. That cut her inside.
"Has he no respect?"
I heard her say to someone on the phone. She wasn't talking about her
swollen eye, no, it was that word cunt.
I saved mum once, didn't realise. I went to the freezer for a chocolate lovely.
Chocolate with fake cream on top. So hard, it would bend a spoon. You had
to bang your way through the cream to get to the chocolate, like an Eskimo
getting to its ice hole fish.
I walked to the freezer, checking my back, always check your back. Lifted the
lid, put my hand inside and mum was there. She'd been stuffed in.
"What you doing Mum?" Maybe she was playing hide and seek?
"Don't say a word, " is all she said, after she'd climbed out.
"I won't. Can I have a chocolate lovely?" She carried on walking away, so I
grabbed one.

Daddy was odd, I knew that, all of us knew it, bar him. Well maybe he did, but that wasn't something he was going to talk about.

He was a stamp man, he'd put them in real neat. I'd walk past the room and he'd be there, album open, tongue licking stamps. I'd watch till his eyes caught mine, then I'd walk on. He never patted the seat next to him. No, stamps were for him. They arrived by regular post. He had a collection. I nearly opened an album once. It was on a table in front of me. I had the leather cover in my hand.

"Don't." Is what he said to my back. I turned, he was lighting a cigarette, like a cowboy who'd just come to town. He had one eye looking at me, one at the book.

Dad cleaned things. He'd clean my nails like he did his shoes. He'd take a brush and scrub. Shoe or nail it didn't matter. You held your hand out until he was done. Sunday's were the worst. That was the holy night when he liked to get his kin clean. After a drowning in the bath, it was time for nails. You'd stand there, until it was your turn. He'd clip them like a man doing a hedge. He had this drawer, where he'd keep our details. Weight and height. He'd use his ruler and put your name in nice and neat. It was your living, changing, Sunday chart.

He had strange writing. I don't mean what he wrote, I'm sure that would have been. But I couldn't read it. It was full of straight lines, crossing over each other. Like a snakes and ladders' board. You didn't know where it started and where it stopped. I showed a friend.

"What's that?" He said.
"Dad's writing." I said.
"Can you read it?"
"Haven't a clue." I said.

Dad once came to watch me play football.
Only the once. He shouted from the touch-
line that's all he did, shout, and it was all
directed at me. It put me off my game and
him. Tears came to my eyes, made it hard to
see the ball.
"You're yellow. Get effing stuck in."
Every time I got the ball, I'd hear the sigh
and 'get effing stuck in.' Followed by, "He's
useless. Get him off." He meant me. My
own dad calling for his son's substitution. I
thought I was good at it and he wanted me
taken off the effing pitch. He would have
loved to pull me off with his own sweet,
smelling, leather gloved hands.
But this isn't about me it's about him. Maybe
talking about him opens the door to me.

I'm looking at Daddy, dying on his bed.

It's a hospital bed, too small for him. It's a bed to have an operation in. Be cut in, a bed not to hang around in.

"How are you Dad?"

"The bed's too bloody small. It's a bed for midgets. And how many midgets do you know son?" He wiggles his toes.

"I don't have any as friends, that's not because I'm anti them, you just don't meet them."

"Exactly, exactly, so why am I in a midget's bed? You tell me that son?"

"I don't know, I could ask?"

"I already have son."

You could say we were starting to get close. The sheets can't hide his feet

 "You remember the baths you used to give us Dad?"

"Not really." He says.

"I do. You used to sink us like a submarine. Drown us near as damn it."

"Why did I do that?" He says.

"Well that's what I was going to ask you?"

"Should have told me to stop."

"I did, I used to say I can't breathe."

"If I did do that, then I'm sorry son." He says.

"It's ok, it doesn't matter Dad."

We go silent.

Dad's on a ward, men with one-way tickets. Men with tubes into arms, carrying blood from bags. And cards resting by drinks, "wishing luck."

Dad's wishing cards have fish on them.

A man from a bed shouts

"Help, help me?" He's asleep.

"He always shouts that." Dad says, pointing to the man who cries for help.

"Who do you think he wants to help him?" I ask.

"Whoever it is, isn't listening?" My Dad says.

Dad's eyes are milky blue. He closes his eyes.

I go. I go down in the lift, leave the hospital.

Walk to the taxi, fire her up, turn her to yellow and start my search for flesh.

Another day finishes.

Another day begins.

I go into the hospital, Dad says as I come in

"Best nights sleep I've had, looks like he got his help." He points to the empty bed.

"So where did he go?"

"Wherever you do go? Where do you think you go son?"

"I suppose that depends on whether you're a believer. Are you a believer Dad?"

"I gave you a Christian name. Are you a believer?"

"I'll wait and see."

"Don't wait too long."

Next to Dad, is a man by a window. Getting ready for his jump. A bible in his hand, a tube to his neck.
"There's a quote which says, every man takes a secret to the grave. Have you any Dad? Any secrets you want off your chest."
"What secrets? Of course I have. Have you been looking after my fish?"
"Yes."
"Keeping them fed, clean, changing the filters?"
"Sure Dad."
"That's good."
I've been looking after his fish. Dad's always had fish, fish and a tin in which he kept all his bits.

Dad's shaking, trying to get the foil off the liquor, to give himself a shot.
Liquid slides down his pyjamas, moves to his crotch.
"I need the toilet son."
I push him to the toilet. Pull down his pyjamas. His penis is no bigger than a nut.
Someone knocks on the door.
"Anyone in there?"
"Us." My Dad says. "Me and my son."

I push him back to the ward.
A man in overalls comes in to fix a flickering light.
He gets on his ladders.
"So what's the view like up there?" Dad asks.
"No better."
Dad laughs. The man in the overalls comes down his ladders,
"Job done." He says.

Dad looks at me, runs a finger across his throat. Slow, so I know. Shakes his head. Looks up, looks up for whoever to receive him.
"It's nearly all over son."
I nod.

A nurse comes in,
"So how's he doing?" I ask
She comes over to me, leans forward.
"Not so good, the doctor says he has fluid on his lungs. He's drowning."
"Drowning?" I say.
"Drowning. Kidney failure, it's all packing up."
"And tomorrow what?"
"Who knows? That depends on the fluid." She turns on her heels.
Leaves the ward.

Dad's skin is drawn tight over his bulbous split legs. Blood seeps out of his tubed neck, down his pyjamas. He sighs.

Shakes his head. His skin's turning yellow, yellow like the nicotine he
smoked. He's getting ready to turn to ash.
He smoked Peter Stuyvesant. His first son's called Peter after his favourite fag.

I get up to go.
He isn't going to talk, he's not going to give me a nugget. No nugget, no gold.
Am I pan-handling him? For his last piece of gold? Me, trying to get at his last
piece of gold?
"What you thinking son?"
"I was thinking about you."
He closes his eyes.
Before the tubes, the wires, he'd give you a hug, a squeeze, a scrunch.
That was it. He'd said it all there, in the hug the hold.
Behind his bed, on a radiator, his coat, on a hanger, blue with a Marks and
Spencer check. Which I don't want, the others won't want. And his plain
blue v-neck, on the back of the plastic brown chair. Another one to go. And
his pants, his socks, his shoes, his belt, his hanky, his dressing gown, his
slippers, the lot. All to go. All to be taken out in a black plastic bag, provided
by a white tunic ked nurse.

We've already had Dad's wake, five months ago. The food was cold and the
chef had left, the waitress cried. Cried at our table, Dad said
"Don't worry! Take your time." She smiled.
We talked in wicker peacock chairs, about what he wanted, what needed to
be done.
"Your mum's sorted. I've spoken to the accountant. She'll have enough
money to see her through."
He went on,
"And I don't want to be buried, I want to be burnt, nothing on."
"OK Dad."
"Why waste perfectly good clothes?"
So he's going in naked. With his eyes open wide. And he's going to burn, turn
to ash.
"Do you want any music Dad?"
"Give us some Burt Bacharach"
"Alright, we'll play some Bacharach."
"And keep the service short."
"Sure."
"And wear some new shoes boys."
"Anything else?"
"No, that's about it."
We took a photo, we all stood in a row and a stranger took the shot.

I don't want him to die, not like this, with his big fat bloated stomach, torn,
splitting legs. He's done today. I'll come tomorrow. I kiss his head, walk to
the swinging door, I drop a tear. Walk to the lift, another tear. I won't work

tonight. The next day I go back to the hospital. Dad's had another bad sleep, choking, gasping for air. It wakes him in the night, when it's quiet, death and Dad fighting. Death sitting on his chest.

I brought my girls last week, his grand-daughters. To say "Good bye." They thought they were saying "Hello."
But I, he, we knew.
"Why has Granddad got Panda eyes?" The youngest said.
"Because he's turning into a bear." I said.
"Do all old people turn into bears?" Billie, the oldest says.
"Only the special ones." I say.
"Our Granddad must be special then."
The girls played around his bed. He puts his hand out, lets their hair run through his fingers, with tears in his eyes.
I looked out the window, I didn't want anyone to see.

That was last week, and now, here, I say.
"You know what I want to do today Dad, I want to sit here, hold your hand and cry."
"That wouldn't be a bad thing, but you'd set me off."
"You know you were a good Dad."
"Funny, I never thought I was. I was always trying too hard to sell those belts."
"You were ok."
"That's nice of you son. I don't want any more visitors. Not seeing me like this."
"Whatever you want."
"That's what I want." He says.

 A nurse comes in.
"Time for these Ron?" He shouts.
Dad hates the name Ron. But on his dying bed, he's Ron.
The nurse holds a pill. With his short sleeve top, showing his pale freckled arms. Stains on his trousers, and a leaking green pen.
Dad raises his eyes.
"Your pill." The Nurse shouts
"So this is going to make him better?" I say.
"Help with the fluid on his lungs!" The nurse shouts. Then leaves.
"What's his problem?" I say to Dad.
"He's deaf, deaf in one ear, didn't you see his hearing aid."
"He should wear something, saying I'm deaf in one ear, I'm prone to shout like fuck."
"I don't think it would be allowed." Dad says.
"He's an odd nurse."
"Put it this way son, I can always here him at night."
 He might be the man my dad calls out to in the night. The last man to hold his hand. Wipe his head, hear his fear.

Dad's getting weaker. Mum will be in later, with her scarf, her coat. The other brothers are flying in. We're all coming in. Mum comes through the door. Her make-up's not on right. She pulls out a prawn sandwich from her bag. I leave them together. I turn at the door and look, Mum wiping his head, Dad holding open the sandwich, looking at the prawns. The next morning I'm in bed, the phone goes.

"He's coming home, he wants to come home." Mum says.
"Is that ok?" I ask.
"He wants to come home, he wants to die at home." She repeats.
"Will you be able to cope?"
"It's what he wants."
"And what do the nurses say?"
"Well it's unusual, but it's what your Dad wants."
"And what do you want?"
"I just want him better."
He wants to die at home, in his bed. Under his sheets.
"I'll bring his fish over."
"Yeah he'd like that."

There's a lot of sorting, nurses to be rung. Things a dying man might need. The next day I go round, Mum's waiting by the door. I've got the fish tank in my arms.
She's smiling.
"He'll be happy to see his fish. Him and those fish." Mum smiles.
"I'll take them in."
He's asleep. I get a chair and put the fish tank on it. Run a lead to the wall and put the light on. It turns the tank neon blue. Mum's tired she's picked up a shake, her smile's starting to slide.
"Come here." I say. Put her in my arms. Hold her.
"We'll be alright, we'll manage won't we?" She says.
"Yeah, we'll be alright." I say.
"And Jonathan's coming home."
"Good." I say. She's the only one who calls him that.

Joey is the youngest. He's on a plane now.
The oldest is going to miss the finale, he'll be in some departure lounge, thinking of his last Internet porn, hiding.
Businessing.

Dad whistles from his room. We go in.
"Thanks for bringing the fish." Dad says. "Thanks for looking after them."
"We liked having them." I say.
"I like to watch fish, can hardly see them now. You ever watched a fish son."

He says
"Sort of, not like you I guess."
"Start doing it more." He says.

The next day Joey arrives. We hug each other. Brothers hugging.
"Alright?" I say.
"Yeah and you?"
"I'm alright. I'll show you the old man."
We go in.
"Joey, Joey, come here son." Dad's smiling.
I leave them together.

It's my first night watch. We sit there with the baby listener. Listening to his turning, sighing, cough.
"I've never listened to a man sleep before." I say.
"Nor me?" Joey says in his transatlantic voice.

Dad whistles from his room. That's his signal. It comes out on the baby listener.
We go to his room. He needs turning. He needs a drink, needs to toilet.
Needs a pillow, needs a book. Needs a lot.
It's four in the morning, and he sucks his lips, and says,
"Cup of tea. I think I'll have half a cup of tea boys."
"Your joking, you know what time it is?"
"No idea."
"Four in the morning."
"Well it's still a good time for tea."
I go and make his tea. Joey sits with Dad. Dad trusts him. Trusts him with the medicine. Thinks he's less likely to fuck up. I take the tea in, Dad's asleep. Joey's looking at him. I sit next to him.
"Why'd you think he said half a cup of tea?"
Joey looks at me.
"Maybe he made a mistake. Maybe he meant to say cup of tea."
"Funny I made him half a cup of tea."
We go silent. Look at Dad sleeping.
"Mum and him lasted. Mum did it for us. She could have left, but she stayed, stayed for us." Joey says with a tear.
"Yeah, I never respected Mum for it. But now, now I'm older, now I've got kids, I understand." I say.
We walk to the lounge.
"I'm going to bed, you stay on American time. It'll be easier for you. You won't have to get over jet lag."
I laugh, he smiles, I go to bed. I close my eyes, then the whistle again. My brother's footsteps go to the bed, quiet footsteps, footsteps to keep a mother asleep. Mine are too heavy, I've already been told.
"Why can't you walk like your brother?"
So Joey can do the night shift, with his light feet. Mum wakes me from my sleep.

"Mark, Dad needs you son?"
I get up, follow her and her dressing gown down the hall.
"Morning Dad." I say as I see him.
"Can you get Joey? I need a shit."
"He's just gone to sleep." Mum says.
"Well I can't lift him with you Mum."
Joey's a sleep, curled on the sofa.
"He needs a pooh." I whisper.
"What?"
"Dad needs a pooh!"
He gets up.
"Joey, Mark." Dad says as we come into the room.
"I'll get behind him, you pull him." Joey says taking hold of the carcass,
taking hold of the situation.
"Slowly, slowly, gently, boys." Dad says, as we pull him up. We get him to the
side of the bed. He's leaking through his hole in his neck. Mum brings over
the commode.
"Mum bring the chair nearer." Joey's in control.
Dad slides across the top, until his cheeks reach the hole. We wait.
"I don't have the energy to push boys."
"Shall we go Dad?"
"Yeah, can you bring the tank closer."
I move the chair, put the fish tank closer to him. We leave the room. Sit in the
kitchen.
"Your all a Mum could wish for." Mum says. "Thanks for coming Jonathan, I
don't think we could have coped without you. Could we Mark?"
I smile at Jonathan. We go back to Dad. His head fallen forward, we lift his
neck. He's shaking. Joey's behind him, massaging him slowly.
"Put me in my chair boys." He says.
He's running out of air.
I go under the commode, pull up his pants. His bottom's red. No muscle left
in his cheeks.
"Thank you." He whispers.
The front door bell goes. It's a nurse. We've had a few. We've got enough
morphine in this place to put a rhino to sleep. Make's you want to have a
little shot.
The nurse says.
"It could be tonight, a month, we specialise in cancer, it's a lot clearer. I don't
think it will be long, everything seems to be packing up, shutting down."
 "So what sort of stuff do you carry in your bag?" Joey asks.
She's holding a bag.
"God, God only knows." She says.
She shows us. Long names wrapped in plastic.
"Ever tempted to have a hit? You know, give yourself a morning shot?"
"Can't say I have. What use would I be." She smiles.

"If I carried that bag, I'd try some." I say and I would, I'd take myself somewhere quiet and jab some in, especially now.

Then the whistle. Dad from his room.
"That's his whistle. Got to go, got to go to the old man and his whistle." Joey says. She follows.
We get him up and to the side of the bed. The nurse brings over the commode. We slide him on it, he can't go.
"May be I should give you a suppository Ron?" They're her first words to my Dad. She looks at us. He doesn't answer.
"Can you help me lift him? Take him back to bed?" The nurse says.
We get him to bed, put him on his side. Bend his legs. The nurse take's something from her bag, yellow, puts a glove on strokes my Dad's back.
"Ok, Ron, I'm going to use a suppository."
He doesn't move. I'm by his eyes. She pushes the little capsule up. And then his eyes open wide. A tear appears. He lays there slaughtered.
"Better move him quick. These things work quite quickly."
So we drag and pull to the commode.
"Shall we give him some privacy?" My mum says walking out the door.
We follow her, she goes into the kitchen and stares out of the window.
"Thanks, thanks for all your help." She says turning looking at the nurse. Tears in her eyes.
"You're all being so brave. I don't think I could do it, not if it was my husband." The nurse says.
"Thank you." Mum says and leaves the room. We sit in the kitchen in silence.
"Boys." Mum calls.
She's in with Dad. He's on the floor. A yellow mess around him.
"It's worked then?" Joey says.
"Yes, he seems to have gone quite nicely. That should make him more comfortable. "Ron, Ron, we're going to lift you and put you back to bed." The nurse says into his ear. He raises an eye. We clean him up, pull and push him back to bed. At the front door the nurse says.
"Look after your Mum, if you need anything, just call."
"Thanks, God what a job you do?" I say.
"It's the type of nursing I always wanted to do."
"Bye then." I hold out my hand.
"Nice to meet you." She says back to me. And then we look at each other. And then she's gone. The day passes. He sleeps during the day, it's the night, all that darkness to heave off his chest when he's restless. I go for a walk with Mum. We walk in silence, her shoes and mine doing the talking. Joey stays, looks after Dad.
"Dad wants a shower." Joey says when we get back. We lug him, pull him, drag his feet down the hall. Prop him up, and drop his pants.
"You'll have to get in with me boys, sorry about that." He says.
So we all get into the shower, father and sons.
"How's the water?" I ask.

"Fine."

We lower him to the bottom, and he sits there. Slowly we soak him. Run the showerhead over his back.

"I'm going to have another shit boys, and I'm not moving."

"You just do it right where you are." I say.

And he does.

"I never thought it would come to this boys." He says with his eyes shut.

We're all naked. I'm soaping him.

"I always wanted to play an instrument, the sax or something. Where did all the minutes go?" Dad says.

"I didn't know that." We say together, two voices as one.

"Yeah I just never got round to it. Be careful to what you get round too."

He's getting hard to hear. And I'm glad I'm here. And more yellow mess comes out.

"The silly old fool said last night he wanted to swim with his fish. Said that's why he came home." Mum says.

I look at Dad.

 "Mum says you want to swim with your fish Dad? Is that right?"

"Please, I've looked at them long enough." His eyes are shut. His lips cracked, and he waits.

"But won't they die Dad?"

"We all die son, I'd just like to swim with my fish." He whispers.

I go and get the tank.

In memory of a dead dad, a man I hardly knew.
Mark Kötting

Kötting
87 Sumait St
Brooklyn NY 1231

Kötting

"Louyre"

Fongax - Et - Barrieneuf

09300 Ariège

FRANCE

AIR MAIL

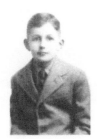
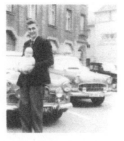
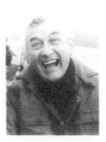
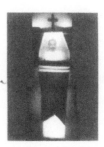

a boy a young man a middle-aged man an older man (dead)

As I sit here thinking about it, there isn't much that comes to mind that is
"happy"...nor sad for that matter.

He was alive and then he had a prolonged death.

I remember him not being there rather than being there.

I remember all the times that he went away - seemingly quite frequently; and
the three prolonged trips that he made: the first two with my mum "around the
world" and the third to move out and live elsewhere with someone else...he did
return though, after several months. (On this occasion I was asked to tell
friends and friends' parents and relatives that my father had gone away on
business again).

He always had that "photograph" smile on, when in photographs. At other times
he would usually sit quietly with a wry smile, if one at all; and then there
was that "hoot" that would only sound when he was in company; "He was always
such a family man".

The Magnificent 7.

"Born:England,1966"

If he wasn't sat quietly, thinking about something (I still wonder what);
watching formula 1 racing, football; smoking a JPS, (later a B&H); looking at
stamps; or golf ball hunting; mowing the lawn/washing the car/having a bonfire;
watching TV: "Good-Life", "Onedian Line" or "Roots", "Thornbirds", "Holocaust",
"Mastermind" and "Antiques Roadshow" or programs that were on after I wasn't
there; he could be heard the other end of the street, such was his Anger and
Frustration and Temper.

I always lived in fear.
I always tried to please. I still do.
I hated it.

'No need to elaborate works - merely say something that can be murmured in the ear of a drunkard or dying man.' E.M.Cioran

And then there was his death.
It started when he was visiting me in hospital. I was eleven. He had his
first registered heart attack right there in the ward with me lying in bed,
writhing in pain. A couple of weeks later I was in a car on my way to visit
his hospital from my hospital. I was in Lewisham, he was in Queen Mary's.

"ForRonald"

After that initial one he had numerous more with over twenty years of suffering.
He never resumed his life of before. He still had his anger, although that did
wane after much a struggle.
Sometimes you could hear it bubbling up through his throat as he slept.
In the final two weeks you could hear it rumbling through the "Fern".

"sonandfather"

When my phone rings now it is tuned to D.E.A.D. D.A.D. D.E.A.D. D.A.D.
D.E.A.D. D.E.A.D. D.A.D. D.E.A.D. D.A.D. D.E.A.D. D.A.D. B.E.E.F.
He is remembered every time it rings.

Summer 2003, Brooklyn, NY.

'No need to elaborate works - merely say something that can be murmured in the ear of a drunkard or dying man.' E.M.Cioran

PS
From: joey Kˆtting [lizabmcl@****]
Sent: 09 September 2003 12:52
To: badbloodandsibyl
Subject: Re: Thursday august 7th

When I was younger there were the Class 4 school field-trips.

On one occasion we all headed off down the road, walking about a mile through the woods, hand in hand, to go and visit the "Cockpit": a place where, not so long ago, cock fights were held. All that remains is a round pit covered in grass. I always thought that it was just a bomb crater. On another occasion we walked back down the same road, hand in hand through the woods, and visited the "Police Station". We were finger printed and identified as if we had been arrested. We were shown into the cells; I was scared stiff. On the way back to school I saw my mum's brown Rover parked outside of "La Belle Femme". KLT 355 K.

There were also the cross-country runs through the same woods, come rain or shine; running through ponds and quagmires, always having the sensation of freedom and abandon; always getting frozen cold and soaked to the bone and every time being totally exhiliarated.

On the afternoon of December 14th, 2001, I left the Fern for the first time in three days. It was about six o'clock and it was almost completely dark. There was a clarity in the air: in the light. Upon leaving, with my first breath, a massive gravity was released. The burden that had been slowly but surely dragging me down over the past ten days was suddenly gone... (It is how you feel jumping into the sky from a plane - hurtling down in an uncontested speed, falling as fast as gravity will allow, wind and breath faster than ever before - then the release from disaster as the chute opens and life is resumed - a massive upheaval.)

I felt free.
He had stepped out with me.
He had been emancipated from the twenty year fight that had become more and more arduous as his time had gone on, as his time had lapsed.
After an hour or so I returned to the Fern.
He did not return with me.
When his wife found his body there was a huge wail.
p.s. When the Undertakers came to take his body it let out a tremendous Almighty fart. We all giggled.

Memory is a darkroom for the development of fiction

MICHAEL HAMBURGER on WG Sebald

34 | SIMON LEBE, Linguist and translator

babe

arms

SO

fright

thought

was

35 | JAMES LEVER, Writer and performer |
No reply

36 | JANNA LEVIN, Scientist and writer |
No reply

but her lover Warren Malone discovers the invitation and replies and also sends me a cd with the recording *just three* on it.

| WARREN MALONE, Singer, songwriter and Janna Levin's lover |

Hi

I saw the pencil that came through the post months ago and thought I'd like to contribute something, but wasn't sure if it was an open invitation as it was addressed to *Janna*, she told me I was being stupid, I forgot about it and she mentioned she had seen you and you had mentioned the project so I set about writing the essay I sent to you.

I don't recall seeing the photos, it must be in Janna's things and she's in the States for a couple of weeks so I guess I wont see them.

Id love it if you used the piece I wrote. You have my permission, and I'll send you a letter signed to say so.

The package should be with you by tomorrow, or Thursday latest.

Thanks Warren

Boys need their fathers and if they don't have one they spend their whole lives inventing one from the little pieces of truth they can wring from their relatives. I often wondered what mine was like, if I looked like him, if we were similar in our mannerisms, but out of loyalty to my mother who raised me and my sisters on her own, I mostly kept these thoughts to myself and it became some unreachable fantasy. Occasionally I would decide it was time to find him, but where do you start? The only information I'd been able to find about father was that he was "no good" and the last time anyone had seen him was when my uncle stabbed him in the guts and sent him to hospital. In fact, it was my uncle who had first met him - in prison - and once his time was up he got out and introduced his new friend to his sister. Two kids later he was gone and my mother wasn't missing him. So after a couple of half-hearted, futile attempts at locating him I resigned myself to never having a father. Besides I didn't really

want to meet him until I had something to show for my time on this planet. I wanted him to be proud of me. Years passed and eventually I found myself in San Francisco and in a relationship that was very good for me. I felt like I was a good person, the person I always felt I could be if I only gave myself the chance. So, with this new lease on life, and armed with a new tool - the Internet - I went about searching once more. I received nothing for months and then one day a letter arrived with a photo of myself as a baby with my mother and sister and also a cousin. The letter was from an aunt who was now divorced from my uncle. She was sad to inform me that my father had passed away a couple of years earlier. She didn't have the details but gave me the phone number of two uncles. From the uncles I got the story of how he had been murdered and the guy who did it was behind bars. I cried and was upset at the news but the saddest part of all was that it seemed to me this man had spent his life drifting aimlessly with 2 children somewhere out there and he was waiting for the right moment, the right time when he could contact them and they'd be proud of him, and he left it too late - 3 people running around the planet wishing they could share each others lives and leaving it just too late. So much waste.

Once back in England I went to visit my uncle. It wasn't much to write home about, but he filled in the blanks and told me how the police gave him an envelope with my father's belongings, a watch, a bracelet, a comb and a buss pass with his picture on it (he was not the handsome devil I'd been led to believe). In a moment of generosity my uncle gave these things to me, and I examined them on the long train journey home. For the first time in my life I felt the weight of wanting to be a man's son had been lifted from me, and as soon as I got back I put those items in an envelope and returned them to my uncle. It was a very freeing moment.

He told me that there had only been 3 people at the funeral and they hadn't gotten a headstone yet, but they would. I knew by the way he said it that it was never going to happen. So here was the great handsome rogue of my boyhood dreams, dead and buried in an unmarked grave with no one to say goodbye.

There's a man in prison who could probably give me a realistic portrait of him, a picture free of brotherly loyalties and romanticisms, but I don't need to hear anymore about a Ghost that I have finally been able to put to rest. I can recognise the story of a wasted life when I hear one.

Just three *(Warren Malone)*

I put the pieces in the mailbox
Sent them back to where they came from
Everything you owned
Inside an envelope eight and a half by eleven
Man that's sad

Just three at the funeral
And no headstone
Transient Ghost
At last you've found a home
Nobody loved you
Nobody showed
Just three at the funeral
And no headstone

You came to me in a dream
You were a new born baby
A wrinkled bloody thing
You were mine to raise
Long after you'd gone
I'll harvest my emotions
In a field of your blood and bones

Just three at the funeral
And no headstone
Transient Ghost
At last you've found a home
Nobody loved you
Nobody showed
Just three at the funeral
And no headstone

So me and my lover
Throw our rock into the ocean
We try to hit America
From the shores of Brighton
I curse your watch, your bracelet and your comb
I put the past in the past
Where the past belongs

Just three at the funeral
And no headstone
Transient Ghost
At last you've found a home
Nobody loved you
Nobody showed
Just three at the funeral
And no headstone

37 | ELISA LIPKAU, Anthropologist and Documentary film maker

All right.

I am sending you the first draft. I chequed it already but I want to check it again. So toorrow I will probably send you another one with one or two corrections. But this way you can read it already of you want to advance. I wanted to ask you if you could insert in the last part an image of the performance you did in the cemetery of Janitzio. With you on top of your Deadad, since the description is difficult and I think it could be nice to have the image as reference, since it is the climax of my text.

Well, hope you like it. Anything you wish to change just let me know.

All the best.

Elisa

Meeting Andrew´s *Deadad*

I met Andrew Kötting, his wife Leila and their daughter Eden in a cheap hotel in downtown Mexico City, and I have to confess it was some kind of a shock. Andrew had told me he wanted to record the celebrations of the dead in Mexico for the project he was making about his dead dad, and he said he was bringing two women with him, but he never told me Eden had Joubert Sindrome, even if it had made no difference for me that he had. I never knew anything about this disease or handicap and maybe it was best that way, because when I met that young girl with her strange jaw comming out and her body moving so difficultly but her smile so full of life and ilusion, I got the feeling I was meeting someone so special that this was going to be a great experience. And it was. Meeting Andrew and his *Deadad* was not only a deeply moving and artistic experience, but one of those in which science is seduced by art and documentary truth trascends itself into poetry.

We set out for Patzcuaro, Michoacan on October 31 in a rented car. A few hours after leaving Mexico we stoped to get something to eat in a small café beside the road. It was then when I realized for the first time I was being observed. Off course, we are always observed when we come into a restaurant, but I work with documentary and anthropology, which are with no doubt vojeuristic enterprises, so this time I realized *we were being observed* because of Eden´s "diference" and I felt as if we were the "anthropological other" to those *rancheros* eating in the restaurant. I noticed that Andrew and Leila didn´t bother at all at those gazes and maybe they were like that since Eden was born. Andrew didn´t bother about his daughters´ "condition"; it seemed not to affect him at all and I was going to learn in this trip he even used it in a radically creative way.

After eating we went out to the parking lot and Andrew took out his *Deadad* from the car´s trunk. That was the first time I met "the old man," although he had told me about this "sculpture" into which he said he would to "climb" frequently. So all of the sudden there we were on the way to Patzcuaro while Andrew is getting inside his strange inflatable ballon like sculpture, with an 8 feet tall digital image of his *Deadad* printed on it, and a hat seller guy comes by and puts one or two hats on top of Andrew´s *Deadad*´s head. It looked quite odd in the middle of the road, beside a big blue truck and I thought this guy worked with his dead dad´s image in a comical way.

Being a woman who lost her dad at the young age of 21, it was quite odd to see someone relate to his father´s death in such an irreverent manner. But I was drawn to what I thought could be Andrew´s surrealist approach to art, and thus I tried my best to open myself and learn a lot from this weird experience with an English man who was carrying his daughter´s wheelchair and his *Deadad*´s figure in the trunk of a rented car.

We arrived to Patzcuaro early in the night at about 8pm and had something for supper. Then we looked for the hotel I had booked back in Mexico. It was a small family owned hostal near the lake. The owner, a retired doctor, and his wife welcomed us and showed us the place he had built with his own hands. The walls were full of terrible "*Botero*" like paintings, the colombian artist who always represents fat people. I almost laughed when Andrew asked the owner if they were originals and the doctor said that he had painted them himself, to what Andrew replied: "Really? I thought they were originals!"

The next morning we went to see the pyramids of Ihuatzio. Eden was dressed in a black and fluorescent green skeleton costume and Andrew got her into the wheelchair with his *Deadad* laying over her legs and pushing her from a distance recorded the scene as he always did. I started to realize Eden was Andrew´s first actress, she was his "star" and she seemed to have lots of fun doing that. I would confirm that later while filming outside a graveyard in the town of *Tzintzuntzan* (just as my cat is named), where Andrew filmed himslef again pushing Eden and his *Deadad* coming out of the cemetery with people passing by.

While he was shooting, an American couple started talking near by, saying something like: "Oh, what a beautiful tree!". I told them that this tree was called Yuka, and they said: "Oh yeah, in English we call it Yuka!" Then the guy told me: "Beware of drunk people! They come out at night! That´s why we always visit the graveyard at this hour, because it can get very dangerous later on!" I thanked him for his advice and didn´t pay too much attention, thinking that Americans are always afraid of "something". But later I would find out that he was quite right about this.

After we left Tzintzuntzan we passed a crossroads where some men were decorating an arch with *cempoalxuchitl* flowers (the flower with one hundred petals). We stopped to record their work and a young woman came by to give us a piece of paper that read something like this:

Welcome!
To all visitors:
Welcome to the town of Ihuatzio
The indigenous community of this town believes that the souls of
our beloved ones come to pay us a visit this night.
Don´t offend our faith consuming alcoholic beverages in a scandalous way.
The authorities will be watching.
Come back next year!

After we read this I recalled the American´s warning about drunk people. We went to the hotel and left Leila and Eden to rest a bit while Andrew and I went back into town, to fetch a lead with which to inflate Andrew´s *Deadad* that night.

Once in the hotel I went to the bar to get a shot of tequila before leaving for the Island of Janitzio, in the middle of lake Patzcuaro. The bar was back in the *patio* or open terrace of the hotel and Andrew was there preparing his *Deadad* for his "appearance". I was drinking and talking to the owner´s son who was coaching the bartender when we heard people saying: *"Llegaron los viejitos"* (The old ones are here).

The dance of the *viejitos* is a very traditional and popular dance represented by small children of a community near Patzcuaro. In this case, the group of dancers was hired by the hotel manager to entertain his customers. While we were watching the *viejitos* dance with their sandals, stamping their feet on the floor and holding on to their walking sticks, Andrew started to inflate his *Deadad* in the background and recording it. The scene looked like an odd movie set while Andrew stood very serious beside that strangely moving sculpture. It looked as if the *Deadad* was playing one of those games, in which children mimic getting in and out of the water while holding their noses.

After the *viejitos* and Andrews´ *Deadad* had finish their respective dances we set out for the Island of Janitzio. On the way there I realized this trip was going to be like a nightmare, but in Andrew's case, probably a comical one. Just when we hopped on the boat, carrying Eden and her wheelchair with the *Deadad* on it, I realized that the Americans´ warning about drunk youngsters in Tzintzuntzan could as well be extended to all Patzcuaro and surroundings. This was a big boat and it was full of very drunk and VERY noisy youngsters. They were at least fifty of them and loud as a hundred, all shouting their hearts out, as if their identity as "modern people" depended on that. They were "singing" mexican pop songs and some "rancheras" but it sounded as if they wanted to kill everyone else with their volume.

Eden, falling asleep, was just moving her head to the boat´s movement and I felt a bit sorry for myself in that moment, having brought her to that horrible situation. Anyway, we got to the island and then the difficult part started. I never imagined that Janitzio would be just like going to Chalma, one of the biggest christian sanctuaries near Mexico City, where thousands of pilgrims go to visit the image of Christ. It was quite a surrealist trip to climb through this

maze of artcraft stores and vendors selling all kinds of things on the street, while hundreds of drunk young people went up or down, with Eden walking almost asleep in her mom´s arms while Andrew followed us in the wheelchair with his *Deadad* on it.

We finally arrived at the top of the island where the church was. Eden and Leila stopped to take a breath while I went inside to look at the altar. In front of it there was a huge offering with fruits and candles, *cempoalxuchitl* flowers and diferent kinds of bread. Almost every minute a new woman came in and contributed to the offering leaving one more element, maybe a candle or a piece of bread, a couple of bananas or pineapples, sugar canes or *guayabas*. I was hypnotized recording their devout performance: they came in, left their part of the offering and then sat down with the rest of the women and joined the praying. The sound of their voices rose over the offering as a luminous energy but I realized I had to go back to Andrew, Leila and Eden, who were waiting for me outside.

I came out and we continued a bit farther up into the cemetery. It was completely dark but there were candles all over. Even when the wind kept blowing them off, people continually lit them on again. I went to take some photos while Andrew was "setting up". But I could not take any pictures and felt as if we were all caged in a strange postmodern anthropological spectacle. The people in the tombs desperately tried to concentrate and lighten up their candles, pray or just talk between themselves, while hundreds of loud and drunk people, not even paying attention to what they were supposedly coming to observe, went about stepping over the remains of their loved ones.

I was trying to take a photograph of a woman who was just gazing like hypnotized into a candle, when a young girl came near by and adressed the woman in front of me without even greeting her first. The girl said: "I am going to ask you some questions lady" She did not asked if she could make the questions, she just did and implied that this woman had to answer them. I realized she was some kind of journalist, student or misguided anthropologist being just a little imposing, not to say rude, and I just stood listening. The young girl asked: "Why do you do this ritual? How long have you been coming here? Who are you mourning? What does this mean to you?, etc.

Suddenly I felt completely at odds with the situation, as if this girl was a distorted reflection of myself, or better say of our times. I stood up and walked back to the cemetery´s entrance to look for Andrew and his family and I saw them way in the back where he had found an empty spot with a view of the whole cemetery and the lake. Andrew was already preparing his performance, he had laid his *Deadad* on the floor and surrounded him with *cempoalxuchitl* flowers and candles. He was constantly trying to light them but the wind persuaded him not to. People started to come around and observe with odd curiosity.

I dont remember if Andrew asked me or I just took out a flashlight to iluminate him. He observed the scene through his camera and said it looked great and was going to start shooting. He asked me what was I saying to people that

came by to watch him setting everything up, and I told him I was saying to them it was his *deadad* that had always wanted to come to Mexico, so now he had "brought" him in his afterlife. He said this was great and then he laid down on top of his *Deadad*.

He positioned his body perfectly on top of his *Deadad*´s body, dressed in the exact same suit and the same shoes as his father had in the photograph of the inflatable "sculpture". Andrew´s head was laying a bit further down than his old man´s head, since the "sculpture" was almost 3 meters long. But if his *Deadad* had a lunatic smile in that image, Andrew was just laying there with a completely numb face, as if he was dead.

He stayed like that for a long while. I think it might have been 20 minutes or so, and he just laid there without even blinking, staring at the stars. I started to think he was meditating but at the same time people came by and looked completely astonished at the scene, so this time I told them he was an English artist who was "burying himself with his old man in the afterlife". All of the sudden Andrew stood up as if he had come alive from the grave and all the girls around us screamed and jumped, running away and shouting like mad. It was the wildest moment I have ever experienced in a cemetery.

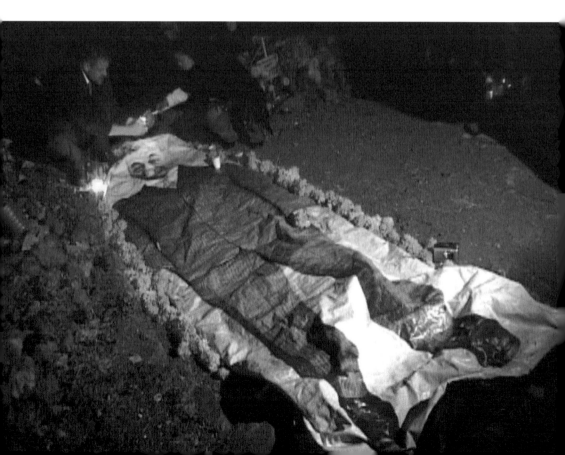

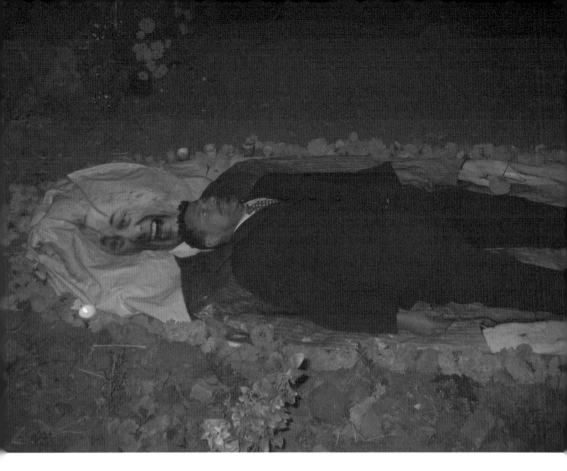

After that it was a challenge to go back but we just "floated" letting people "carry us" downhill to the noisy boats and the hotel. The next morning Andrew "blew up" his *Deadad* for a last time in front of the hotel door. He inflated the sculpture as tall as it could get, but it constantly fell into one side, so he stood by it holding it and imitating his father´s lunatic smile while grabbing Eden by one hand. She was dressed in her skeleton costume with a great *calavera* (skull) mask, while the hotel owner stood by her other side dressed in his own "Ku Klux Klan" outfit.

After eating lunch with Leila´s family and friends, we headed back to Mexico. The next day we returned the hired car to the airport and on the way there I sang some of the tunes the radio was playing for Eden. I was really happy to hear her sing and see her dancing in her own language for me. I gave her the little red devil that I always carried in my own car for protection, as a present and token of my friendship.

After that we all went to the Museum of Anthropology and then I dropped them on *Reforma* avenue so they could pick a cab that would take them to the hotel they had been at first, near the main square or "Zocalo". I went back again that night to visit them with Eugenio, my boyfriend, and we all played some memory games with Eden, making it difficult to say goodbye. It was a really great experience to get to know Leila, Eden and Andrew "in the wake of a *Dadaist Deadad*".

38 | SEAN LOCK, Comedian and writer

I remember getting a lift from Ronald in France and sat in the front seat next to him while you sat in the back with Eden and Leila. It was one of the scariest drives of my life. I couldn't work out why he was in such a hurry as we were only going back to your house in the mountains. He was overtaking juggernauts on the inside lane of a narrow road. The third picture of him reminds me of this trip.

Especially when the road bent suddenly to the left and he carried straight on down a farmer's track. He slammed his brakes on, causing a whirlwind of dust and stones, spun the car and got back onto the road. Unfortunately not quick enough to stop the three trucks he'd passed getting in front of him. He was furious but he still laughed about it. He had no choice as we were all pissing ourselves.

I wondered what someone in a helicopter would have made of your Dad's driving. They may have assumed he was delivering vital blood plasma for a child's operation when in fact we were going home for dinner. Maybe he was really hungry. I remember a couple of hair pin bends he took at lethal speeds and looking at you, Leila and Eden in the backseat and thinking he doesn't realise he's got a quarter of his family back there! You didn't seem worried by it, come to think of it Andrew you drive like a nutter as well. Maybe it's genetic.

He should have been a stuntman. That's what the last picture makes me think. But it also reminds me that my own father will die in the next 10-15 years. An event I am genuinely terrified of.

39 | JOANNA LOWRY, Writer and researcher |

No reply

40 | JACQUELINE LUCAS, Writer and poet |

What do the pictures tell?
He cared what others thought of him. He was unsure of himself.
He wanted a response.
He made people laugh - 'cause he needed to. To deflect attention away from things he wanted to say but didn't. He was a highly sensitive man. He was unsure of others.

What gave him pleasure?
People - not things. Relationships, family, women?
He loved women.

What did he want to say but didn't:
"I need you."
"I love you"
"Don't leave me"
"Don't go"
"I regret"
"I'm sorry"
"Forgive me"
"I want you"
"I never mean to hurt you"
"You're nuts"
"I'm scared"
"I'm scared of dying"
"Where do we go after this?"
"I'm proud of you".

His greatest fear:
To be abandoned- to alienate others
To lose his family and friends
What gave him pleasure?
To be touched intimately by a woman, a special woman and someone secret that no-one knew about ... a lover who he could share some private fears with- take off his mask and be the boy again.

41 JACKIE McCANNON, Writer of letters and mother.

A small boy with Kötting eyes and a having-yer-picture-taken suit on. Proud, awkward new father with baby (first perhaps?).

Surprise! - A middle-aged man having a laugh- first thoughts- a friendly face- open, fooling around- not the face of the tyrant I was expecting.

Flash to my brother-in-law Mike's comment on learning his own dad was dead: "The Tyrant has gone!"

Flash to man in coffin and the strip of four- to Elizabeth Kübler Ross and "The Wheel of Life"- beginning to end. What, in the young face tells us what is to come? Poignant pictures of pensive child poised to make what he will of his life, collecting wisdom or stupidity along the way.

Flash to my grandmother embittered by life - a revelation to discover she was known to my (dead) grandfather as "the laughing one" in the days of bygone courtship. What happened? Weird, hein - what life does to a person, or- rather- what a person does with a life!

No trace here of the man I was expecting- who ruled his own roost with a rod of iron- and Rita with it - the reason Mark ran shaking to hide in the airing cupboard all those years ago.

Ah, that was a story - told with humour and much red wine round a table in a wooden house in the Pyrenees (also years ago)- hé bé dis donc, oui- the house gone, like Ronald tho' the memories live on- my personal candle flame of meditation on the reality of impermanence, Mon Dieu, how it hurts.

Strange, isn't it though, the biggest thing that happens to us (apart from arrival) is our sure and inevitable departure. You'd think that would help us cut thro' the crap but it doesn't. Most of us either pretend it just isn't there or quake in fear, like it's the bogeyman coming to get us.

Was he frightened of dying? He certainly knew it was coming, what with all those false alarms- racing back from Louyre to London to be with a father who was hanging onto life with a grim determination.

In my family the bogeyman was- cancer – no one could even say the 'c' word- or it was whispered with a sibilant 's' like a snake coming up behind you any minute- Now! But mostly it was alluded to as "The Broch"- as in "She's got the Broch"- pronounced with a throaty "ch" like a Scouser working up phlegm It means 'the curse' and funnily enough- was also the name given by my mother to my (alive but absent) father.

Ah but I'm off on one now. Bring me back to poor old Ronald whose heart finally couldn't take the strain of beating any more.

Life wasn't all terrifying tantrums and tempers was it? He had his talents, didn't he, his tricks, his tics, his tender spots?

When all's said and done if Ronald wasn't what he was then Rita wouldn't have been what she was and you certainly wouldn't have been the same at all. And that's what the great ones mean by acceptance- 'cos all really is for the best, even if it's not the best of all possible worlds. I wonder if Voltaire wore the enlightened eyes of a far Buddha when he penned those lines for Pangloss.

The cause of death is not disease but birth.

BUDDHA

42 | ANDREW MITCHELL, Camaldolese hermit and writer |

Dear Andrew,

It's such a shame the face isn't clear in the last photo- are you sure it's your Dad? Look's like he's got a full head of black hair and a neat beard- like F. Murray Abrahams.

One thing that strikes me about the other three photos is the way in which they suggest a regression or falling apart as death approaches. It's as though the boy has the healthiest pact with life; beyond or punctuated by the school uniform there's a sense of repose that's turned to awkwardness in "young man" who holds new life like a goal-keeper and "middle-aged-man" who, laughter aside, looks like he's folded under some nameless terror. With this in mind I want to say that some great demand was made upon your dad between "boy" and "young man" and under which he slowly buckled (died). I want to say that the demand is somehow contained in these photos as the baby he carries as "young man" and that that baby is you. The weight of the child makes the rest of dad's life unbearable or bearable only by out-childing the child- hence the manic infantilism of the middle-aged man. And of course this child isn't just any child, it's you- you're rise, you're life is the perfect account of his demise and death.

Sorry about that.

43 | JUDITH PALMER, Writer and journalist |

No reply

44 | JOHN PENFOLD, Car dealer and childhood friend |

When I first saw those photos
All I could do was smile
As they made me reflect
On the man that was for a while

The good times we had
The moments of interest we shared
We were never the best of chums
But for each other we cared

Then my thoughts turned on me
And my day that will come
When I will breathe no more
To finally rest and be at one

A realisation the clock is running
And how much time has already gone
Although it is a lifetime
It's really not that long

Death is for the living
Not for those that die
A marker on your time and place
And perhaps that's why you cry
So to you Ronald auf wiedersein
Bon voyage et à bientôt
It was a pleasure to have known you
But sadly someday we all must go.

No se debe temer a la muerte, al contrario, es la vida a la que se ha de temer.
One should not fear death; On the contrary, life is what one ought to fear.
JOSE CAMACHO OF COCULA

45 | MARK PERANSON, Writer and critic |

No reply

Only the wilfully blind could fail to implicate the diverse force of religion in most, if not all, of the violent enmities in the world today. Those of us who have for years politely concealed our contempt for the dangerous collective delusion of religion need to stand up and speak out.

RICHARD DAWKINS *A Devil's Chaplain*

46 | SOPHIA PHOCA, Writer and lecturer |

Dear Andrew,

When you first invited me to take part in this project, the only meaning I could invest in the images you sent me was death. This man, who was your father, was now dead. I projected on to your grief, which collided with mine. I felt empty, exhausted, barren.

So I deferred and wrote to seventeen religious figures instead. This was my opportunity to play out a desire for foundational certainties, a search for something solid- I hoped religion could offer me a way to do this. I enclose a draft of the letter I wrote and the nine responses I received. I will not comment on them individually as each letter is a response in itself.

While I found many of the letters inspiring and insightful on death, especially the Greek Orthodox Patriarch's incisive response to you, they did not address my needs. I wanted relief from the solitude of death and religion failed to do it.

For months I remained silent. But then I started to think about the letters, the process you employed and my repetition of that. On Sunday in a second hand bookshop I picked up a book on Derrida's 'Post Principle', in itself a playful response to Freud's 'Pleasure Principle'.

Freud had observed his grandchild playing, which he refers to as the 'fort-da' game, where a child obsessively throws an object to the floor each time it is returned by its parent. Freud suggested that in doing this the child is rehearsing primal separation anxieties from its mother. This became the basis of Freud's understanding of the death drive.

Derrida drew on this and claimed Freud had actually acted out the 'Pleasure Principle' himself, in his correspondences with other psychoanalysts. He referred to the 'Post Principle' as a way of inviting and deferring death (much

like the fort-da game) or as he puts it, like repeatedly sending a letter which is returned by the sender.

It occurs to me that the Dead Dad photographs act in a similar way to the 'Post Principle'. Like a letter being returned to the sender, the photograph is a constant deferral and reminder of death. By sending them out you are playing out the fort-da game much like a child acting out its separation fantasies. I thought about this all day.

The next night, in a pub, over a Vodka Martini, Aaron told me Derrida had died. I ordered a few more and we talked about your project. I felt so excited. I realised it was not certainties that I had been looking for; instead it was some kind of connection- a dialogue on death and here it was. While I had been thinking of writing you about Derrida's ideas on the death drive and its links to your Dead Dad photographs, Derrida was dying. The coincidence felt meaningful. My euphoria began to smother the grief. But then again the Vodka was coursing through my veins.

Best wishes,

Sophia

Nitrous oxide and ether, especially nitrous oxide, when sufficiently diluted with air, stimulates the mystical consciousness in an extraordinary degree. Depth beyond depth of truth seems revealed to the inhaler. This truth fades out, however, or escapes, at the moment of coming to; and if any words remain over in which it seemed to clothe itself, they prove to be the veriest nonsense.

WILLIAM JAMES *The Varieties of Religious Experience*

Dear _____,

I am writing in order to invite you to collaborate on a project I have been asked to work on by Andrew Kötting who is an artist/filmmaker. He recently sent me and other artists/writers a copy of four photographs of his father (see enclosed photocopy). He writes: "At the top of the following page are four photographs of my dad, who is now dead. He was born o 31st January 1935 and died on the 14th December 2000. The first is a photograph of him as a boy, the second is of him as a man, the third of him as a middle-aged man and the last one is of him as an older man, (dead)."

Andrew Kötting invites us to respond to carious questions he poses in order to "compile a portrait through the words or marks of other people". The questions are: "What do the pictures tell you about him? What was his point of view? What did he used to do? What did he want to say but didn't? What gave him pleasure? What were his principles? What was his greatest fear?" I do not feel I can respond to these questions about a man that I did not know and the photographs do not offer me sufficient information to speculate on the questions.

I look at these photographs and wonder how to respond. But I am looking at the wrong place. After a while I realise that it is in fact the framed space underneath the photographs (that I have not been looking at), which poses the question for me. I cannot speak about the living man represented. It is the vacant space offered, representing both the dead man and my expected text that preoccupies me now. Somehow the two (the non-corporeal man and my speech have collapsed in to one. How do I represent the dead man? What is a dead man? What is death?

Now these are the questions I pose to you. I would welcome any feedback you may have on this. I am asking various religious representatives from different faiths to respond. I do not think it is appropriate for me to prescribe the length of the text or the form of the text as the original request from the author of the project did not. So please feel free to respond in the way you believe is the most appropriate to you. You will of course be credited and the text will be published in a book compiled by the author Andrew Kötting.

Please contact me at the above address, or by email sphoca@***** or on 01622 ****, if you have any further queries. The deadline for his project is the end of March.

Yours sincerely,

Sophia Phoca

Dear Miss Phoca,

Thank you for your letter of 8th January, concerning a project on which you are engaged on behalf of Andrew Kötting.

You ask about death. For Christians, death (as our Lord Jesus Christ says) is our entry into life (cf. John 5:24). As the Apostle to the Nations reminds us, "Death, where is your sting? Grave, where is your victory?" (1 Cor. 15:55). You will probably find it useful to read the context of this verse - namely, St Paul's first Epistle to the Corinthians, chapter 15, verses 51 to 58. Here you will find a summary of Christian teaching on death.

51 *Behold, I shew you a mystery; We shall not all sleep, but we shall all be changed.*

52 *In a moment, in the twinkling of an eye, at the last trump: for the trumpet shall sound, and the dead shall be raised incorruptible, and we shall be changed.*

53 *For this corruptible must put on incorruption, and this mortal must put on immortality.*

54 *So when this corruptible shall have put on incorruption, and this mortal shall have put on immortality, then shall be brought to pass the saying that is written, Death is swallowed up in victory.*

55 *O death, where is thy sting? O grave, where is thy victory?*

56 *The sting of death is sin: and the strength of sin is the law.*

57 *But thanks be to God, which giveth us the victory through our Lord Jesus Christ.*

58 *Therefore, my beloved brethren , be ye steadfast, unmovable, always abounding in the work of the Lord, forasmuch as ye know that your labour is not in vain in the Lord)*

For the hymnographer of the Orthodox Funeral Service, life is but "a flower, a vapour and a morning dew"; and, meditating on death, he says:

"Where is the attraction of the world? Where is the illusion of what passes? Where is the gold, where is the silver? Where the throng and hubbub of servants? All dust, all ashes, all shadow."

Elsewhere he comments:

"I looked again into the tombs and saw the naked bones, and said: Who then is the king or soldier, rich or beggar, just or sinner?"

Death is also seen in a certain way as being joyous for the hymnographer writes:

"We give thanks o God because (the deceased) has left his family and is hastening to the grave. He has no further care for things of no moment, affairs of the much-wearied flesh."

The hymnographer also places himself in the position of the deceased and expresses the Christian conviction that his destination after death is to "the place of the light of life", that his death will result in his return to the "longed-for fatherland" and that he will "once again" become "a citizen of Paradise".

We ought, perhaps, to also remember that, for an Orthodox Christian, death is In fact a falling-asleep, a repose. Indeed, some of the English terminology reflects the Greek meaning- as in the word 'cemetery' (a place of rest and repose).

But, somehow, I do not think that this will satisfy Mr Kötting. We must remember that children look at their parents in a completely different way from that in which parents look at their children, colleagues look at each other, husbands look at wives, the lover at the beloved, etc...

Photographs are, in themselves, dead objects, frequently recording how we would like to project ourselves or how others would like to think of us. They freeze a moment in time, a moment that will never come back, never return.

In all cases, the photographs under discussion appear posed. The first appears to be a school photograph or something similar (and presumably taken during the war years). The boy's gaze is serious, slightly melancholy, the jacket sturdy and serviceable. Does this tell us anything about his family background?

The photograph of Mr Kötting's father as a young man presumably shows him with his son. He appears to be a conformist despite holding his son Buddha-like in his arms and the foreign car number-plate in the background. Could this photograph have been taken abroad?

The third photograph is clearly the most interesting. In a way, it appears to be out of character with the two previous ones. Here is someone who is willing to be seen as non-conformist, perhaps "a bit of a character". And yet, one wonders whether this is an artificial pose - one for the camera. Is he someone who would like to be thought of as "letting his hair down" on occasions?

The final one depicts finality. The dressing of the dead and the arranging of the coffin are undertaken by others. Frequently, the deceased has no resemblance to the person we knew in life - particularly when the funeral home uses a bit of make-up to disguise the pallor or produces a hairstyle that was never used on the deceased whilst alive.

Anything that one might say about these photographs can be only superficial. As you say, "How do I represent the dead man?"

As to your question about "What is a dead man?", this can be answered in a number of ways. I am sure that you have already considered the biological, philosophical, theological and other possibilities to be looked at.

As you will appreciate, this letter is not an attempt to answer the questions that you have been sent to you. It is, however, an attempt to answer the questions that you could follow up in your research.

However, in a way, it might be said that Mr Kötting is trying to be iconoclastic in his approach to his father. He is not trying to discover the truth about him, the depths of his father's feelings and emotions, his relations with his family and friends. He is not even really trying to come to terms with his own emotions, his own feelings towards his father. I doubt that he will ever be able to discover his own feelings through compiling "a portrait through the words or remarks of other people".

It may of course, be that Mr Kötting, by inviting answers to his questions, is attempting to philosophise about the meaning of life in general and trying to approach this mystery in depth, that he is trying to comprehend what it means to be a human-being. It may be that he is trying to surpass his own personal feelings, faults and limitation in order to see humanity as a whole. However, we have to remember that the mystery and the embrace of death is always present and that is in some way a part of our everyday life. Particularly when we are young, we neither care nor think a great deal about death. But, when it touches us through the death of someone close to us, then we realise how close it in fact is. As our life passes, we come to realise how short our life really is, and it is then that we try to come to terms with death - particularly, when we are very sick.

For your own understanding of how our Mother Orthodox Church looks at death, I think that you will find helpful the enclosed copy of the Prayer of Absolution that is read at a funeral by a bishop (should one be present). In that prayer, it is possible to see how our Church understands and approaches the Mystery of Death.

Hoping that you will find these comments of some use, I remain,

With best wishes and blessings

Gregorios, Archbishop of Thyteira and Great Britain

THE LIFE AND DEATH OF A FATHER

When I look at these four pictures and then look at the space below, my immediate reaction is what comes next. Death is both an ending and a beginning, the beginning of a new, all-embracing eternal life. It speaks of new experiences, uncharted waters, with thanksgiving for all that has been, the family, the laughter and achievements are all part of that unbroken continuity.

When I look at those four pictures I also think how brief is man's span of life, no more than a 'twinkling in the eye of God'. In terms of the centuries of human history what is a life? But then the pictures make us aware of the generations that follow, the continuing of the family name, markings and mannerisms and they also point us to what came before, the previous generation that produced this boy. We have three score year and ten if we are lucky and many are not, so these pictures speak to me of fulfilment and a working out of a personal history.

Thomas Aquinas tells us that we exist but that we are constantly threatened by non-existence. Death is about the physical side of us ceasing to exist but the spiritual side of us bursting out of the tomb, like a firework display or flowers bursting in to bloom. It is through death that our souls have new opportunities for growth and development with the One who created us: "Remember O Man, from dust you came and from you shall return".

Death is also about separation from the people we know and love, although it is also our pointer to reunion, with those who have gone before and ultimately those who follow us thereafter. Death is a wrenching and a lonely experience that is individual and entirely unique. Death can come like a "thief in the night" or with all the noise of a brass band. It can be peaceful or traumatic, sudden or lingering, for young and old because death is no respecter of age but however it comes, it is an inevitable part of human life waiting for all of us. How we deal with it of course is entirely up to us.

Only normal that man should no longer be interested in religion but in religions, for only through them will he be in a position to understand the many versions of his spiritual collapse.

E.M. CIORAN *The trouble with being born*

RADHA MOHAN DAS, Religious Figure

Dear Sophia

Thank you for your letter asking for my comments on the subjects of 'what is a dead man'? and 'what is death?', and assumingly, how this specifically applied to the photos of the man you sent me.

Just like you, I find it difficult to say much about the man himself in detail based on 4 small photographs, so the majority of my letter concentrates on the subject of 'death', the soul and the body.

Like all people, this person was unable to express himself to the fullest: That is because essentially we are all divine spiritual beings- but living in the material atmosphere of this world. We cannot find full satisfaction or love in this world because our true loving relationship belongs in connection with Lord Krishna (The Supreme Personality of Godhead).

Like most people, a life including a mixture of humour and pain, piouty and impiouty, so near and yet so far from solving life's ultimate problems. Ultimately this body is a source of suffering, but we are not the body but the soul within simply experiencing karma due to our activities in this life and previous lives.

Ultimately everyone is good and pure, including the man in the photographs. We are all looking for love. In fact, I would say he was essentially a very good-hearted person, but perhaps within certain restrictions. Everyone is

'good', but due to our contact with this mundane mortal world, we become contaminated and sometimes show symptoms of someone who is not blissful and pure.

On the subject of the soul, body and God, please let me quote from one of the most well-known scriptures in the world: The Bhagavad Gita:

Bhagavad Gita
Chapter 2, verse 13

SANSKRIT
dehino 'smin yathA dehe
kaumAraM yauvanaM jarA
tathA dehAntara-prAptir
dhIras tatra na muhyati

ENGLISH TRANSLATION:
As the embodied soul continuously passes, in this body, from boyhood to youth to old age, the soul similarly passes into another body at death. A sober person is not bewildered by such a change.

EXTRACTS FROM PURPORT (COMMENTARY):
(By the Founder of the Hare Krishna Movement- His Divine Grace A.C. Bhaktivedanta Swami Prabhupada):

Since every living entity is an individual soul, each is changing his body every moment, manifesting sometimes as a child, sometimes as a youth, and sometimes as an old man. Yet the same spirit soul is there and does not undergo any change. This individual soul finally changes the body at death and transmigrates to another body; and since it is sure to have another body in the next birth-either material or spiritual-there was no cause for lamentation...

Rather, he should rejoice for their changing bodies from old to new ones, thereby rejuvenating their energy. Such changes of body account for varieties of enjoyment or suffering, according to one's work in life.

...Any man who has perfect knowledge of the constitution of the individual soul, the Supersoul, and nature-both material and spiritual-is called a dhira, or a most sober man. Such a man is never deluded by the change of bodies.

The ... theory of oneness of the spirit soul cannot be entertained, on the ground that the spirit soul cannot be cut into pieces as a fragmental portion. Such cutting into different individual souls would make the Supreme

cleavable or changeable, against the principle of the Supreme Soul's being unchangeable. As confirmed in the Bhagavad Gita, the fragmental portions of the Supreme exist eternally (sanatana) and are called kSara; that is, they

have a tendency to fall down into material nature [from the Kingdom of God].

These fragmental portions are eternally so, and even after liberation* the individual soul remains the same fragmental. But once liberated, he lives an eternal life in bliss and knowledge with the Personality of Godhead.

* After a life of a high level of loving devotional service to Lord Krishna, one may be liberated from the cycle of birth and death and re-enter the spiritual atmosphere (the Kingdon of God) from whence we came.

Chapter 2, Verse 17:

TRANSLATION
That which pervades the entire body you should know to be indestructible. No one is able to destroy that imperishable soul.

PURPORT
This verse more clearly explains the real nature of the soul, which is spread all over the body. Anyone can understand what is spread all over the body: it is consciousness. Everyone is conscious of the pains and pleasures of the body in part or as a whole. This spreading of consciousness is limited within one's own body. The pains and pleasures of one body are unknown to another. Therefore, each and every body is the embodiment of an individual soul, and the symptom of the soul's presence is perceived as individual consciousness. This soul is described as one ten-thousandth part of the upper portion of the hair point in size.

This very small spiritual spark is the basic principle of the material body, and the influence of such a spiritual spark is spread all over the body as the influence of the active principle of some medicine spreads throughout the body. This current of the spirit soul is felt all over the body as consciousness, and that is the proof of the presence of the soul. Any layman can understand that the material body minus consciousness is a dead body, and this consciousness cannot be revived in the body by any means of material administration. Therefore, consciousness is not due to any amount of material combination, but to the spirit soul. The individual atomic soul is definitely there in the heart along with the Supersoul, and thus all the energies of bodily movement are emanating from this part of the body. The corpuscles, which carry the oxygen from the lungs gather energy from the soul. When the soul passes away from this position, the activity of the blood, generating fusion, ceases. Medical science accepts the importance of the red corpuscles, but it cannot ascertain that the source of the energy is the soul. Medical science, however, does admit that the heart is the seat of all energies of the body. Such atomic particles of the spirit whole are compared to the sunshine molecules. In the sunshine there are innumerable radiant molecules. Similarly, the fragmental parts of the Supreme Lord are atomic sparks of the rays of the Supreme Lord, called by the name prabhA, or superior energy. So whether one follows Vedic knowledge or modern science, one cannot deny the existence of the spirit soul in the body, and the science of the soul is explicitly described in the Bhagavad-gItA by the Personality of Godhead Himself.

I hope this is useful information Sophia!

Yours sincerely

Radha Mohan das

Anything in folklore that remains comes from before Christianity. The same is true of whatever is alive in each of us.

E.M. CIORAN *The trouble with being born*

DR MUHAMMAD SHABBIR USMANI, Religious Figure

Life after death

A Muslim believes in the following Six Essential Fundamentals of Faith:

1. Belief in Allah (One God)

2. Belief in Messengers

3. Belief in the Scriptures

4. Belief in the Angels

5. Belief in Destiny

6. Belief in Life after death

The question of whether or not there is life after death does not fall under the field of science, because science is only concerned with the classification and analysis of recorded data. Moreover, man has been busy with scientific enquiries and research, in the modern sense of the term, only for the last few centuries, while he has been familiar with the idea of life after death since times immemorial. All the Prophets of God called their people to worship God and to believe in life after death. They laid so much emphasis on the belief in life after death that even a slight doubt in it meant denying God and made all other beliefs meaningless. The very fact that all the prophets of God have dealt with this metaphysical question so confidently and uniformly - the gap between their ages being thousands of years - goes to prove that the source of their knowledge of life after death, as proclaimed by them all, was the same, that is, Divine revelation[1].

A Muslim believes that the existence of the whole universe is not purposeless and particularly the existence of humankind on this planet. Allah says in the Holy Qur'aan:

'Do you think that we have created you in jest and that you would not be brought back to Us (for account)?' [23:15]

Allah Almighty also says:

'As We produced the first creation so shall We produce a new one; a promise We have undertaken; truly We shall fulfill it.' [21:104]

Many of the people whom the Prophet addressed in Makkah did believe in a Supreme God, but many of them thought that it was impossible for their dead and decayed bodies to be resurrected. They therefore mocked the Prophet when he told them about it. The Qur'aanic reply was that there was no reason for such astonishment and mockery because resurrection is not only logical but a physical possibility. If it is God who created man in the first place, why should it be impossible for Him to re-create him when he dies? Resurrection should be easier than original creation. Why is resurrection desirable?

[1]*Life After Death*, published by World Assembly of Muslim Youth, Riyadh.

Without the idea of resurrection, God would not be the just and wise and Merciful God that He is. God created men and made them responsible for their actions. Some men behave well and others do not. If there is no future life in which the virtuous are rewarded and the vicious are requited, there would be no justice and there would be no purpose in creating men with a sense of responsibility and in sending Prophets to them to remind them of these responsibilities. Actions without purpose are not expected of man known to be rational and just, so how much more do we expect of the Perfect Creator.

Life after Death and the Day of Judgment is a system of Allah's justice. The people will be reckoned according to their worldly deeds, righteous will be rewarded while the evil will be requited. Allah says in the Holy Qur'aan:

'Or do those who earn evil deeds think that We shall hold them equal with those who believe and do righteous deeds, in their present life and after their death? Worst is the judgment that they make. And Allah has created the heavens and the earth with truth, in order that each person may be recompensed what he has earned, and they will not be wronged.' [45:21-22]

The belief in the Last Day yields tremendous benefits such as:

1: Arousing the desire to do the acts of obedience, striving to carry out them in the hope of achieving the reward of the Last Day.

2: Awakening the fear of committing act of defiance and acknowledging them, fearing the torment of that Day.

3: Calming the believer over affairs of this world that may escape him, by that which he hopes for, from the bliss and reward of the Last Life

Denying the reckoning after death claiming that it is not possible. Such claim is wrong and its invalidity is evident by the Divine law, Sense and rational.

Allah is the One Who originated the creature of the earth and the heavens. Having the ability of originating the process of the creature, He the Almighty is not incapable to do it again.

He the High said:

'It is He Who begins (the process of) creation; then repeats it; and for Him it is most easy." [30:27]

Responding to those who denied of giving life to decayed and rotten bones, Allah said to the Prophet may the blessings and mercy of Allah be upon him:

'Say: He will give them life Who created them for the first time! For He is well versed in every kind of creation!' [36:79]

The belief in the Hereafter also includes the belief in what happens after death:

It is called the affliction of the grave, which contains questions asked from the dead regarding his Lord-Rabb, his religion and his Prophet. Allah will keep strong those who believed with the word, which stands strong. The believer will say: My Lord is Allah and my religion is Islam and Muhammad is my prophet. But the wrongdoers will answer: "Haa! Haa! I do not know." The hypocrite will answer: "I do not know, I heard the people saying something and I said likewise."

Nevertheless LIFE AFTER DEATH is a divine system to reward in full those who obey the Lord and perform good deeds; and to requite those who defy the Lord and earn evil deeds.

Allah says:

'For to Us will be their Return; Then it will be for Us to call them to account.' [88:25-26]

He the Almighty also said:

'He who does good shall have ten times as much to his credit: he who does evil shall only be recompensed according to his evil. No wrong shall be done unto (any of) them.' [6:160]

Also said in the Holy Qur'aan:

'We shall set up scales of justice for the Day of Judgment so that not a soul will be dealt with unjustly in the least. And if there be (no more than) the weight of a mustard seed We will bring it (to account): and enough are We to take account.' [21:47][1]

[1]*The Fundamentals of Faith* by Sheikh Al-Uthaymeen, translated by Dr Muhammad Shabbir Usmani.

RABBI DR CHARLES H MIDDLEBURGH, Religious Figure

In the wake of a dad dying

A personal reflection

Judaism believes in the immortality of the soul, the pure essence of man that is also the pure essence of God. Judaism also teaches that bthe dead will be resurrected with the advent of the Messiah, though quite when that will be and how it will transpire is much less clear.

Judaism also respects the body of a dead person, watching over it from the time of death to the moment of burial.

These four photographs represent quite literally, snapshots of a life. The child, pure and looking out innocently to a future full of discovery and experience; the young father, proudly standing in front of a new car and holding a new baby – possibly feeling pride in achievement on both counts? The middle aged man, happy or manic, it is impossible to say which, but definitely grey, lined, and rich in experience and possibly, suffering. And finally the dead man – lying as if asleep in a coffin shaped bed, to rest for all eternity.

There are many potential messages in these photos, but for me as a Jew, the three principal ones are these; first and foremost, that Ecclesiastes got it right when he talked of times and seasons for everything under heaven – an awareness for a pattern of by which we are all governed: second, that death is a natural part of life, of which we should be aware but never afraid: and third, that the immortality of a person is multi-faceted, and whatever may be the life of the soul after the death of a body, the best immortality for each of us is the snapshots of memory cherished of us by those we loved in life and who will still love us in death.

Rabbi Dr Charles H Middleburgh
Rabbi, Dublin Jewish Progressive Congregation and senior lecturer at 3deo College-Centre for Jewish Education

REV. G. ZAFIRAKOS, Religious Figure

Dear Sophia,

Please see below a very basic and brief summary of what Greek Orthodox believes about death. I apologise that it has taken so long to reply and I hope that what has been written will help you in your studies.

All people generally fear death. Mainly as it is the only thing that they can not control and defeat in their lives. For Christians, death should not be the most frightening event in their lives, as they acknowledge that it is not the end of their entire existence, but the beginning of their new life. It is considered a deep, long sleep, where the physical body dissolves but the spirit continues to live in another spiritual world where it continues to experience happiness, sadness and also continues to think!

Christians believe that God created man in his image and was given the chance to resemble his likeness, in terms of being a good being. Man's body is created from the earth and man was given life from the breath of God, which was blown, upon his face. Thus man is made from 2 things, physical matter (earth) and spiritual elements (breath of God), which made him immortal- as God himself.

The immortal man lived in Paradise with the Angels and with God's guidance and protection. He was however, given a warning not to sin otherwise he would die! Adam and Eve (his partner) sinned, thus they were forced to leave paradise and come to this world and death soon became upon them- and thus upon us also.

The first mention of death in the bible was of their son Abel who was killed by his brother Cane. Hence it suggested that death was created by doing sin. So for man to escape from this death and sin, it was necessary for God to help them. God therefore sent his son Jesus to the world, where his crucifixion beat death and sin and to once again be able to go back into paradise.

For Christians, the most important religious event is the resurrection of Jesus Christ. This is because Jesus killed the original ideology of death through his resurrection and thus man has conquered death. This good news is expressed in the following hymn sung at Easter:

Christ has risen from the dead, by death trampling upon death, and has bestowed life to those in the tombs.

In this day of resurrection, we celebrate the ending of death.

O King and Lord, in the flesh, thou didst sleep as a mortal, and rise on the third day, Thou didst raise up Adam from corruption and abolish death. O Pascha offer us in corruption and salvation of the World.

With his resurrection, Jesus has told us not to fear death, as we will also be resurrected when our body dies. He has said:

"Whoever believes in me and dies, will continue to live,"

It is also noted in the bible that, Jesus always referred to death as 'sleep' which is expressed with his friend Lazarus's death. He said,

"My friend Lazarus is sleeping, I am going to wake him."

And then after 4 days, Jesus raised Lazarus from the dead.

So where do our spirits go after death? When we die, our spirits go to a spiritual place where they await the second coming and where they will be judged by God to either enter paradise or go to hell. In this place where our spirits/souls go once they leave our bodies, some are happy as they are eager to go to paradise, but some will be sad that they will go to hell if they have sinned in their lives. They also recall their previous lives on this earth and they can also pray for us and our progress in our lives. These spirits can not commit sin in this place. However we can pray to God on their behalf, so that they would be forgiven at their judgement, where they might be able to enter paradise. Thus we pray for our friends and families through the "mnimosina" memorials and in addition the spirits also pray for us.

On judgement day, it is written that we will all appear in front of Jesus (dead and alive) to be judged. First it will be the turn of the dead and then the living, thus the free spirits will be able to return to their bodies in the form of Angels. This is because when man sins, he does so within his human body. As a result of the judgement, those who have committed evil will be punished and those who have done good in their lives will inherit the resurrection on life and thus will go to paradise as it was in the beginning.

Sophia, I have written a very small amount about death and tried to explain to you the basic and fundamental beliefs that we have as Christian's regarding this subject, I hope it is helpful.

I wish you all the best in you studies

Yours sincerely

Rev. G. Zafirakos

2nd April, 2004

Dear Sophia Phoca,

I am sorry to be so long in letting you have the enclosed. I do hope it is not too late as I see your deadline is for 31st March.

I must apologize for the rather scrappy presentation. Unfortunately, my computer is refusing to operate, so I have had to resort to my trusty manual typewriter!

Please contact me if you need further information or clarification.

I wish you good luck with your project.

Yours sincerely,

Revd Michael Woodgate.

Ms Sophia Phoca,
Kent Institute of Art and Design,
Maidstone College,
Maidstone, ME16 8AG

CATHOLIC CHURCH'S TEACHING ABOUT LIFE AFTER DEATH.

Catholics hold a very positive view about death. They believe
that when a person dies the soul leaves the body and enters
the life of the world to come. The soul is that person's
real self. In other words, they enter into everlasting life,
which is less about length of life than quality of life. It
is then that the person concerned meets Christ and is judged
by Him. Since no one who dies is yet ready to see God face to
face, they need a process of preparation or purification so as
to achieve the holiness necessary to enter the joy of God, to
see His face and be in union with Him. This stage on the
final journey is called purgatory and the departed can
here be helped by the prayers of their Christian brothers and
sisters on earth and also especially by the offering of the
Holy Eucharist (the Mass) on their behalf.
At the end of this process (and one cannot really speak about
time when one is talking about eternity!), the departed person
will enter what we call heaven and so enjoy the sight of God
with all the saints and angels. Catholics along with all
Christians believe that heaven is our true home, where we
really belong. Jesus once said "There are many resting-places
in my Father's house" and so we may take this to mean that
the departed are at various stages on their final journey to
heaven.
But because of the resurrection of Jesus on Easter Day,
Catholics believe that at the end of time the Kingdom of God
will come in its fullness and all who have died will/be united
with a new and wholly transformed body - a resurrection body.
In fact, the whole material universe will be transformed.
What about those who have chosen to reject God or have refused

to love and serve Him, or have died without being sorry for
all the hurt they have caused both to God and others, those
who lived throughly selfish or even evil lives? Here the
Catholic Church teaches that they will be separated from God
in the after-life just as they chose to be separated from
Him on earth. This state of separation is called hell.
But the Church prays that no one will be finally separated
from God. "God desires everyone to be saved" says St Paul
and for God "all things are possible". For this reason the
Church will never say that any particular person is in hell -
even Adolf Hitler or Joseph Stalin, to name but two tyrants.
We simply do not know the state of a person when they die
and what has been going on between them and God during
the process of dying.

God, Catholics and other Christians believe,/because He loves
us and as a great Christian teacher, St Augustine of Hippo,
once said, all souls are restless until they find their rest
in God.

Catholics frequently remember the departed and pray for them,
often by having a Mass celebrated for them. They think of

them as very close to us. November 2nd is a day in the year
when all departed people are remembered and prayed for. It is
called: The Commemoration of All Souls.

Fr. Michael Woodgate
(Based on " Catechism
of the Catholic Church")

2

Death

My first reaction was of the photos that were not given. There was no baby photograph and no photograph of old age. So we are not being a 'cradle to grave' selection for the chronological span of the father's life. The first three photos are of a living person whose character may possibly be glimpsed – perhaps in a way that can't be with the photo of a baby. This leaves other questions, such as maybe this is a selection determined largely by available sources. Maybe the photo of the boy is the earliest record that there is of his father. If this is the case then what is the story behind this – were photos taken and if so were they lost?

The pictures suggest for me that a death happens 'in life'. The choice of these four photos suggests to me that the author sees death as an event in life. One of the pictyures that Andrew Kotting has selected is of his father holding a baby (possibly himself?).

There is then a picture of a time of close to a birth in this selection that includes the image of a person after death.

I sense that taking photos of dead relatives is still a relatively uncommon phenomenon, even in an age where we are able to and do record many moments in our family life. Perhaps many people do take images of dead relatives but do not talk about it much and rarely show the photos to others.

When talking to students about attending funerals, I find myself pleased if I hear that the coffin was kept open for part of the ritual. It seems important to me that the living encounter the dead as a normal part of life. To those that have never seen person who has died there is often something scary imagined. People frequently say; 'I did not want to go and see him dead, I wanted to remember him alive and well'. And yet people who have seen the bodies of their friends and families do not describe being haunted by the image. Rather it seems from my experience of talking to people and from seeing dead bodies myself, that somehow the contrary is true and that some kind of peace in the midst of grief happens from seeing the body. What people often talk about to me about is the fact that when they see the body of someone whom they love they sense that the person is 'not there'. A dead body is just a body. There is still some kind of presence in seeing the body. However the person who was known and loved is frequently seen as no longer being present.

So seeing the

(At which point he stops)

Andrew Wilson St Francis Church

If a bishop presides he says the following prayer:

O Lord our God, Who is Thine infinite wisdom has created man from the earth, Who has fashioned in form and beauty and adorned him to be a precious and heavenly creature, and in Thine image and likeness, for Thine own praise and the glory of Thy Kingdom.

And when he disobeyed Thy command and deformed and kept not the image he shared, he Thou, O Lord God of our fathers, in order that evil become not immortal, has ordered Thy divine will the mixture and unity of this mysterious bond to be cut and dissolved, and the soul proceed where it had been received its being till general resurrection, and the body be decomposed and dissolved.

Therefore we beseech Thee, Eternal Father, and Thine Only- Begotten Son, and Thine all-holy, con-substantial and life- giving Spirit, to reject not this Thy creature to be swallowed by perdition. Instead let his body be dissolved into what it was made of and his soul be set in the ranks of the righteous.

O Lord our God, let Thine infinite mercy and Thine incomparable love prevail. And if this Thy servant has been cursed by his Father or mother, or has fallen into his on condemnation, or had embittered any of the clergy and received an undissolved spiritual bond; if he has been punished by a Bishop with a very lengthy excommunication, and because of negligence or indifference he has not been pardoned, absolve him, O Lord, through me Thy sinful and unworthy servant. And may his body be dissolved into the elements that have made it while his soul be guided into habitations of Thy saints.

O Lord our God, Who hast given to Thy disciples and Apostles authority to absolve sins, saying whatever the bid or solve be bound and solved, likewise hast lovably transferred to us, though unworthy, the same great grace, absolve Thy departed servant (N.) and let him/her be forgiven of his/her spiritual and physical sin, now and in the age to come, through the intercessions of Thy all pure and ever virgin Mother and of all Thy saints. Amen.

(Another prayer said instead of the first one)

Let us pray.

O compassionate Lord Jesus Christ our God, Who entrusted the keys of the heavenly Kingdom and in Thy grace has granted the Thy holy disciples and Apostles, after Thy resurrection from the dead, the authority to bind and solve sins of people, so that whatever they solve on earth be likewise the same in heaven. Who has deemed us worthy though Thy worthless servants, to become their successors, in the administration of the same holy grace, to the effect that we may bind and solve whatever happened among Thy people, do Thou the same merciful King, forgive through me Thy useless servant whatever sins

Thy departed servant (N...) committed in this life. Forgive the sins he has done by word, or deed, or thought, and whatever bond he set upon himself, in excitement, or by other causes produced by the envious influence of the devil, Thou, O good and merciful Lord, be pleased that his soul be among the saints, who in the ages past, have pleased Thee, and his body be given to the nature that Thou hast created, for Thou art blessed and glorified for ever and ever amen.

If There is no Bishop present the priest reads the prayer 'O God of spirits and of all flesh..." which is followed by the Dismissal.

KEITH D MILNS, Religious Figure

Dear Sophia,

Thank you for your invitation to contribute to your input to the project investigated by Andrew Kötting. I trust that the following comments, which have religious bias, are of some value. They (as all beliefs of Jehovah's Witnesses) are based on Bible teachings.

I have also enclosed a brochure, which you may wish to use for further reference.

If I can be of further assistance, please do not hesitate to contact me. My telephone number is 01622 7644**. However, if you would like a face-to-face meeting then I would be happy to visit the college.

Yours sincerely

Keith D Milns

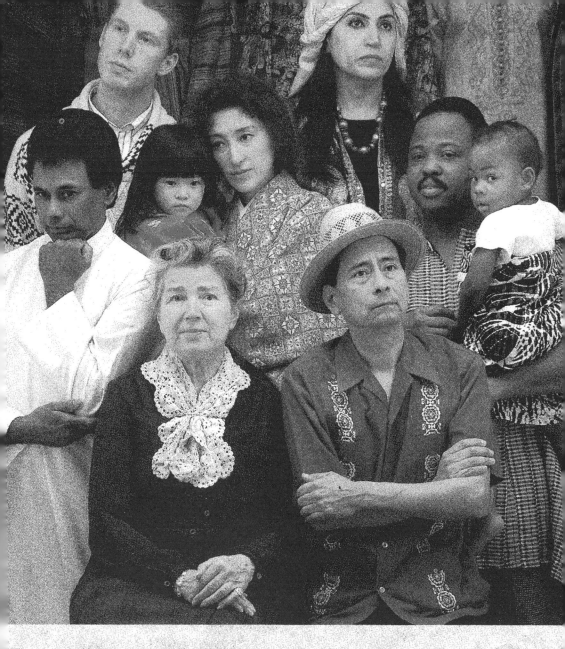

WHAT IS THE PURPOSE OF LIFE?

How Can You Find It?

a boy a young man a middle-aged man an older man (dead)

A Boy?

What is in store for this boy? What goals and aspirations does he have? Even though young in years he has already experienced a world war and no doubt is aware that many brave people have not returned from an appalling conflagration that has caused so many difficulties and pain for him and his family. In addition, he is probably aware that his future will include old age and eventually death - a scenario that each person on the earth has to face. However, at this stage that may be far from his mind as his life is full of playtime and talking about what job he will do and whom he will marry.

Perhaps he was made to go to Sunday School at the local church, but like most young people he finds it boring and it is hard to believe in a God that can have any relevance to his life.

Psalm 62: 8
"Trust him at all times, O people. Before him pour out your heart."

Psalm 119:9
"How will a young man cleanse his path? By keeping on guard according to your word."

Ecclesiastes 12:1
"Remember, now, your Grand Creator in the days of your young manhood, before the calamitous days proceed to come, or the years have arrived when you will say: "I have no delight in them.""

A young Man

By now he is beyond puberty and adolescence and settled with a wife and perhaps a baby. Is the child in his arms his son or daughter? Whatever the situation, he seems to be proud of the new life in his possession. No doubt he is struggling to make a living and yearns to own a motor car and a home of his own. His life is full, and apart from funerals, weddings and christenings, an active faith is hard to fit into his busy life. Even though his own parents may be alive and ageing rapidly, old age to him is a long way off. His wife and family are paramount and their needs fill his life.

Matthew 24:36-39
"Concerning that day and hour nobody knows, neither the angels of the heaven nor the Son, but only the Father. For just as the days of Noah were, so the presence of the Son of man will be. For as they were in those days before the

flood, eating and drinking, men marrying and women being given in marriage, until the day that Noah entered into the ark; and they took no note until the flood came and swept them all away, so the presence of the Son of man will be.

A Middle Aged Man

Still full of fun, but maybe some of the vigour has disappeared from his life. Thinning, grey hair and wrinkles now bring out a different appearance to a man whose physical body is beginning to 'groan', but his mind and thoughts are no doubt as sharp and active as they have always been. At this stage in his life he may be thinking about his own mortality. His parents, and perhaps some of his friends, may well have died. He realises that trees and even a tortoise will outlive him. Technology has done so much for his world. Man has walked on the moon and discovered much about space, and yet cannot live without fear in many places. Billions of pounds are spent on weapons as millions die around the world because they have no clean water. He may well ask the question: 'What is the purpose of life?' The man may well be inclined to consider spiritual matters. He may consider these bible texts:

Jeremiah 10:23
'I well know, O Jehovah, that to earthling man his way does not belong. It does not belong to man who is walking even to direct his step."

Job 14:1
"Man, born of woman, is short-lived and glutted with agitation."

John 3:16
"For god so loved the world that he gave his only-begotten Son, in order that everyone exercising faith in him might not be destroyed but have everlasting life."

John 17: 3
"This means everlasting life, their taking in knowledge of you, the only true God, and of the one whom you sent forth, Jesus Christ."

An older Man (Dead)

No more pain or anguish - only his loved ones and relatives feel that now. However, not all is lost. There is still hope. The Bible leaves us in no doubt that he has a future. Where? How? The following scriptures give the answers:

What is the condition of the dead?

Ecclesiastes 9:5
"For the living are conscious that they will die; but as for the dead, they are conscious of nothing at all, neither do they anymore have wages, because the remembrance of them has been forgotten."

Is there some part that lives on when the body dies? No.

Ezekiel 18:4
"Look! All the souls - to me they belong. As the soul of the father so likewise the soul of the son - to me they belong. The soul that is sinning - it itself will die."

If there is no spirit that lives on, what is the hope? A Resurrection!

Acts 24: 15
"…and I have hope toward God, which hope these [men] themselves also entertain, that there is going to be a resurrection of both the righteous and the unrighteous."

John 5:18, 29
"Do not marvel at this, because the hour is coming in which all those in the memorial tombs will hear his voice and come out."

Where will the resurrection take place? A paradise earth.

Ezekiel 34:26-27
"And I will make them and the surroundings of my hill a blessing, and I will cause the pouring rain to descend in its time. Pouring rains of blessing there will prove to be. 27 And the tree of the field must give its fruitage, and the land itself will give its yield, and they will actually prove to be on their soil in security."

Revelation 21:4
"And he will wipe out every tear from their eyes, and death will be no more, neither will mourning nor outcry nor pain be anymore. The former things have passed away."

Isaiah 33:24
"And no resident will say: "I am sick""

Job 33:25
"Let his flesh become fresher than in youth; let him return to the days of his youthful vigour."

Although life in this present system may be full of woe and trouble, the future of mankind is positive. God's will is that his original purpose for the earth will become a reality, that is: paradise on earth populated by perfect people living forever.

The following gave no reply to Sophia:

Heruka Buddhist Centre

Manna Christian Fellowship

Strange Cottage

2 Sycamore Drive

Sikh Missionary society- UK

All Saints

Amberton Ave

Rabbi Whittenberg,

Chief among humanity's illusions in Freud's view, was religion. He saw the spiritual comfort given by religion as a false support used by people who had not out grown childish dependence on parents. Maturity, according to Freud, would consist in facing squarely the hard realities of life, and death, and not searching after false hopes.

ROBERT JAY LIFTON AND ERIC OLSON *Symbolic Immortality*

When I live in a house that I know will fall about my head within the next two weeks, all my vital functions will be impaired by this thought, but if, on the contrary, I feel myself to be safe, I can dwell there in a normal comfortable way.

CARL JUNG

I tell you what, if God just walked over that hill now and went, "Hi boys', I would fucking punch his lights out and smash him right in the fucking face. And if he doesn't know what it's for, then he's a bigger fool that I thought he was, I'd pin him to the floor with my boot on his neck, all powerful though he is. I'd punch his lights out for this fucking fabulously optimistic planet with fuck-all behind it. 'What d'you mean? You can't give me all this and then take it away.' It's insane. I'd have to smack him in the fucking face. That's it. That's life and death in a nutshell.

DAMIEN HIRST *On the way to work*

47 | VITO ROCCO, Movie maker

Dear Deadad,

You don't know me and I don't know you. One day when I grow up I am going to be your Dad. I hope that you will be like me. If you are a boy we can go fishing together. And watch football. If you are a girl then you will help my wife. I don't know her name yet. Francine is a nice name. We won't have to go to church a lot. We can pretend to be pirates. I will be the Captain. You can sit in the crow's nest and be lookout while we sail across the world to South America and find lots of gold. Then we will eat a banquet and come home.

From,

Your Future dad.

48 | JONATHAN ROMNEY, Writer and critic
No reply

49 | JOHN ROSEVEARE, Project manager and musician
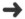

In the wake of a dad dying

(and in the wake of a mother being killed)

In my mind's eye I see Peter, Andrew, Mark, Lisa and Joey, gathered noisily about their father's deathbed. (Mind you, they never gather other than noisily.) The boys are marking the occasion with some carry on or other, no doubt set to a sound track of *'I'm not sure about that'* played in the silently-tutting-with-folded-arms form.
I know all the Kotting siblings, but I never really knew their father Ronald. Which means my contribution is cobbled from the half remembered half knowledge of their utterances, gripes and deeper emotions: the pulsating knot of blood memories. The place of hatreds & loves, resentments & despisements, empathies & antipathies, fleeting connections, detachments & fondness.

A place somewhere beyond Philip Larkin's bald, bitter, mid-20th century cop-out - Parents: They Fuck You Up.

So soon. So soon. I am drawn by the irresistible heave of our age, the personal. The first person reflective. **The "I…." and the "yes but *my*…."**

Because I've been looking at pictures too. Pictures of *my* dead-mother. No. My killed mother. My mown down by a motorcyclist mother. My smiling, dancing, laughing, mother, killed on the 17th September 2002 by 1000cc of spitting chrome. I emailed this to my family about six weeks after she was killed.

> *I went down to Rodmell on my own yesterday and put some flowers next to the pumpkin. A lady from the church came out as I was standing there and gave me the cards they kept when they threw away the dead flowers. Decent and practical, as they seem to be down there. Then I stomped along to the river, round up through Southease, across the road and on through the muddy-cow farm, up and along, then back down to the back of Breaky Bottom and up to the rich house on the hill (which has sprouted huge unfriendly iron gates since I was there last) finally coming down the road to the pub for a late lunch.*
>
> *I had made myself all tearful by listening to 'In the Garden' in the car as I turned up through Kingston. It was a very autumnal day - all wet leaves and muddy grass - but still, the sun shone for me as I tramped round. I knew I was retracing Joy's last steps and it just got sadder. Trying to think what she might have been thinking - always so upbeat and uncomplaining. Oh what a lovely day go walk feet carry her forward look at that clump of parsons botchwitchel still flowering at this time of year I mustn't forget to post that letter all smiles and shiny eyes I think it'll be nice in Cyprus oh what a lovely day I wonder if Emily's story went down well mustn't forget the newsletter and here we are at the top of the road and nothing's coming and quickly over…….*
>
> *Not hugging the side of the road on the path, which they probably put in last time someone was hurt. Not paying too much attention because it's really too much bother. A (very) deaf ear muddling things up, and a quiet motorbike.*
>
> *I glared the angry glare of the bereaved at the hapless motorists. But for the life of me I could only see a slightly impatient happy lady doing what she always did, getting about her business. And tramping on with aching knees (will they take me further than the pub when I'm 70?) I gave myself another*

solace. At least she carried herself forward in vigour, and did not go gently into the good night. No Guru, No Method No Teacher. Maybe. But No Zimmer Frame, No Strange-shaped toilet seat, No Lost Marbles. Which was one thing she was very sure about.

It's not just artists, is it, who are dragged into what has been called 'higher autobiography': we are all there one way or another. The spirit of our age, with its social disjuncture, self-absorbed reflexes and accelerating trajectory, seems to gives us little option.

--

As a middle aged man

 I met Ronald maybe 3 or 4 times, once at his home in Sydenham. He always seemed pleasant enough to me, outgoing, talkative, apparently straightforward.

Like him? Are they? Is he? Chalk & cheeses? Remember. Half the genes. Half the genes.

Though I wasn't in the line of fire at the dinner table that Sydenham Sunday, I sensed beneath the surface the glowing embers of frustration, fanned by years of the angry ferment that is 'small business'. The seething injustice of it all. The incomprehension. The volcanic eruptions at the family after another day uptown juggling customer happiness'. DO YOU UNDERSTAND? HAVE YOU **ANY** IDEA WHAT LIFE'S ABOUT? NO YOU DON'T DO YOU. **NONE OF YOU**. The crazed verbal onslaught at the inept facial hairdos and muddle-headed twoddle – *TWODDLE!* – of his louche pot-smoking children. If only they knew what it's like. They will. Some day. (Do they?).

This is the middle-aged man picture, with the mouth laughing harder than the eyes. The permanent Hancockian outrage and disbelief. SMALL THINGS ANDREW. LOTS OF PEOPLE THINKING SMALL THOUGHTS ABOUT SMALL THINGS. *THAT'S* SMALL BUSINESS. **AND THERE'S NOTHING WRONG WITH THAT** – MAKES THE WORLD GO ROUND. NOT YOUR IVORY TOWERED HEAD IN THE CLOUDS ARTY FART NONSENSE. THAT'S ONE THING I'M *QUITE* SURE ABOUT.

This isn't really true, is it. I didn't *sense* this at the Kotting's dinner table that afternoon in Sydenham. I heard them tell their stories later, over the years. Which I suppose is how we come to know people we don't know well, particularly other people's parents. Funny that. This mismatch. The verbal record of the children, seething with unfiltered yet deep-seated emotion and the face-to-face meetings with apparently normal people.

Wait a minute. Didn't he try and put your mum in the deep freezer?

Inadvertently I've started in the middle, in the middle age. Probably because that's where we are. In middle age. Which no amount of careful alteration to the final language of our trouser hang will change.

--

As a boy

Do we see any of the middle-aged man in the boy? Not really. We can guess that being an umlauted English schoolboy during the 2nd World War carried it's own peculiar baggage. I have pictures of my own father (undead, unumlauted, similarly aged) from this era, much the same in pose: the deadpan but ever so slightly smug expression. There is, though, a hint in the barely detectable hunch of the shoulders and forward tilt of his upper body that confidence would have to be earned. It would not come as the automatic birthright so often offered in the *superiority-as-a-given-but-ever-so-decently-meted* deportment of the public schooled men of Ronald's generation. It's hard too not to believe his daily arrival at school was, for a time, greeted with Nazi salutes and 'Krauty Krauty...' taunts. This is pure conjecture, but like our royal family it must have been a confusing world for the tender minds of young children with blood ties to Germany. At the very least it would have been more difficult to proudly emphasise the little phonetically suggestive dots on the second letter of his surname the way his offspring have. The Nazi salutes of course carried on into the next generation, offered in ribald by the sons of second hand car dealers and nere-do-well household goods retailers who inhabited South London's public schools in the 1970's, strangers yet to political correctness.

As a young man

The picture of Ronald as a young man? I see Mark. Tall, proudly presenting one of his attractive children, a self-effacing smile playing across his face.

From the motor vehicles we can assume it's late 1950's early 1960's. Ronald is in his twenties, his life ahead of him. He's married a pretty girl and the children have started to come thick and fast. (Thick in body, boys, not in mind). Middle-class men of this era who spawned four or more children were like my father too, *de facto,* family men. Like it or lump it, the sheer weight of numbers meant they had to muck in with the nappies, the car trips to piano lessons and the careful alignment of pineapple and cheese on toothpick. From the post-war years onward, the years of New Labour version 1.0, old Tory and sloppy Labour (was Old Labour ever in power?),'maid service' was simply not an affordable reality for large middle-class families, as it had been before the ranks began to swell. Washing machines and easy wipe plastic surfaces may have changed the domestic load, but there were no mechanised child minding devices.

If the breathless Sunday columnists are to be believed in our own time New Lad replaced New Man, only to be presented with the unassailable Beckamian paradigm. A man simultaneously hard, hair band wearing, heroic, resolute, 'deep' (apparently), skirt-wearing, baby holding, goal scoring. But the Beckhams' domestic entourage surely harks back to the 1920's and 1930's in it's sheer size and emphasis on *style*, rendering the paradigm ineffectual as a yardstick. Perhaps *our* fathers, contrary to our scathing contemporary dismissals, were the original New Men. We have spent many years demonising them as cold, unemotional types. The generation for whom the inner demons stayed resolutely inner. But with the jury out on our own generation for whom introspection so easily became an unhealthy reflex, we might pause and consider Ronald's virtues. Committing early to marriage and staying with it; making a business capable of feeding, clothing and educating five children, paid his taxes, took his knocks. *Petit bourgeoisie* as we would cleverly dismiss such efforts in our red brick Universities.

Before him, Ronald the young man has many thousand trips to the office, to business meetings, to nurseries, to bad schoolboy rugby matches, to parents' evenings (5 kids x 11 years in school x 2 p.a. = 110). Best of British to him. He'll need it.

Here as a young woman my mother's open smile is a treat. She too will later travel thousands of miles in a battered green Bedford Van, lifting children to and from cubs, brownies, football matches and god knows what else. A responsible full time job as head teacher of an infant's school and five children aged 4 to 13? Sometimes we take the generous for granted.

My mother carried an immovable faith in God, or the Father-Mother as he/she is known in the 15 volume Herald of the Cross that make up the doctrines of the Order of the Cross. He/she it seems, was the source of GOOD.

And what of death? In her world 'souls' passed over to heaven – an almost literal 'other' world. The Herald of The Cross has this to say (Vol. VIII (1934) pp 102-103) "Why should love cease because the Soul in the earth-sense has reached the horizon, passed beneath it, and gone elsewhere? Surely where hearts can deeply love; where Souls have been in unison; where there has been a real rapport of spirit, there is no separation because the Being for a time must needs to go into another sphere of experience. "

I loved my mother, but I despise her religion. Though we had found accommodation for this disjuncture over the past 10 years or so, I have to look closer now, to dig beneath the surface. Because religion sinks into your bones and never really stops flirting with your emotional responses. God as 'Father-Mother'? The only useful memory I have is using it as a chat up line during the more strident years of loopy feminism in the early 80's.

I guess I have to stick all this in my higher autobiographical pipe and smoke it.

Boy do I dislike religion.

As an older man (dead)

Dead is dead. My mother found it hard to understand my view that this was so. Death in her end came without pause for reflection. Ronald had some time to reflect, and I don't know how it went for the family. I suspect though he was more inclined to follow Dylan Thomas' famous advice: 'Do not go gentle into that good night, Old age should burn and rave at close of day; Rage, rage against the dying of the light.'

Thomas' father became soft and gentle in his last years: Thomas apparently hadn't wanted him to change. Perhaps with Ronald Kotting a reverse process came into play. His family wanted him to soften, to calm his incandescent rage. Ronald simply carried on his raging.

This picture was taken in Regents Park about 10 weeks before my mother was killed, the last time I saw her. I think she is laughing at me (I'm sitting next to her). There is a strong chance of course that she hasn't heard what I said (she was many many part deaf by this time), but in her customary manner is joining in, in any case.

Death by road accident is cruel, a gaping hole left suddenly where once a gentle, lively, smiling lady got on with her life, and was much loved for it.

And so we must on with our lives. Saddened, older, facing up to death without a god. And if we're lucky we'll come out the other side strengthened in fortitude, humbled, humanised.

Maybe it is us who have to rest in peace.

John Roseveare
December 31st 2003

50 | HOWARD SCHUMAN, Writer |

No reply

51 | NAT SAGNIT, Writer and performer |

You'll be familiar with the term esprit d'escalier. Well I'd like to propose a couple of additions to the d'escalier family. One, joie d'escalier, pertaining to the things you're glad you didn't say. The ill-considered vow, the vicious last word in an argument, the unsayable afterthought you only just suppressed. The joke whose crassness or specific-insensitivity-in-this-particular-company you grasped even as the words were forming on your lips.

Two, peur d'escalier. Meaning the fear that you'll feel esprit d'escalier unless you pile in *now* with every conceivable response to the situation in hand. I felt peur d'escalier on the Eurostar to Paris the other day. I'm six foot two and admit to the averagely tall man's pompous territoriality over his legroom. One can get white-lipped about it like certain pregnant women get about proximal smoking. As in, sorry, can't you see I'm quite tall? Move. Your. Legs. Anyway there's not much legroom in standard-class Eurostar carriages and the guy opposite me was taking liberties. My toes were at least half an inch my side of the imaginary line dividing his legroom from mine. And yet he'd insinuated his shoes *between* mine so if the floor were white and our soles inked round their perimeters we might between us have printed one of those road sign-pastiche coitus- connoting two- sets-of-feet silhouettes you get on unfunny badges and birthday cards. So for maybe twenty minutes we'd been waging a tiny war, this guy and I, undetectable to the other passengers but for the faint squeak of contending shoe leather, little nudges and shunts of refusal to budge, when he had the temerity to ask, Could you move your feet please? I mean there were no two ways about it, he was *right* over on my side. You can imagine how I felt. You can imagine the *fear* I felt at the prospect of spending all weekend, my girlfriend's special long birthday weekend, not enjoying the food and the art and the beer in small glasses, but obsessively devising withering put-downs aimed at a chickenshit middle-management footbully I'd almost certainly never see again.

So I piled in with everything. I said I bet you're a hit with the girls in accounts. I turned to the guy's neighbour, who was French, and said something like; it's this kind of pedantry and titchy-dicked little Hitlerism that the French so admire in English middle management isn't it? I suggested a link between acute sexual frustration and anxiety over the invasion of one's personal space, leaving myself open to an obvious counterattack the guy didn't make but which left him, no doubt, suffering unbearable esprit d'escalier two hours later in Gare du Nord. I tucked my feet between my arse and the seat and said. Is that better? Is it? I derogated his beard. I said I found his reading matter offensively middlebrow

and would prefer if he put it away. I insulted him so comprehensively, lost myself in such a gleefully exponential riff of defamation that the poor guy was left with nothing to do but stare at his fingertips. All he'd done was ask me to move my feet. This is the trouble with peur d'escalier. Act on it, and it can induce another potentially more painful condition, the fourth in the d'escalier family. Regret d'escalier, or the feeling you may have gone too far.

I get this habit from my father. Admittedly his preference was for the one-liner, as opposed to my lengthy improvisations, perhaps because he was born in New York and comes from a more laconic tradition. In any case, it was with a mixture of filial pride and extreme embarrassment that I bore witness to the verbal cutting-down of the girl behind the tobacco counter at Woolworth's, for example, after she'd overcharged my dad for his tin of Erinmore Mixture, then got snotty when he'd (perfectly politely) pointed it out. As I remember it went something like, With a face like that you should carry a health warning. You know the kind of thing. It wasn't like my dad was aggressive by disposition, at least not when unprovoked; there were always good grounds for an attack. It's just when a riposte was called for it was a matter of honour and/or mildly Tourettic compulsion to make it, and make it as peremptory as possible. No doubt there was an element of socially programmed male belligerence in this. Harry Shawmut, the helplessly candid narrator of Saul Bellow's short story 'Him with His Foot in His Mouth', offers ' kind of perversely happy *gaieté de coeur*… demonic inspiration' and the 'intellect of man declaring his independence from worldly power' as partial explanations for the will to offend. But in dad's case I reckon the impulse came primarily from a hysterical fear of regret, a lifelong case of peur d'escalier born of frustration with his own artistic output, his failure to achieve quite the recognition as a painter he'd aspired to, and deserved, as a young man.

I see evidence of something similar in the pictures of your dad. I have no idea what he was like or whether he judged himself a success in whatever he did but note something that reminds me very strongly of my father in the third, middle-aged picture. It's the smile, or the laugh - the big unreserved super-charismatic openness that nonetheless carries the suggestion of threat. Ferocity, or defensiveness. Maybe this is banal. Maybe if you looked at three pictures taken at similar stages of anyone's life you could trace the same sort of growing awareness, or wariness, of others, from the boy's placid inwardness, through the young man's level smile, to the expectation of difficulty, of contention, in the middle-aged man's slightly averted gaze. It's just that third picture suggests an unusually conspicuous urge to be open and unreserved that looks specifically like my dad's - an urge which made his defensiveness, paradoxically, that much harder to conceal.

I'm not sure I've inherited my father's openness, or urge to be open. This might have something to do with physical bulk. Like my dad, and yours, from the look of him relative to the cars in picture two, I'm tallish, but not as big. As imposing. Or at least I don't think of my self like that. Even before he put on weight in middle age my father always seemed aware of his bulk, of how much air he displaced. Picture three suggests your dad may have been like

that. Impelled by his size to impose himself, to be present, to be noticeable. Whereas I guess my greater reserve comes from a scrawnier self-image. But I have inherited his defensiveness, his ease in taking and giving offence, his fear of regret. Hence the aria on the Eurostar. And the form of peur d'escalier I felt when my father was diagnosed with bladder cancer five years ago. He's fine now; the cancer was caught early; he underwent a relatively simple operation and so far there's been no recurrence. But this panicky presentiment of regret I felt compelled me to act. In the months following his operation I encouraged him to show his work after decades of reticence about it. In other words, if you'll forgive the headache inducing loop-the-lop, I pre-empted my regret, by helping my father to cut off his fear of regret at its source- his lack of recognition - before it was too late. Whether it'll work or not remains to be seen. In the last year, for example, he's exhibited in King's Lynn, at Sotheby's in Shrewsbury, and a gallery in West London. He's more productive than he's been in many years. His latest paintings are beautiful (and unreserved).

But whether I'll feel less regret when he goes than I would have done if I hadn't pre-empted the regret - whether regret is finite and thus reducible - I just don't know. All I know is the impulse is there. It's interesting the fourth picture, of your father in his coffin, is taken from what seems to be high up. In *Experience* Martin Amis describes 'the sense of impending levitation' he felt when his father was dying, now 'the intercessionary figure is… being effaced, and there is nobody there between you and extinction. Death is nearer, reminding you that there is much to be done… You have got work to do.' Fittingly picture four says far more about you than your father - the formal composition, the element of absurdity. It looks like a frame from one of your films. I don't know whether or not you took the picture, but I'd like to think you did, that it's your work, your dad's work being done. And I guess helping your father complete his work, aside from being an act of love and pride, is also self-interested, slate-cleaning attempt to ensure my work, when I'm older, is mine alone.

Decay is inherent in all component things!
Work out your own salvation with Diligence.
BUDDHA

62 IAIN SINCLAIR, Writer

➜

Fetch

Dear Andrew,

here is my response to your challenge, a letter. I thought, in the end, that was the only way to do it, right off, no polishing or revising, swift unmediated response - after a walk from Hackney to the coast.

Please feel free to use it in any way you like. My four images (which don't have to go with the text) are from the walk.

I'm sending an invite to a show Emma Matthews is having next week, painted memory-pulls from film. Emma used to work as an editor (a good one) and remembers being in the next room, at the time of *Gallivant*.

With best wishes,

Iain Sinclair

FETCH

For Andrew Kötting

'When your daddy was a little girl, we used to fetch him down here.'

So fetch him now, whoever he is, wherever, which daddy. Faces migrate along sympathetic contours, temperatures of memory. Lazy souls drift seaward towards biscuit-tins with newspaper cuttings, murders, suicides, marine exile. Vampire hunters with their black bags and Victorian estate agents with Kodak cameras and peepholes. Everything slides, out of London clay, sparkling chalk, clear flowing reaches, watercress bed, into greensand, salt and shingle. Fetch him. Water hinge. Fetch him to a steep beach of smooth, sharp stones. Exhibits that defy geological classification. Time, no time. A letter to a dead man.

I know nothing about the subject of these portraits – and his son, obliquely, through films, watched more often in my own sitting-room than the cinema (they are elusive, not around when you want them). My evidence then? The opening of *Gallivant* and a block of four soft-grey photographs. A car with the number plate MU- indicating membership f a secret society? ('Pop music's most esoteric creations: Zodiac mindwarp and the Love Reaction and the Justified Ancients of Mu Mu…') An initiate child who might be the future director? Photo 3, man closest to my own age (trapped between laughter and rigor mortis), is the one on which I'll concentrate.

I declined an offer to look at my own father, laid out, pre-incineration, preferring to remember him alive, moving, but now his face is always here, in coloured snap shots, the death-fix of chemicals and held light: I am impersonating him. The doctor. My involuntary gestures. Clasped hands. Angle of head. For a short time. Then darkness. And the choice will come around again: my son remembering his grandfather.

Bexhill and the De La Warr pavilion seemed to be the right starting place: grandmother, granddaughter, deck chairs, brass band. *'We are about to embark on a journey.'* Learning to forget, full to overflowing, learning to inhibit conditioned reflexes: Bexhill is where the dead come, at ease with themselves, their wardrobe in charity shops. Waiting for clearance. A benevolent version of the Purgatorio at the end of Jim Thompson's *The Getaway* (not Peckinpah's, he opted for hell without the detours).

I set out from Hackney, checking cellophane flowers wrapped around rough concrete posts, notices stapled to trees. I compared the lost animals with my strip of monochrome portraits. The narrative of a life in four photographs: serious (inscrutable) child, proud father in blazer, amused (terrified) citizen, deadman (as icon). I found water and followed it: Grand Union Canal, Thames (ferry to Hilton Hotel). Christopher Marlowe's memorial slab ('Cut is the branch that might have grown straight…'), River Darent to Palmer's Shoreham. Held up once: Prince Charles and motorcade visiting a heritaged sewage plant.

Across the High Weald, orchards, windfall, scarlet carpet, pick your own or leave it to the economic immigrants. English Arcadia. Many notices on the track. And, nearer to the sea, photos of the lost vanished, pained, buried. Rewards offered.

The 'middle-aged man', laughing, is he on a boat? He's got his muffler. And we can assume that his son took the portrait, an outing?

In Bexhill there are many men hovering between photos 3 and 4, between the scream of recognition in the joy of the present moment and the long tranquillity of the wooden bed (propped up like a Mexican bandit) waiting for the day of the dead.

Everyone here has been downloaded from a photocopy nailed to a tree, wired to a lamppost. This is where they wait, the fetches, the Undead – moving on rails, crooked in empty deckchairs. Soon we will all be required to carry identity cards, portraits made by strangers, names, dates/ the unforgotten as the unrequired.

The greatest fear, for all, is that there is no way, even walking won't do it, to halt this progression between images, the stills that flick into the film of life: the smart boy who is forever fixed (tie, jacket, haircut) is also and has been, and knows it, the painted stiff. It is the same mouth. From which breath leaks. The same eyes. From which light declines. Life happens, when it happens, in narrow white columns between images.

Silence.

Car, boat, box.
Life as a project.
Detective story. Field report. Fable.

Erase the human presence and the photographs hold their interest:

1. A boys jacket.
2. Cars parked outside a European building. (Vehicles, number plates, heraldic mural, columns of an arcade.) This is not Bexhill, an earlier life. A young father, angular with potentialities.
3. A section of boat, a misty jetty.
4. The cross and coffin.

The story has a clear trajectory, already we know too much of this man, the dignity of a life in it's free-falling predestination. Follow the wavy line of those elevated eyebrows and a small possession occurs. I don't know what happened, but the spirit explodes from that open mouth. The box-boat slide into an ocean of flame. The man wakes.

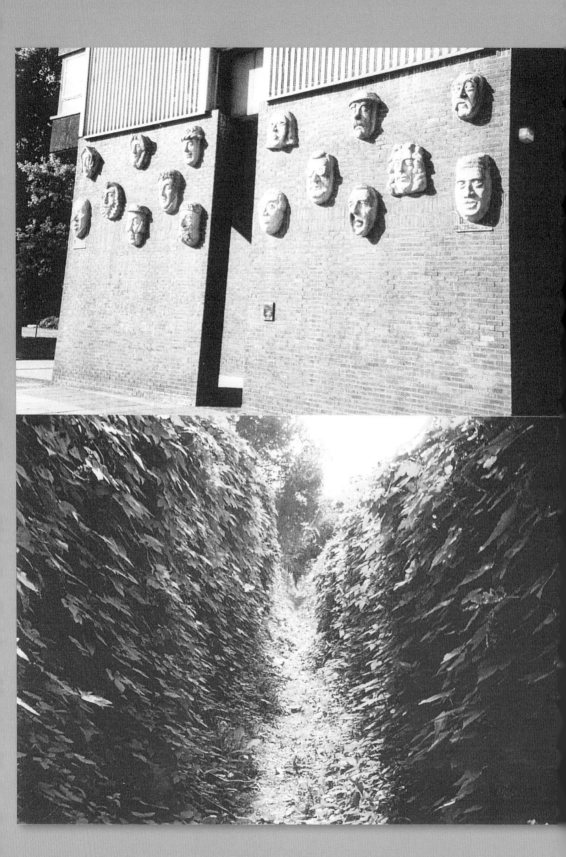

53 | KERRI SHARP, Writer |

No reply

54 | KIKI SMITH, Artist |

No reply

55 | NICK GORDON SMITH, Film-maker and director of photography |

My dear Andrew,

Sorry for delay but my secretary managed to hide your invitation under a pile of papers

Much love Nick

Your dad was a Proud Dad. I met him once many years ago, I don't remember much about him except that he was a big man and had big hands, he was like a big grizzly bear. Like many other men, my dad included, he had a favourite comfy chair that he sat in when he needed to relax. The chair was really 'his' chair, if someone else were to sit in it they could never get comfortable because they knew, deep down, they were usurping 'his' chair, his throne. They would always be looking over their shoulder to make sure he wasn't right that moment heading for his chair and if he was to see you in 'his' chair that would make you almost like a traitor and you would have to jump up like you had sat on a red hot poker and go and sit somewhere else. But I've been told that when his kids felt like rebellion they would sit in 'his' chair and feign ignorance in the fact that it was 'his' chair and they would sit in that chair for the sake of it, even if they were bored up to their armpits of the goings on in that front room just so that they could annoy him. His chair was in front of the television and he also took control of the television remote, its buttons were all rubbed clear of numbers by constant use, the remote would rest in his big hands, his thumb above the buttons in constant readiness to change programmes or find information on ceefax..

Your Dad, when he was a kid, had big ears that stuck out like sails but when he was a middle-aged man his ears had become more streamlined but had grown larger, ears never stop growing until you die. When your dad died his ears stopped growing and in the little picture of him in his coffin I cannot see his ears.

Your Dad had a lot of children, he worked very hard to support those children, especially the boys who would constantly get into scraps and he had to spend a lot of time making sure they reached their potential.

Your Dad would have said 'put your head down and work and you will get the fruits of your labour'. He still had a bit of German in him.

Your Dad inherited an import/export business from his dad who imported buttons and various knick-knacks from the Wuppertal region of Germany. These buttons and things were finished off and polished to a high standard in this country before he exported them all over the world especially to the USA.

Your dad would have liked to cuddle his kids more but as his kids grew up they got harder and harder to cuddle so he found happiness in cuddling his grandchildren.

Your Dad had catholic principles.

Your Dad's greatest fear was being buried alive on the pronouncement of being dead by a second rate doctor.

I'd love to rise from the grave every ten years or so and go buy a few newspapers. Ghostly pale, sliding silently along the walls, my papers under my arm, I'd return to the cemetery and read about all the disasters in the world before falling back to sleep, safe and secure in my tomb.

LUIS BUNUEL *My Last Breath*

Dear Andrew –

Please find enclosed a brief piece – I hope that it is what you want? It took me a long time to put together and it then seemed so short, but it did bring back lots of memories whilst doing it.

Hope that you are well and doing lots of exciting things –

Best wishes to you and your family

Love

Frank.

Over a period of seven or eight years I used to meet Mr Kötting about three or four times a year. Our meetings were always brief, limited to about ten or fifteen minutes. A bell would ring then he and Mrs Kötting would say goodbye and move on; for these occasions were 'Parents Evenings'. I taught two of his sons art.

These occasions were always enjoyable, he always greeted me with a huge grin and instead of a handshake, a bear hug. He would get down to basics straight away - Were his sons working hard? Making enough progress? Was the work done on time? Were they giving me any problems? He expected me to be honest with him for unlike a lot of his parents, e realised his sons were not always angels. Having got all of that out of the way it was my turn to be examined. Was I still painting? Had I any exhibitions planned? Where was I going for my next holiday? - For such a short period he managed to cover a great deal.

Like most schoolboys, Andrew and Jonathan managed to break a fair number of school rules, and when caught appropriate punishments were handed out. The School's actions were always fully supported by Mr Kötting, except on one famous occasion.

Andrew was a member of the school's 1st XV Rugby team, which had been on a tour of the West Country playing against other public school teams, and they had been very successful winning all their matches. The tour ended in a very pretty and quiet small West Country town - it was Saturday night and a time to celebrate; but the celebration got a little rowdy, for some reason the team, all Sixth formers and Prefects decided to celebrate in the nude. The local inhabitants were not amused by the sight of so much young male naked flesh running up and down their ancient High Street. The police were called and the whole team ended up clothe less in the local Police Station.

The Headmaster on hearing the news was not 'best pleased', in fact he exploded. All the Prefects were demoted and everyone lost their Sixth form privileges. Mr Kötting was also not 'best pleased'. But his anger was directed towards the Headmaster, he felt that this was a case of high spirits going slightly over the top but no more than that and that the Headmaster had over reacted. His son had just participated in a highly successful sporting event and should be rewarded not punished.

Mr Kötting came to school to confront the Headmaster. The noise from his study was alarming, several members of staff stood outside wondering whether they should go in, and who should they rescue? Suddenly the door opened both men were smiling, a compromise had been reached, Mr Kötting had made his point.

As Andrew and Jonathan's school careers were coming to an end it was obvious that both their futures lay in the world of Art and discussions where focused on what Art College would be most appropriate for their individual talents. Mr Kötting listened to my suggestions, they were all in London, he thought for a moment and said Are there any Art colleges in Scotland?' I was slightly surprised, taken off guard thought quickly - There is the Glasgow School of Art' I replied. Oh no' he said I was thinking of somewhere further north than that. At this point Mrs Kötting interrupted You see he is longing to use the bathroom for longer than five minutes at a time without being interrupted, and this is the solution he can think of.' Unfortunately for Mr & Mrs Kötting both sons did their Art education in London.

I last met Mr Kötting some years after his sons had left school, this was some time in September 1996. I was having an exhibition of my paintings at a city of London Church, All Hallows by the Tower. At the private view many friends, ex colleagues , ex pupils and their parents turned up, including Mr & Mrs Kötting. He was in great form, he knew all the past pupils and remembered them by name. He was one of the last people to leave.

I got his usual warm bear hug, his sincere warm smile as we said goodbye for the last time.

My Grandfather 'Papa' Kötting with a bear, somewhere in the north sea 1944-1945

My Grandfather 'Papa' Kötting with a bear, and his 4 children
somewhere in Germany, 1950-1951

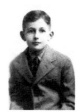
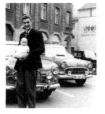
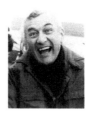
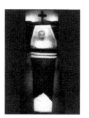

a boy a young man a middle-aged man an older man (dead)

57 | DUDLEY SUTTON, Actor |

Looks a bit of a lad
Your Dad
Not bad
Bit of a cad?
Never by Gad!

I'd like to add
My Dad
Made me mad
For which I am glad
Thanks Dad!

THE PHOTOGRAPHS

Every photograph requires the presence of the photographer.
These do not look like delayed time shots.

1. I love the look of eagerness of him as a boy. Eagerness fired by dreams? How many dreams fulfilled? How many unrealised?

2. Is he weighing his baby? Perhaps. I would feel safe in those huge hands.

3. He looks manic or full or fun. All if necessary or none: just pulling a face to screw up the shot.

4. Peace at last! And a clean bib. The lighting is very good. A Ken Russell shot if ever there was one. Or a Kötting. And clean sheets!

A good old dad, just like you.

Love Dudley.

**And my father was dead
Or he was the preecher dressed
In a tall black hat
And I was knocking his teeth
Out with a brass paper weight**

BILLY CHILDISH *At my funeral*

58 | HEILCO VAN DER PLOEUG, Singer songwriter, actor, impresario and schoolboy friend

I remember Ronald somewhere in between a young man and a middle-aged man. He was a Bigman, seriously comfortable in leisure–wear, because that's all I ever saw him in. Always had a top of the range rover or two in the drive which I had the privilege of washing on a few occasions, on crisp Sunday mornings having been to the Bull in Chislehurst with Andrew and all the chums. I remember seeing some dirty magazines Andrew found which he said were his dads! They were all brimming with huge cocks and glassy fannies, black and white pictures of mostly the girls and boys next doors sort of models. They were all German too. Which reminds me again he had a loud German Sid James laugh. He was always odd because whatever he was laughing at didn't seem to be that funny. Now I'm older I laugh quite loudly too.

A bit more?
Sorry I've forgotten.
Anyone for MaiTai?
Love Heilco
Xx

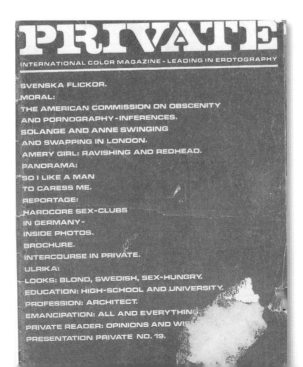

59 JANNI VISMAN, Writer

A MAN HAS DIED

A man has died. His son has sent me four pictures that show him at various stages in his life. The last picture shows him dead.

In the letter that came with the pictures, his son invites me to write about the man his father was from what I can see.

A boy. A young man. A middle aged man. A dead man.

The things his son has told me about him over the years of our friendship, I would not guess by looking at the pictures. His face is friendly.

It would be easier to make things up if he were a complete stranger. If I had been told nothing. If I make things up then his son could have a different father. It seems he was not happy with the one he had. I understand.

It is a shame none of the pictures show his hands more clearly. He was a man who got pleasure from doing embroidery. I have seen some of the embroideries he made, framed and hanging in his son's home. The images he chose to sew were pretty. They verged on the sentimental. They are carefully constructed, neat and delicate. They signify he was good with his hands. They signify he was sensitive. A man who sews must be sensitive.

I have been told his son's partner once called him 'a cunt' over a Sunday lunch because of the extreme views he held. He was a man who apparently liked to opine. I have noticed this runs in the family. Those that I have met. I understand he was of German extraction.

I look at the photograph that shows him holding a child. He is smiling. Proud. His son is one of four sons. There is a daughter too. He is smiling in all the pictures, except in the one where he is dead. I know he was a large man; he stood a head above others. A large man leaves a large gap. I got the impression he loved all his grandchildren dearly. He would make embroideries from their drawings.

He would thank the parents, his children, for bringing his grandchildren into the world, in satin stitch.

For Leila with my love and thanks for bringing Eden into my life. Taken from a 1998 drawing by Eden and now worked by her Grandad Ronald Kötting.

March 1

Head of thick hair; slight jutting forehead; prominent but well proportioned nose, ears that do not lay flush, strong jaw line, deep-set eyes, a gaze that holds in it the desire to be in control. Or the need. He has passed on these features to his son. As well as a not too perfect heart. His son has check-ups regularly.

I met him only the once. He was wearing a black leather car coat. It creaked as he extended his hand towards mine. He repeated my name as his son introduced me. I do not recall the quality of his handshake. His name was Reginald, I think. 'Call me, Reg.' His mouth was thin but his smile was charming. His voice was like his son's. Gruff, but soft, a hint of a lisp on C's and S's . 'W's' sometimes confused with 'V's. South East London accent.

I look at the picture that shows him dead. I am glad it is a small picture. (It is approximately five centimetres by three.) He is laid out in his coffin. It is taken from above. His face is not clearly distinguishable in the haze of computer print out. This does not diminish the sense I have that it is a violation to see him dead. Without his permission. Death, like sex is a private and personal matter.

I wonder why his son wants others to see his father dead. It is as if it is an announcement of freedom. Or a posthumous humiliation. The final nail in the coffin. I realize it is also very tender. This wanting to share. It is also funny. Other people send photographs of their new-born babies. He sends a picture of his dead dad. It is a tribute and a trial.

Reginald is smiling in all the photographs except of the one of him dead. In the one that shows him as a boy the smile is reticent. I imagine he had a good sense of humour. But I imagine it was at other people's expense. I think he suffered as a child and later was cruel through bad jokes and criticism. I imagine he was a proud man to whom a lot had to be proved.

I wonder how he must have felt as an ill old man being stripped naked and bathed by two grown sons. They had stripped him naked then they had stripped naked and got into the bath with him and washed him head to foot. One of the sons was the one who sent the pictures. The other was the one who had once, I had been told, when he was in his twenties, dropped his trousers and defecated in his father's living room, in front of him. It was an act of defiance. Something the father had said or done. It was indicated he had a propensity for tyranny. It must have been a tight squeeze in the bath. It must have been a tight squeeze in that family. One father. Four sons. I wonder how many times fists were clenched. Released eventually by placatory female words.

I think of the first time his son ever mentioned his father to me, on a hot day, in a dark film edit room. We had not known each other long. He had come to visit and see what I was doing. Sitting next to me, his attention was taken by the many discarded paper wrappers of my Juicy Fruit chewing gum. (You were not allowed to smoke in the edit room.) He lined them up horizontally end-to-end on the table. 'My dad used to make belts from these,' he said. 'I used to have a belt like that,' I told him.

The paper wrappers came without the gum, in large boxes; all the children would help thread them on. He and his siblings sat in a row at a long table. I recall feeling a strange connection to his family, thinking of their hands making the belt I used to wear. This link felt oddly important at the time. He told me his father was in the business of producing machine embroidered merchant labels that were sewed into clothes.

The room smelt of the plastic sweetness of chewing gum and the chemical sweetness of newly processed film. He pushed the lever on the Steenbeck; the film clicked clicked through, the sprockets were still tight. We turned the light off and watched the film.

A son and then the daughter would take over the business. Later still the business would fold. I saw all the boxes full of labels; they were being stored at his son's house. Thousands of labels all saying the same thing, which had nowhere to go. Nothing to attach to. I cannot remember what they said. The redundancy of the things struck me. It was not long after he had died.

I thought how strange it was that a man who had come to learn and like to embroider had initially run a business that sewed names and pictures by machine. As if he had not been able to admit his pleasure of sewing until very late. As if he had been putting it off all his life. Or had kept it once removed. I think as a child he was not allowed to be who he wanted to be. I think maybe he harboured a desire to be an artist. Three of his four sons are artists. The two other siblings are the ones who took over the business. They are shrewd, as he must have been.

When I met him, I should have asked him about the belts he used to make. I should have told him I used to wear one of his belts as I had told his son. The belts were thin, encased in clear laminate. I recall I wore mine with my Wrangler jeans. I was wearing it the day I lost my virginity. I don't remember if I told his son this. I don't think I would have told his father.

His son showed me the copies of the magazines that were found when cupboards were cleared after his father died. They were circa mid to late 1970's, the same time period as the chewing gum wrapper belts. The pictures showed rooms decorated in brown and orange. Mainly bedrooms. On fake fur bedspreads, white people rendered pink yellow by bad colour reproduction, were having hard-core sex. The women had hair do's that were as stiff as their partners' apparatus.

He had showed the magazines - flicking through them, pausing on the most explicit, lingering on the blow jobs and cunnilingus - with a little too much enthusiasm, to shock perhaps but strangely to show his shock and perhaps the shame of the discovery. There was some pride there too. I did not look away; my father used to take Mayfair, sometimes Penthouse. A little classier, a little more Vaseline on the lenses - as opposed to the genitals – fingers tantalizingly placed – as opposed to being shown inserted entering a particular orifice. His son showed the magazines to my husband and myself, while in

the background were the sounds of pasta boiling and his partner telling him to put the magazines away. We had been invited for lunch. Over lunch (pasta served with smoked salmon and cream), I told how my father would cut out the pictures of the women he particularly liked and stick them to the inside door of his, or my mother's, wardrobe. Perhaps I was competing. Maybe I should have asked if his father shouted louder than mine...if there could have been a measure.

His father and my father were born in the same year. 1935. They endured post war austerity. Enjoyed the 1960's and 1970's. Weathered the 1980's. My father had been a beatnik and then a hippy. His father looks like he had been neither, but I suspect there was a time he wore winkle pickers and drainpipe jeans and danced to rock'n'roll, a fag pointed back in a cupped hand.

I have seen pictures of my father as a boy and he has the same reticent smile as my friend's father in the photograph at the same age. There is the sense that childhood had rubbed them the wrong way. That something they had wanted was not forthcoming. That there was already some sort of struggle within. Masculinity. Sexuality. Their place in the world. The worry of what the world expected from them. The fear of failure. It seems that it was already all there waiting to be dragged out. Dragging at them. And the remedy seemed to be to develop ways to keep things in control. Following traced lines with thread. Following the modus operandi of a martial art. Keeping family procedure tight. Shouting. Criticism.

The love for such fathers can be very fragile...

I only met him once. When his son was still a student, at an end of year show. All his family were there, scattered in the busy gathering. He arrived late. When he walked into the room I noticed how each of his children broke from their respective conversations. Before they had even seen him. As if they each registered the pulse of his energy. As if it resonated in themselves. His children, his own personal radars. Or perhaps they were just waiting. Expectant. His children returned to their conversations, sipped their drinks.

When their eyes had met his, they had smiled and I recognized love. But I recognized also a certain fear combined with contempt and the process of psychic withdrawal. The wanting and not wanting to cut the ties that bind. These things are not easily noticed. Except by those who know the same. This knowing I sensed between myself and his son from the first day we met. Unspoken, more a vibration. The mark of a father who has caused much confusion. A frequency that exists at gene level. That began as the reticent smile of a young boy unable to know their place. I knew we could sing the same song. I knew we held the same position. Trying to understand why in order to promote sympathy. The similarity of experience brought a trust. For our friendship, I have to thank in some part his father...and mine.

That night at the end of year student show, when his father had walked in late, his mother had been there too. She had turned and smiled as her husband then

walked in. She went to greet him. Together, they walked to where the son, whose show it was, was standing. I was standing beside him and his partner. I was introduced. I said 'Pleased to meet you,' and I made my goodbyes; a friend was calling me over. He put his arm around his wife as I left and kissed her cheek. I recognized she would love him whatever. Whenever. She would forgive him always, as is the nature of lovers.

I think it takes longer for children to forgive. Maybe this is what his son is doing. Maybe that is what this is all about.

A son makes a project of his dead dad. It will be a while until he rests in peace. The king is dead. Long live the king.

An observation which to my great regret, is always verifiable: only those are happy that never think, or rather, who only think about life's bare necessities, and to think about such things means not to think at all. True thinking resembles a demon who muddies the spring of life or a sickness which corrupts its root. To think all the time, to raise questions, to doubt your own destiny, to feel the weariness of living, to be worn out to the point of exhaustion by thoughts and life, to leave behind you as symbols of your life's drama, a trail of smoke and blood – all this means is you are so unhappy that reflection and thinking appear as a curse causing a violent revulsion in you.

E.M.CIORAN *On the heights of despair*

60 DAN WELDON, Film producer and writer

N.B.

My dad is also dead.
His name was Ron too...
not just a pretty coincidence
I didn't really know him either
and I see him in me each passing year since
he fell off. It doesn't make any sense, and that's
the point. It doesn't make any sense... it's not supposed to.

I miss him, miss the big, black, laughing silence.
with my Ron- if you're interested - I am certain of one fact
and let's leave it at that... he loved apples.

Plate 69: Lord Nor Nodlew

61 | FAY WELDON, Writer |

Dear Andrew,

I found this in the great New Year clearout, left unanswered at the time- I'm sorry. I hope it doesn't stir up too many memories better left undisturbed. Your Father, from the pictures, reminds me a little of Dan's dad - full of hope as a child, over sensitive, too much hurt by the world, and so prone to lashing out, frightening to a child, I imagine. Terrified of being unloved, and hopeless at making him-self loved. But then all fathers are like this, astonished to find themselves fathers at all, having to play the role of persecutor when they were born, like all children, to be the persecuted. And your father, my contemporary, was brought up in a pre-Freudian world, where there were no models for fatherhood, or any acceptable by our contemporary world.

I hope you like the Faroes. We thought it was a terrific place. Loved Gallivant. What's happening now?
Best wishes,
Fay Weldon

62 | RICHARD WENTWORTH, Artist |

No reply

63 | IAN WHITE, Artist and Writer |

No reply

64 | LOUISE K WILSON, Artist

Notes on Andrew and his Dead Dad

He seems benign. Bright and full of light as a child. A huge warm presence as a middle-aged man. But I know now he's not what he seems.

My father died over 10 years ago but we're still throwing out his belongings. At the weekend I was at my mum's and we moved some of my dad's things down from the attic. Some are still waiting for a good home to be decided on (the extensive collection of geological samples) and some are being shredded. We threw out a painting that was given to dad when he left one particular department in the MOD. It was a really horrible amateur watercolour painting; it seemed to show a warship in front of what looked like a gas terminal or shipyard. I thought it was a sad gift to give as a gesture of friendship.

What else? He obviously wanted a family, as I know you have siblings. I think. Why was the picture of him holding a baby (you?) taken in a car park? The baby (though it looks more like a doll with its outstretched inert legs) has just left the maternity ward. Mothers stayed in hospital longer then (in the late 50s?) so perhaps you, Andrew, (and I'll assume it is) had fairly recently been born.

One of my fondest memories in Russia is the aftermath of the parachute training on the zero gravity flight, just before the plane took off. You challenged me to a race to see who could put their Russian-issue heavy khaki parachute on first. I can't remember who won – I suspect it was you. It was a nice thing to do - it diffused the anxiety.

Last night I dreamt I was walking around various stationery shops looking for materials to write this with. You were following me as I trailed from shop to shop because the copy deadline had past. I can't believe that I procrastinate even in my dreams.

I'm thinking of a few other artists who have made work about their dead dads, but theirs has been very metaphorical. The animation of the dodo by Katy Shepherd (though was it actually a homage to her mother?), there's a few seconds of it – like a fragment of archive film. The black and white image of a dodo in a zoo, it's flapping its wings and looks agitated. There's an American sculptor – I can't remember his name – (I've found it, it was Allan McCollum) - he filled a vast Museum space with casts of dinosaur bones... he painted them lurid colours, but I could be wrong about that. In an interview he said he had a need to make it after the recent death of his father.

The artist Annette Robinson made a piece using inked-up rubber stamps made up from casts of animal tracks and skulls that she found in the attic – her father's natural history collection, he was an amateur enthusiast. She found them after he died.

Bones, casts, resurrections....

(A lot of artists are making work about their dead dads, if they know it or not)

In the printout I have of dead dad, the 'dead' dad is the most curious. Despite the facial hair, he looks younger than the previous picture – was that skilful work by the mortician, an effect of a bad copy or 'merciful release' as they say? Why does the coffin seem bound in rope?

Two nights ago I dreamt that we were together again for another Arts Catalyst art trip. This one was going to be even more exciting than the last one (the zero gravity flight in Moscow). This time we were all going up into Space and then it transpired we were also going to land on the Moon. Already everyone had their art projects organised. I was getting very nervous. It turned out that one of the art projects – arranged by some cosmonauts – was going to focus on a large sailing ship-size mast that was going to be implanted into the lunar surface. We were told that when we were on the moon, we'd each have to grab hold of it and swing round – like some sort of playground ride – except we'd reach speeds of 200 miles an hour. I think I decided to back out of the trip in the end – I didn't think we'd been fully briefed on the effects of weightlessness and the hazards of Space flight.

You told me ages ago that you were going to make an inflatable sculpture of your dead dad and take him travelling, to a remote island in Scotland I think. Was it your experience in zero gravity that made you want to make your dead dad weightless?

Louise x

When they create images of death, do they really shatter reality or simply show that today reality, including death, is dominated by images?
BENJAMIN NOYS *The Culture of Death*

65 | BEN WOOLFORD, Film producer, musician and ex car dealer

A boy in a flannel suit, grey, and so went to a good school when all he wanted was a Wagon Wheel.

A young man holds his first child, Peter, proud of having taken the baby to Germany in his Ford Zephyr.

A middle-aged man has lost his repose; he contorts his face for the camera. This is the dark time Andrew, when you went up the tree and violence was melted out, Anger and Confusion.

An old man (much loved), forgiven, reconciled, heard his son speak to him again and bred his grand-daughter, then died so he could be tweaked, recorded and photographed.

Me, I never knew him and he never even wrote me a letter, I was told he was a businessman, but I don't think that was what he wanted. I have met his wife and one, two, three, four, five of his children. I don't know if he wanted so many. I was told he was angry, especially with his wife. This was unfair because it wasn't her fault.

"How can I run a business, pay the bills with FIVE kids running around!?" ...slap!...-Listen mate, you started it - On the other hand, stress is a terrible thing and you can't always blame the stressee. He wanted the two things he feared most, freedom and chocolate, so spending more and more time in the garden was a good compromise, especially when he started to know (before anyone else) that his heart would stop.

I was on an unnecessary, meandering excursion through the Pevensey Levels, when I saw a familiar corner, a farm on a hill, an old car crash in slow motion into a bank. So I phoned you up and you told me you were very moved because you'd made up with him, he was responding to Eden, something had happened. For ages you thought he would die soon. That was about 199 (?).

This is 2003
xxx
Ben.

Don't you think you could have worked just as well from a box of photos that someone had brought you, from a family you didn't know, so that they would have been providing you with the ingredients of a fiction?

FRANK VENAILLE TO GEORGES PEREC IN *The Work of Memory*

What is said endures.
There's nothing in life that's less real for having been well described.

FERNANDO PESSOA *The book of Disquiet*

CHAPTER FIVE

*Of making an effigy of my deadad,
discovering a new family in the Faroe islands and
then making a pilgrimage with both my deadad and
my deadad's deadad to places of significance*

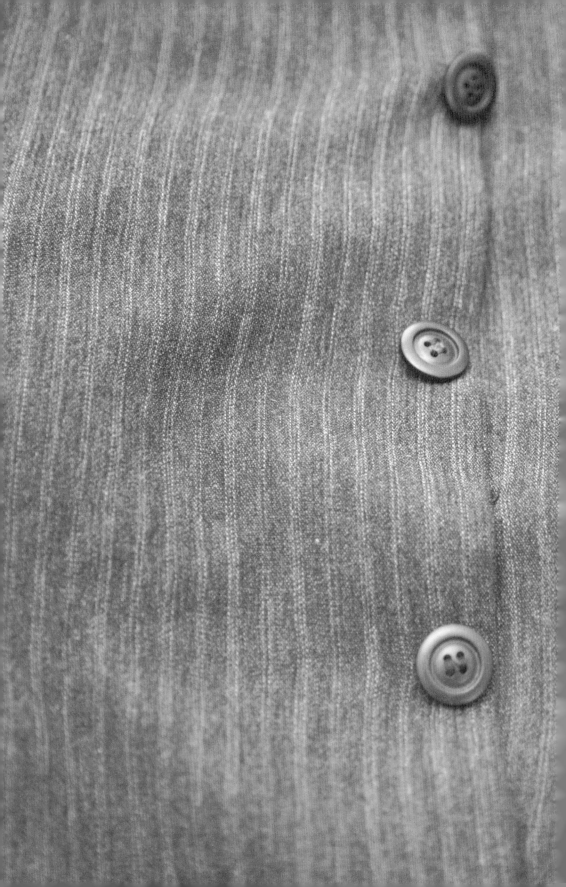

So I thought it might be a good idea to make an inflatable sculpture of my **deadad** and take him on a journey to areas of outstanding personal significance to either his life or mine. It would be an excuse to spend some time together and mull over the rage that I could still feel towards him.

Born out of a mutual misunderstanding and some horrific Rememberings

We might visit

The house he grew up in

*The hous*e I grew up in

The graveyard in which our German ancestors were buried

The graveyard in which his ashes were buried

The church in which he pulled bells with my mother when they were younger

And

The beach to which I lost my virginity when I was younger

I wrote on

Remembering

Remembering is a malady for which forgetting is the cure

Remembering wouldn't be remembering if it weren't for forgetting

What comes by remembering goes by the forgetting

Small forgettings make big rememberings

Remembering adds to our pains, forgetting to our pleasures

Remembering delivers us from forgetting, but who will deliver us from remembering?

Happiness is therefore in forgetting, not remembering?

Happiness is thus remembering the forgetting.

(Inspired by a Remembrance)

And for those who can't remember, remember that remembrance is a thing of the past.

Of his Being Dead, I should explain myself:

(My Deadad is to be catalyst and cipher. He will lead me towards notions of *implied narrative* within the context of an expanded cinematic experience. To this end I will explore my Deadad's backstory; I will be rooting around in the mire of mnemonic.)

A mind at making him a familiar.
Of inflating him to the size of an ego:

> From: Advanced Promotional Advertising [apacorp@coqui.net]
> Sent: 19 February 2002 14:17
> To: badbloodandsibyl@
> Subject: Inflatable
>
> Hello Andrew,
>
> Thanks for your email but unfortunately I cannot help you. While we do sell inflatables, the manufacturer does not make replicas of people due to the incredible work that this would entail. We make replicas of products such as cans, jars, containers of sort, credit cards, phone, pagers, etc, but people have many small details that simply they cannot do well with the equipment and technology they have.
>
> Sorry and best regards,
>
> Juan

There was a cheap option

www.a1partysupply.com
1-888-716-5822

 help

ordering feedback contact about us

Product Details

Back to products

Categories

Home Page
Action Figures
Bathroom Items
Boobie Related
Clothes
Condoms
Decor
Dolls
Edibles
Food And Drink Related
Gag Gifts
Games
Gifts For Couples
· **Inflatable Dolls**·
Jewelery/Keychains
Office Supplies
Party Planning
Penis Related
Toys

The over 18 products

Humor - The Guy Code

Bookmark Us!

**Alphabetical
product list**

Site Map

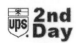
eCheck

UPS **2nd Day**

Check if all words
must be present

SEARCH

Top Selling
Products

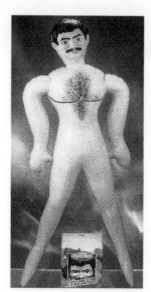

John Doll

Price **$19.95 USD**

(add to cart) (view cart)

Tell a friend
about this

But Rick Dennis got back to me:

From: Rick Dennis [Rick@woewhatonearth.com]
Sent: 13 March 2002 15:07
To: badbloodandsibyl@ukonline.co.uk
Subject: RE: inflatable deadad

Hello again Andrew, I discussed your situation with Rodney, our sales manager, and explained that it was an artistic endeavor, which seemed to have a warming effect, because he agreed to reduce your investment. I hope this is an acceptable compromise Andrew, best of luck with your time lapses.
Sincerely
Rick
>>> "Badbloodandsibyl"> 03/12/02 12:54PM >>>

Rick
i'll set to work on the vector file(s),
Yours
andrew Kotting

The fluidity of the remembrance and the damned imposition of autobiography.

The voice of reason versus the voices of memory:

I chose a photograph of his slightly manic happymad face, my sister had taken of him in the Faroe Islands, many years earlier. It was the same image that I had sent out as part of *'The Invitation to Write'* project.

His face haunted me and I re remembered the voice that had battered me.

Us.

All of us.

I felt the past closing in around
me like a fog and it was comforting.

From children towards fathers, it is rather respect. Friendship feeds on communication, which cannot exist between them because of their too great inequality, and might perhaps interfere with the duties of nature. For neither can all the secret thoughts of fathers be communicated to children, lest this beget an unbecoming intimacy, nor could the admonitions and corrections, which are one of the chief duties of friendship, be administered by children to fathers. There have been nations where by custom the children killed their fathers, and others where the fathers killed their children, to avoid the interference that they can sometimes cause each other; and by nature the one depends on the destruction of the other.

MICHEL DE MONTAIGNE *That to philosophise is to learn to die*

From: Rick Dennis [Rick@woewhatonearth]
Sent: 21 August 2002 21:06
To: badbloodandsibyl
Subject: Re: inflatable deaddad

Hello Andrew, I hope all is well with you and your deaddad inflatable, be sure to check with me if you have any problems, I have answeres, just call me "answer central". Hope all is well with you and yours, drop me a line sometime, just to keep in touch.
Sincerely
Rick Dennis

What On Earth Inflatables Inc.

800-248-4823

>>> "Badbloodandsibyl" 03/11/02 02:48AM >>>

Dear Rick

it was good to talk to you earlier today on the phone from London. I attach two versions of the inflatable that i would like an estimate on. I am very flexible in terms of what might be easiest ie if it is simpler to make a very straightforward model of the human form without clothes then this is fine, or if a model with the suit, then this is also fine. If it is cheaper/easier with one or two colours, say flesh colour and black then this also fine. The size is also contingent; twice 'normal' size is good but not an imperative.

The pose (which is vaguely based on Michaelangelo's DAVID would be nice but is also dependent on what you might advise me.

Many thanks for taking the time
Andrew Kotting
telephone : 0208 691 7262

ps. if you could also let me know the average turn aroubnd then this would be useful.

Then out of the blue as if from nowhere a letter arrives from the Faroe Islands. It is addressed to all Köttings listed in the phone book and living in the UK. There are not many, 4 to be precise.

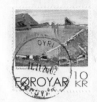

ANDREW KOTTING
52 BENCE HOUSE
PEPYS ESTATE
LONDON
SE 8 5RU
ENGLAND

Dear mrs./sir.

I, undersigned am in search of relatives and found your name in a London area telephonedirectory.

My name is Walther Emil (Kötting) Thomassen, born on 18. of January 1946.

In documents left to me after my mother's (Óluva Thomassen) death, in Aug. 2000. I am the son of an Emil Walter Kötting, born on 14. of Feburary 1906 in Langerfeld, Schwelm, Germany. His last known address is, 175 Regent Street, London W.1. He was an english corporal R.A.S.C. no. 252297 serving in the Faroe Islands from 1944 to 1945 when he was recalled back to England.

If You have any knowledge of this man or his relatives, I would be very pleased if You could write me a letter at this following address.

Yours sinserly.

<div style="text-align:center">

Walther E. Thomassen
Fo-435 Streymnes
Faroe Islands

</div>

A flurry of family activity.

The younger members were enthralled. I wrote him a letter, my mother was all a dither and my deadad's brother replied rather formally a lot later. Others wished to god that things had been kept under the covers.

There was also another from a family interloper:

London, 3.2.2002

Dear Mr. Kötting,

thank you for your very interesting letter – but I am afraid, I can't help you:
My family doesn't have any connections with Emil Walter Kötting, born in Schwelm in 1906
– as far as we know.

I, myself, am German – I moved to London only one and a half years ago. I work here as a
foreign radio correspondent for the German Radio.
My father was born in the North of Germany, a small town near Meppen, called Twist.

None of my relatives has ever lived in Britain before I moved to the UK .

I know that a film director with the name Andrew Kötting lives in the UK. I have never met
him but I think he lived in the UK for a much longer time than me.

I am very sorry that I can't help you.
Good luck!

Kind regards

Eva Kötting

(Eva Kötting)

The Faroes

An old Faroese legend has it that when the earth was being built, the foreman in charge of works stopped to clean his nails and what was discarded plopped into the North Atlantic and this became the Faroe Islands.

Faroe Islands - *Manhood* - Faroese

The Faroe Islands - *Sheep Islands* - Danish

The Faroe Islands - *Far Islands* - Gaelic

They are far out on their own and there are sheep everywhere.

They hunt whale and this upsets the sensibilities of a lot of Babylonians.

There are over 20 of them of which 17 are inhabited.

Their national emblem is the puffin, which they also eat and this also upsets the sensibilities of the Babylonians.

They wind dry sheep and fish on their washing lines, which stinks.

They cover an area of over 540 square miles and lie 260 miles north of Thurso

They are administered by Denmark and with a population the same size as that seen at Old Trafford on a Saturday?

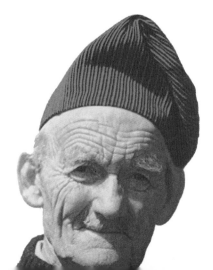

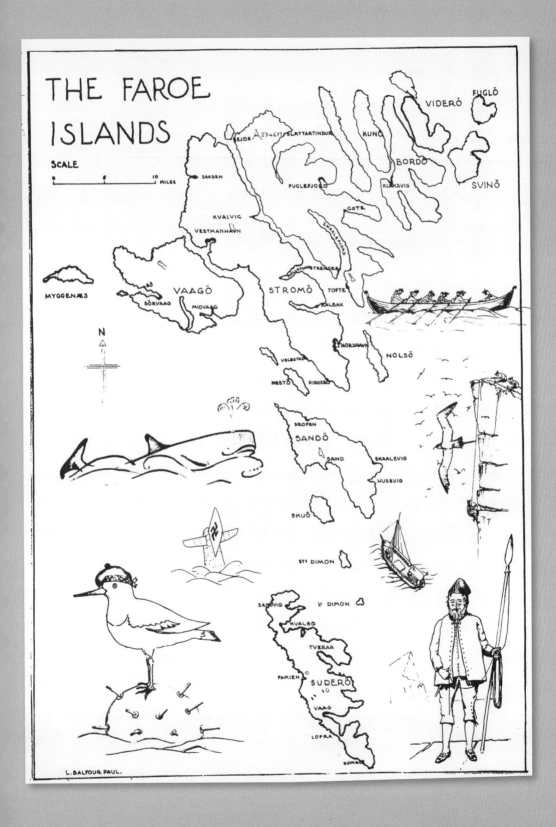

My Deadad's deadad – Granddad or *'Papa'* - was stationed up there during the Second World War. Originally from Wuppertal in Germany he had left and made a life for himself in London as a businessman. He wore a bowler hat, carried a brolley and supported Charlton Athletic football club. And everyone loved him dearly, with his thick German accent and his laid back generosity. He served for the British Army and I was left wondering about his infidelity to a wife and family.

That's him with me.

Sometime in late
spring early summer of 1945 Emil
Walter **Kötting** (Papa)
begot a son Emil **Walther** with Oluva **Thomassen**
who was born on18 January 1946.
Oluva deemed it better that her sister bring him up
on the other side of the mountain in order that she might get on with her own life
without the stigma of Papa's son.
Later Emil Walther **Thomassen** who is known as **Walther,** married
Marjun Zachariasen and begot
Gisleyg
a girl
Lena
a girl
Bogi a boy
And
Zacharias and
Ola-Jakup twin boys.

Walther now has at least seven grandchildren and *Papa's* legacy moves along.
Him and his laid back generosity.

Dear Andrew.

You are welcome and vit look happely to see you.
You are eapal to rent at car on the Faroes, but that
we can talk about when you arrive. You can always rent one from os becouse
we have two and my work car.

You ask about the weather in April it is some times good and some times not,
but I can not say, becouse it chages all the time. To day is a little snow
but it is the first time in 2 months .
You most tell my what plane you are using so we can come to pick you opp.
It
takes about half an hour to drive to the airport
Best whisses to you all

Walther Thomassen

THIS A FOTOGRAF

OF MY SELF AND MY FAMILY 1997

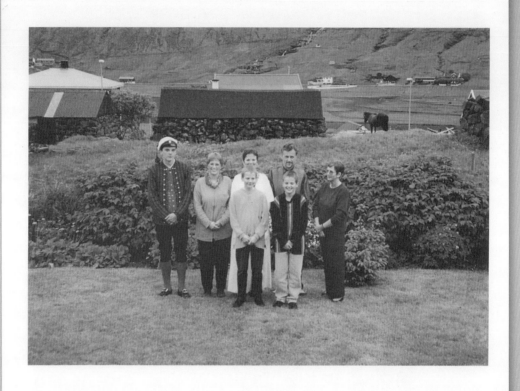

BOGI - KRISTEN - GISLEYG - LENA - MY SELF (WALTER) MARJUN
 25 32 30 56 61

 ZACHARIAS - ÚLP - JÁKUP
 17 17

So

I got back in touch with Rick Dennis @ WHATONEARTH and set to work on another inflatable effigy. My deadad's deadad was coming with me to meet the family that he must have known he had.

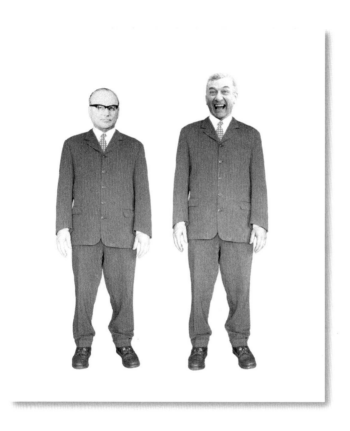

From: Rick Dennis [Rick@woewhatonearth]
Sent: 16 May 2003 20:15
To: badbloodandsibyl
Subject: RE: inflatable deadads

Andrew: They're done! They will be shipped Wednesday, it will take a couple days to arrange shipping and brokerage, which we are in the process of getting quotes for right now, and we will use your card for the balance when you email me with your OK on that. If you have a shipper of choice, let me know, otherwise we will send it the least expensive way possible. If time is short for you, we can send it express, please advise. As promised, I have attached your photos. We have a long weekend, so I hope to read your email on Tuesday. Take care.

Rick Dennis
What On Earth Inc.
800-248-4823

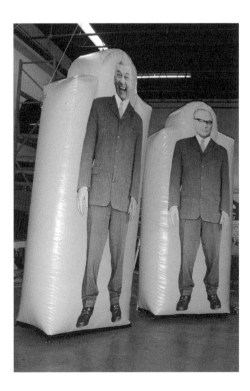

From: Rick Dennis [Rick@woewhatonearth]
Sent: 13 June 2003 19:44
To: badbloodandsibyl
Subject: Re: deadads

Fantastic! Glad to hear it, Andrew, be sure to spread the word. You can buy a transformer, in answer to your questtion. Explain that it is a North American fan and you need a transformer to make it work with European current, you should be OK.

I've attached some instructions, it's just a matter of attaching the tethers to an anchor - either eyebolts (available at any hardware store) or even a couple of sandbags. If you are putting them on a roof, put the eyebolts in the parapets, not the roof. Take it down if the wind approaches 35 KM per hour. Store them in a dry condition, see the instructions to use the tethers. The tethers are adjustable, just unsnap the cam, slide the tether through to the desired length, and close the cam. Take care, Andrew, and if you have a minute, please send off some info about your dad, we're very interested to know why he is so famous.

Sincerely
Rick

(The bloodline meanders a precarious path to the generator that inflates the sculpture that is a site-specific re-enactment of my own particular mythologising.)

Of letting things conceived come into being
The happenings will allow me a contemplation
A Mortality Meditation
A Heretofore Visitation
A *Hislifemylifeourlife* correlation
In the form of A Cold Air Emission.

An Inflation
And
Then all of a sudden
The deflation
A puddle of the men they used to be

Into what nightmare thingness am I fallen?

SAMUEL BECKETT - *The Calmative*

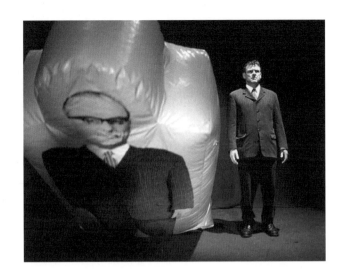

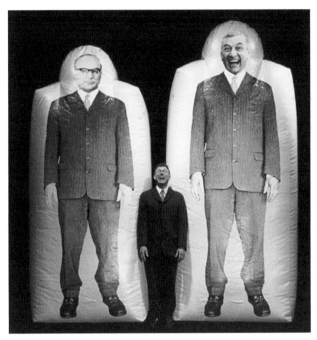

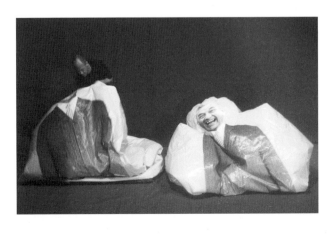

As an

In Remembrance of His Life, His Deadad's Life and My Life

I decided to present 65 *Inflations* - (or parts thereof) – one for every year of His Life.

Inflations

The location and the ritual inflation (or attempted inflation) of the sculptures, ensure that they are imbued with the sacred spirit. As the air enters the body they are again erected in the image of the Deadad and his Deadad before him. The bloodline has continued and I join the fray as proof positive. I am posing in the same garb as that of the Deadad effigies and this provides satisfaction in the wake of the erection.

Beuysian GilbertandGeorgian augmentation.

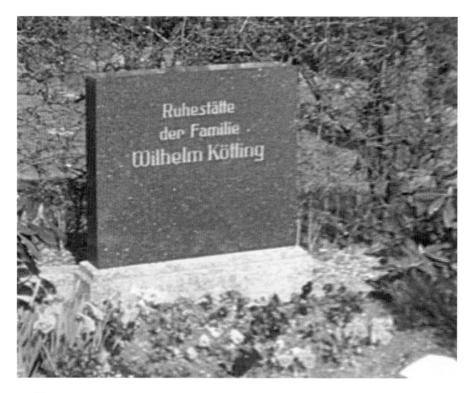

1 Of the family grave in Wuppertal

Buch, Germany and the Kötting side of the family from whence the patriarchal blood-line all began.

2 Of the ancestral home in Germany

The farmhouse, Buch, Germany and the family moves along.

3 Of the road in which he was conceived

Onslow Gardens, Highgate, North London.

4 Of the house he grew up in

196 Longlands Road, Sidcup Kent and the house my father spent most of his childhood in.

And the garden into which hot shrapnel fell.

5 Of the office in which he would earn a living

Regent Street, London, Otis lift, metal gates with a view onto the hubbub below.

6 Of the train that took him to work in Germany

The Shweberbahn, Wuppertal, Germany and the mythological elephant that got stuck on the train whilst being transported to the circus.

7 Of the factory in which he worked after the war

Huppertsburg textiles factory, Wuppertal, Germany. He worked here for almost a year and returned to the UK fluent in his father's mother tongue and with an eye for a yarn.

8 Of the church he pulled bells with my mother in
St Nicholas Church, Chislehurst, Kent.

9 Of him marrying my mother

St Johns Church, Sidcup, Kent, which is another place where they would both pull bells together.

Cheyennes do not so much fear their own deaths as they do the deaths of others who will leave them, making them lonely

ANNE S. STRAUSS *The Meaning of Death in Northern Cheyenne Culture*

10 Of respite from our deadad's rage

Archive super 8 of us all at a very young age and where memories reside.

R is for Remembering

A small boy,
i come out of the front door and dance in the school uniform that my
older brother danced in a year earlier. He is a lot shorter, but familiar with
this first-day-at-school photographic palaver.

(And there we both are dancing around the doorstep.)
Like the rage that might quickstep around his head

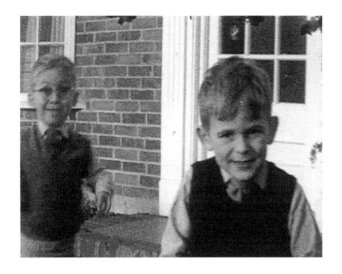

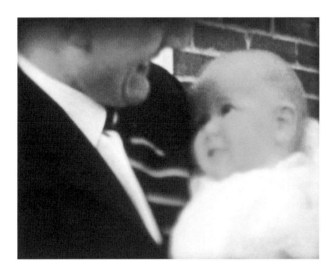

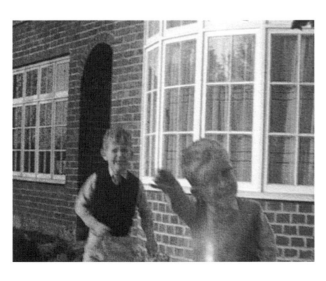

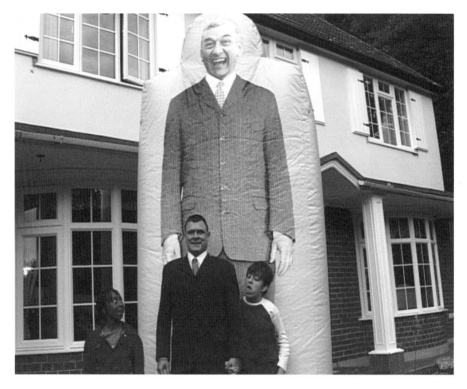

11 Of the house he built

Morköt, Elmstead Woods, Kent. Now owned by a Zimbabwean family and full of tropical fish, curious of my purpose but helpful nevertheless.

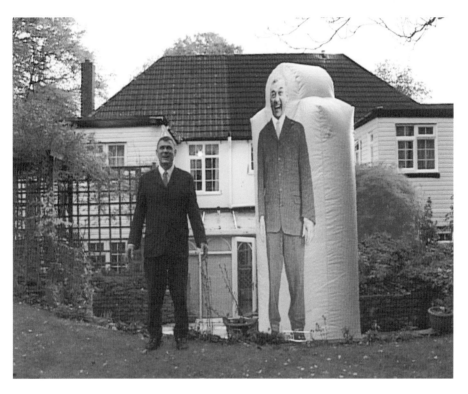

12 Of the garden he nurtured

The back garden that he fashioned with his bare hands, which his children
then set about destroying with footballs, pedal cars and what have you.

N is for Now

For *him*
The garden, **Morköt**, Elmstead Woods, Kent.
I grew rhubarb, you grew rhododendrons and angry.
Were you deeply in love when you named the house after each other?
Morris and **Köt**ting.
Or were you tolerant of her and her hectoring ways?
Was it this that eventually drove you all over her?
What went on in that house?
Was it a happy house?
I do know that there was an old oak tree that would comfort me and protect me
From
You.

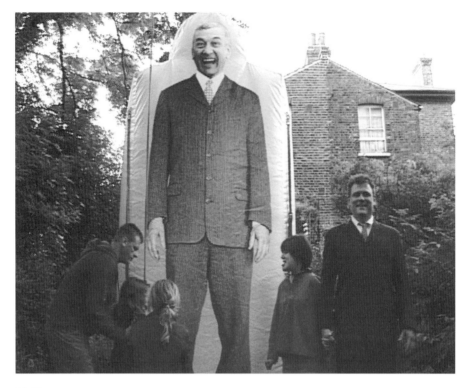

13 Of kissing the Deadad

His granddaughter's Billie and Etta set about kissing the man they forgot to kiss before he died.

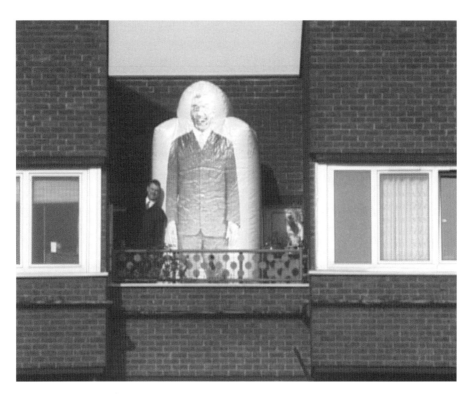

14 Of the flat in which I lived

Bence House, Pepys Estate, in which Eden was conceived and I lived for almost twenty years of my life.

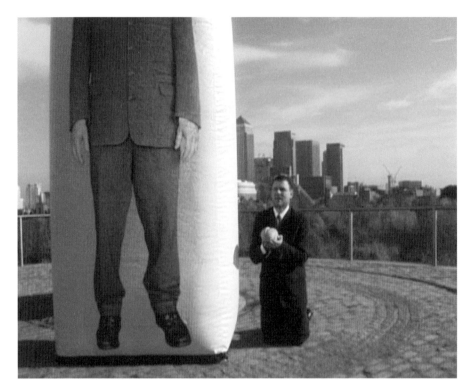

15 Of pretending he was a saint

Surrey Docks, Bermondsey and a hidden view over London, like the violence that he might meet out.

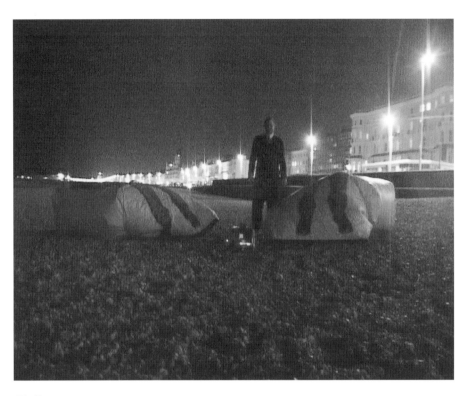

16 Of the beach to which I lost my virginity

Hastings, East Sussex. I'm 16 and seduced by a 32 year-old language
student from Italy. In all probablity my virginity was lost to the shingle
just after *Nutbush City Limits* by Ike and Tina Turner and just before
The Faith Healer by the Alex Harvey Band, and of which neither of them
knew anything.

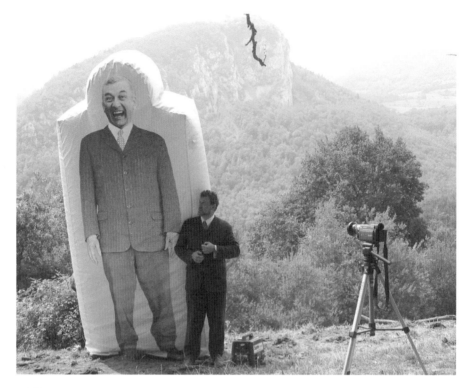

17 Of Pyrenean pastoral and my life he could never understand

The French Pyrenees with Montségur in the background and Andorra
behind that, holding me close to her bosom as she always does. Then some
German walkers pass by who can't quite work out what all the fuss is
about.

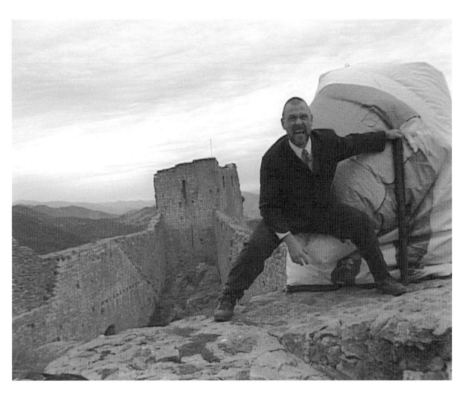

18 Of the castle he was always too ill to climb

The remains of the castle famous for its heretic Cathar inhabitants. They were to fling themselves from the battlements and into the flames rather than renege on their faith. The deadad visited us once but had had too many heart attacks to attempt a climb.

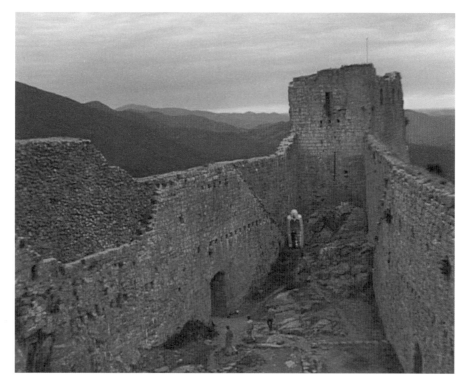

19 Of Montségur and the holy blood and the holy grail

The castle to which the Holy Grail might have been smuggled and launching pad for the blood line of Christ, apparently.

20 Of the house we rebuilt

Louyre, Ariège, France, from the stream looking up. We set about 'talking' in this house once, talking so much that it made him cry.

21 Of him facing the mountain of fear

The view from the studio towards the Pyrenees and the
Montagne de La Frau

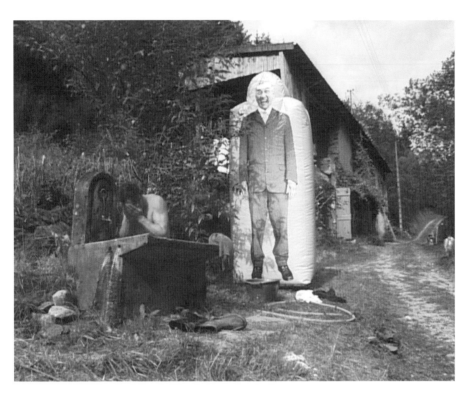

22 Of the bath at our house

Our bathroom at Morköt was light blue Formica, our bathroom here is an old trough that the hunters wash their boots in.

23 Of showing him the sacrificial stone under which I would like to be buried

Forêt de Bélesta, close to the Pas d'Ours, Ariège, Midi Pyrenees and where I would like my corpse to be buried:

I sit in this forest late at night,
My ex voto stone beneath me,
Waiting for something to come and get me,
In the same way that sometimes my Deadad got mummy and I thought that the police might be necessary.
Died because he was wound too tightly.
A lot of the trees were down this year, which meant that there was a lot of tidying up to do.
My father used to polish the sink with the same towel that the five of us would dry ourselves with after a bath.
He was very fastidious.
Not when it came to wine because he drank Liebfraumilch, which would arrive in a lorry from Germany.
I don't know if he was frightened of the dark or whether he ever killed a rabbit, but he told us he was on sentry duty once and something spooked him.
Immensely.
And I've been told by others that he was scared and a cowardly custard.

When I'm dead I want to come back as a ghost and dig up my own corpse

DAVID SHRIGLEY AND CHRIS SHEPHERD

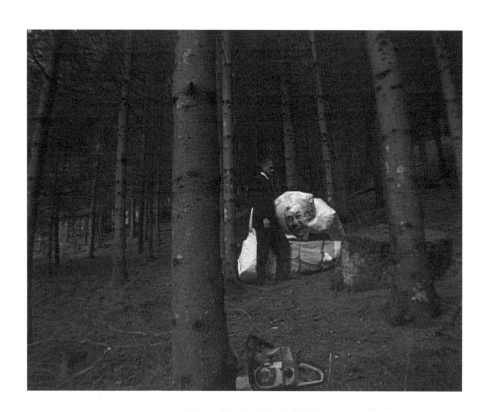

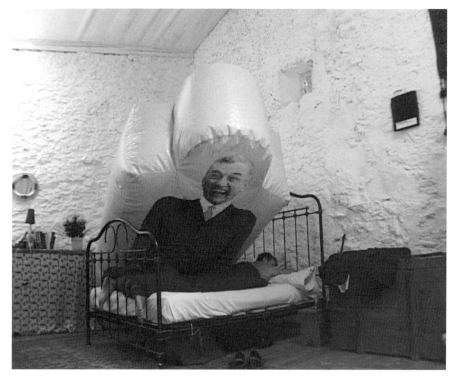

24 Of the bedroom he never knew I had

Big yellow and white like the whip snake that sleeps above our heads,
which he would not have liked.

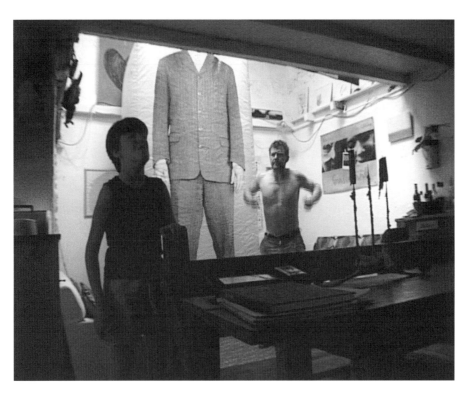

25 Of life is life

Eden's song, her summer 2003 song, sung after lunch to the deadad who
was about to become the Bigman.

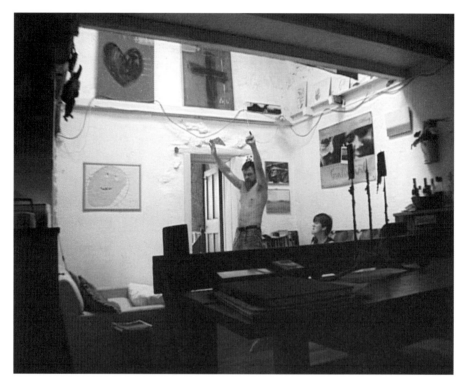

26 Of hello grandad how are you today?

Holed up in the French Pyrenees, Eden decides to stop calling the
Deadad Grandad and starts calling him the Bigman.

Also by way of introduction to *my* dead
Grandad: Papa.

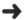

27 Of the deadad's deadad talking for posterity

Papa (the deadad's deadad) talking quietly in his German accent long
before the discovery of an extended family way up in the north sea.

Papa: *"What shall I tell him? Oh I see, I must talk quietly and be off my best
behaviour, I'll try."*

Fólkakirkjan

Føði og dópsbræv

Ættarnavn	Thomassen
Fornøvn	Emil Walter
HNIB 658713	

Føðibygd, sókn sýsla:	Tórshavn, Føroyar
Føðingarár og -dagur:	1946 - 18. januar
Kirkjan, har barnið er doypt ella heimadópur er lýstur:	Tórshavnar kirkja
Dópsár og -dagur. Er barnið heimadoypt, tá eisini ár og dagur heimadópur varð lýstur í kirkju:	1946 - 7. apríl
Øll nøvn og starv foreldranna ella ádóptivforeldranna:	Óluva Thomassen. *Sytradal ?*
Viðmerking um upptøku í ella útgongd úr fólkakirkjuni:	

Váttað verður, at hetta er, sum í kirkjubókini stendur.

Tórshavn , hin 19. nov. 19 65.

Inusigli embætisins.

(prestur)

28 Of documentation as proof of a new bloodline

Emil Walther Thomasson's birth certificate and the reason why I will travel so far to meet *my-his-our* extended half family.

10. Fremlagt i Færøernes Ret d. 21/5 1946

I, the undersigned, Emil Walter Kötting, born on 14th February,1906, at Langerfeld, Schwelm, Germany, now a British subject, residing at 175, Regent Street, London, W.1. to whom the boy, born to Miss Øluva Thomassen, Thorshavn, Faroe Islands, on the 18th January,1946, has been affiliated, do hereby solemnby declare:

THAT I recognize the paternity and subject myself to the decision of the Danish Authorities as regards my obligation to pay alimony and cover the expenses in connection with the mother's confinement and her maintenance during a period before and after the birth of the child.

That I am acquainted with the legal effects of my recognition, in particular that the said boy will be entitled to use my surname and will be my legal heir, in conformity with the rules for legitimate children.

London, 7th May, 1946.

Emil Kötting

--

This is to certify that Emil Walter Kötting, whose identity was proved to me, has signed the above declaration personally, to-day, in my presence, after having been well acquainted with same.

Royal Danish Consulate General,

London, 7th May,1946.

For the Consul-General

Vice-Consul.

29 Of the ferry that took us to the Faroe Islands

Smyril Line Ferries from Hantsholm in Denmark. Alone on the old ferry with reindeer which were dropped off in the Shetland Islands. Full of expectation about meeting the deadad's half brother that he never knew he had?

Meanwhile:
My mother kissed me goodbye with a
"and if they offer you any of that wind dried sheep just say no, don't have any".
But I just have and it doesn't taste of wet dog.
It just smells of it.
My mother has kissed all her children goodbye
At one time or another.
And her father
And her mother
But perhaps most painfully
A few years ago,
My father.
Her lover.
I'm sitting here thinking about it.
The sun sets over the North Atlantic and she really doesn't want to
talk about it.

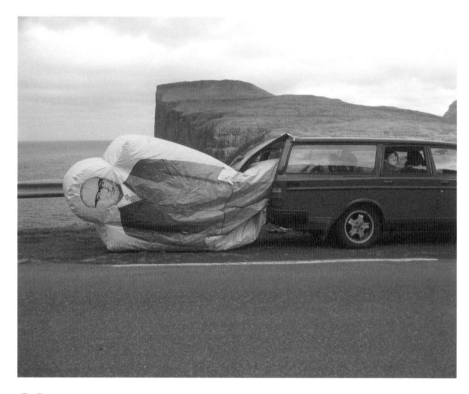

30 Of the car that took us to the Faroes

The Volvo that drove us across Europe to The Faroe Islands. A country
Papa continued to love long after he left, acting as Chairman for the Faroe
Islands Forces OCA and organising fund raising for the community and
indirectly his illegitimate son?

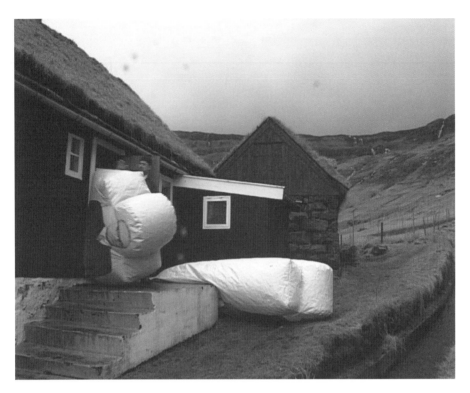

31 Of the house in which we stayed

In the tiny village of Tjørnuvik a sodded roof and silver birch bark guttered dwelling. Traditional and warming despite the gales blowing and snows that eventually started falling.

32 Of the Faroese capital in which his deadad conceived a child

Tórshaven, capital of the Faroe Islands, (population of 48,000) and probably where The Deadad's Deadad - Papa (Emil Walter) met with Oluva Thomassen and conceived Emil Walther who then set about tracing *his* Deadad and thus me.

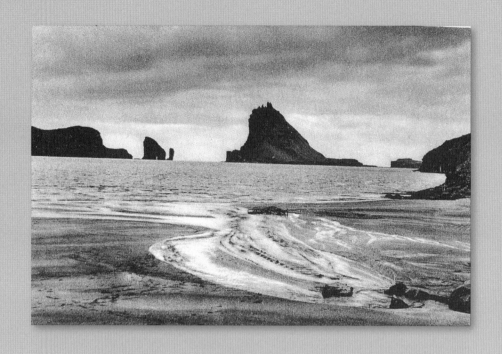

33 Of the Faroese light making rhythms

On the Island of Vágar and where Papa worked as an English Corporal
RASC no 252297 serving there from 1944 until 1945 and the seascape
he must have seen whilst building a runway for the British army. Then a
discovery that the camera makes its own music when you stop and start it.

34 Of the church his deadad photographed in the Faroes

The Church in Sandavags, which his Deadad would visit during the war and of which I found photographs as proof. The roof was a revelation; red never looks good in black and white.

Memorials as Inflations now function as commemorative sculptures, depicting scenes from the deceased's life, or desirable material recollections - Morphic resonance from the ancestors, abounds?

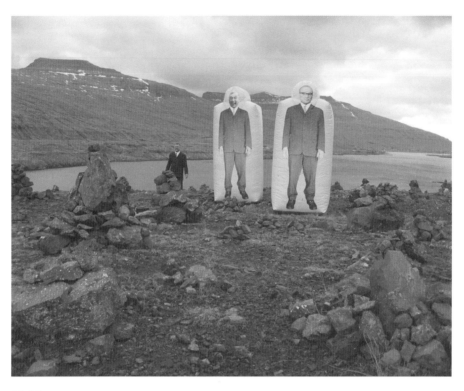

35 Of the cairns and their significance

Burial mounds on the island of Streymoy and contact with a Viking blood-line?

36 Of a Faroese photographic re enactment

The Faroese foreshore and revisiting the exact same spot after almost 60 years.

37 Of the Faroese homestead to which his deadad's illegitimate son was sent

West coast of Streymoy, alone and remote, and abandoned by his mother. Papa's son was brought up by a sister in a place where the neighbours didn't even talk to each other.

For Papa:
This is the landscape that
Shaped your son
That you knew you had.
That never knew he had you.
And that's the mountain he had to walk over
To deliver the milk
To
The town you knew
His mother
In
And the sea below me has the sound he heard daily
Whilst you shuffled around the garden of 196
Sidcup
Kent
On your bottom
With your suit on
That I now dwell upon
And these are the smells that I can smell
But you can't anymore.
And this is the coastal path he would run along
Your son
Whilst you strolled down Regent Street with your beloved bowler hat on.
And your other son,
My deadad, your eldest son
Would frighten the living daylights out of us,
His children
When he had a berserk on.

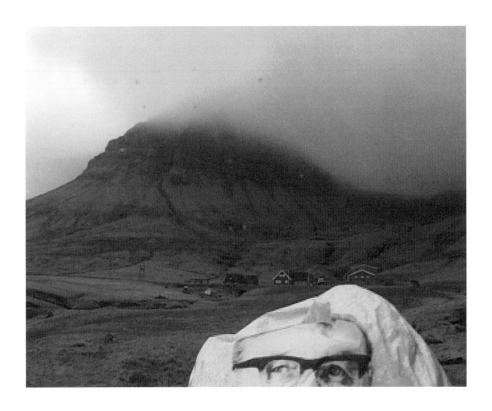

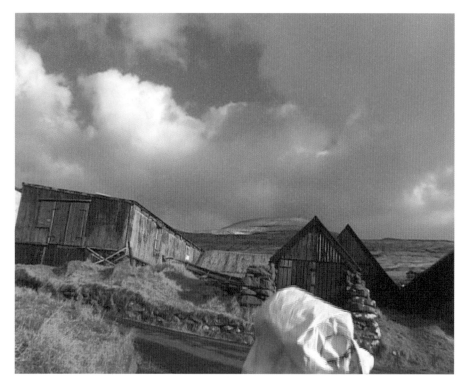

38 Of the long and windy road

The Faroe Islands and the final leg of the journey that took us to Papa's illegitimate son, Walther, begot some sixty years ago.

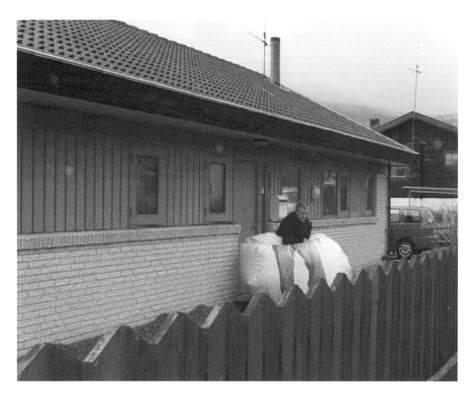

39 Of touching his deadad for the very first time

The Deadad's Deadads' son, born 18th January, 1946, known by me but never met by them? Touching his deadad for the first time in an attempt to assist me with his own 'inflation'.

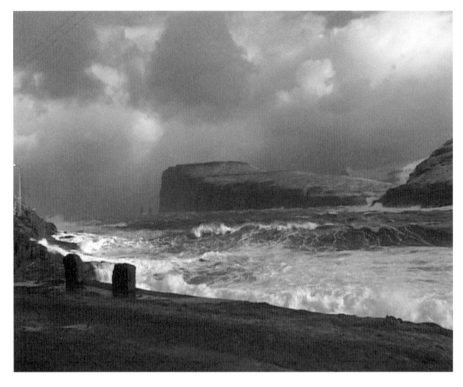

40 Of Faroese sea spray on the day we tried to get away

The storms closing in, our exit was thwarted by gale force winds and snow.
The ferry had to leave four days later, which was a pleasure.

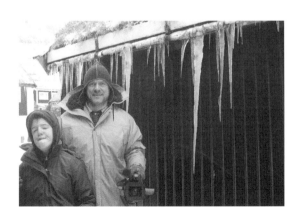

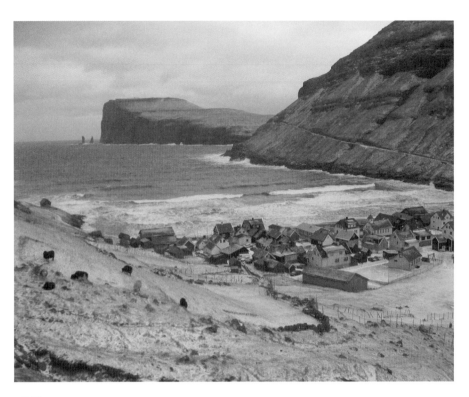

41 Of an ode to a deadad

We stayed on and I wrote an ode whilst looking down onto the village of Tjørnuvik.

**I stage everything as it is after having visited my mind
I work in a foggy No man's land between reality and fiction**

JON BANG CARLSON *How to Invent Reality*

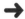

ODE

Contemplating Ronald Walter, my father:

The starting point is the landscape, imagined or real.
The stories fall onto the landscape
History is born.
The pastoral, in his case, a little berserk.
Then
Denis Hopper wanders in pretending he's Tim Page
And rants about Kurtz and his own Apocalypse.

A remembrance of things dead

(ODE TO A DEADAD)

HE WAS A GOOD MAN, A TIDY MAN,

HE WAS A FAMILY MAN, NOT A HIPPY DIPPY MAN, MAN,

A LAWN-MOWING MAN,

HE WAS A POST-WAR MAN,

NOT A POST MODERN-MAN, NOT A MAN IN SEARCH OF A NEW
VOCABULARY MAN,

MOREOVER, HE WAS A BUY-A-BRITISH -CAR MAN, MAN,

HE WAS A BIG MAN, A POLICEMAN TYPE OF MAN, MAN.

BUT

HE FORGOT HIMSELF MAN

HE WAS AN ANGRY MAN, MAN

HE WAS OF UNSOUND METHODS MAN

IF YOU COULD HAVE HEARD THE MAN SHOUT MAN

IF YOU COULD HAVE FELT HIS VOICE BEATING AGAINST YOUR BODY MAN

HE FORGETS HIMSELF MAN

HE PUSHED MY MOTHER INTO THE REFRIGERATOR MAN

TRIED TO FREEZE HER MAN

HE BEAT HER MAN

HE WAS A CLEAR IN HIS MIND BUT MAD IN HIS SOUL MAN, MAN

A HORNBLOWER, HAMMOND INNES, HAMMOND ORGAN,
EASY LISTENING MAN'S MAN, MAN

A JAMES BOND, BARBARA STRIESSAND, STEAKHOUSE TYPE OF MAN, MAN

AND WHEN HE DIES IT DIES MAN

THAT GENERATION OF STAMP COLLECTING, CAR-WASHING,
HANDKERCHIEF IRONING, PIPE SMOKING, ONEDIAN LINE WATCHING,
MIDDLE CLASS, FONDU-EATING, GOD SAVE THE QUEENING, MAN, MAN

WHEN HE DIES

IT DIES

MAN.

(Supper's ready Eden.)
(*Ranted in an Apocalypse Now! Hopper Flurry*)

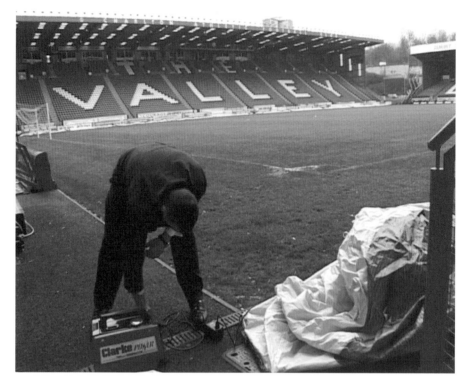

42 Of the football club they both supported

The Valley, Charlton, London and a grounds man that explained:
'ashes are normally kept up there behind the score board but whatever tickles your fancy.'

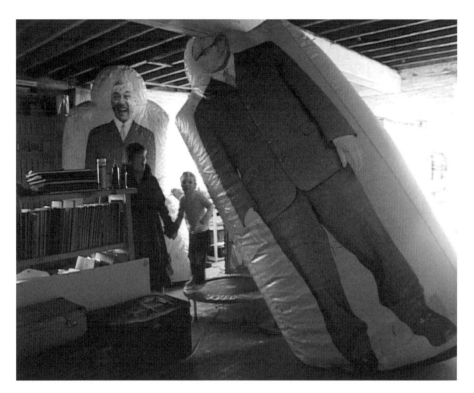

43 Of their grand daughters and great grand daughters in my studio

Old Town, Hastings, East Sussex and a trampoline where the inflatable sculptures are now kept and where Eden makes her *'still life'* drawings.

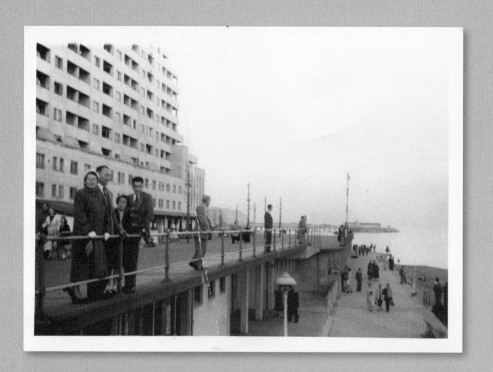

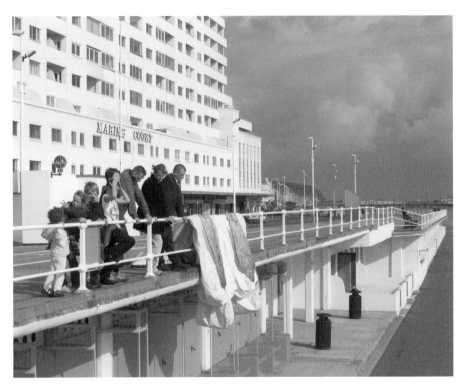

44 Of the esplanade they would visit for a day out

St Leonard's on Sea, East Sussex. My Grandfather Walter, his wife and family posing in front of Marine Court, behind which I now live as do my brother and my sister and our families as if drawn by some incredible memory magnet. Then posing for the re enactment.

Did the deadad take the photograph?

Him having seen his hasbeen?

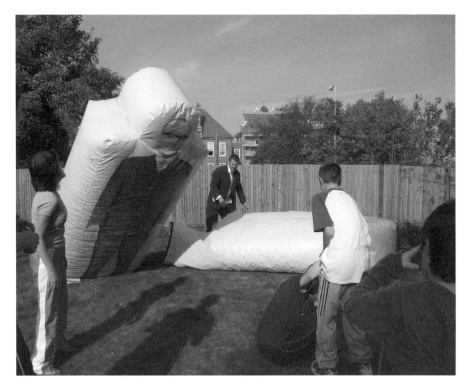

45 Of being at Eden's new college

Glyne Gap Faculty, Bexhill College in East Sussex where their
granddaughter and great granddaughter, Eden, is now educated and
continues to do her growing up.

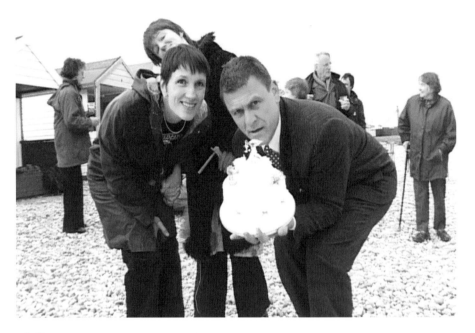

46 Of bearing witness to a wedding

Cooden, East Sussex and the beach on which we had our reception and
wedding night.

Modern death does not have any significance that transcends it or that refers to other values. It is rarely anything more than the inevitable conclusion of a natural process.

OCTAVIO PAZ, *The Labyrinth of Solitude*

A trip to Mexico for the day of the dead
in order that he might meet other dead

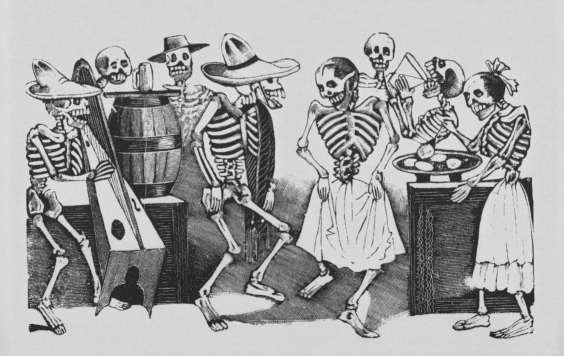

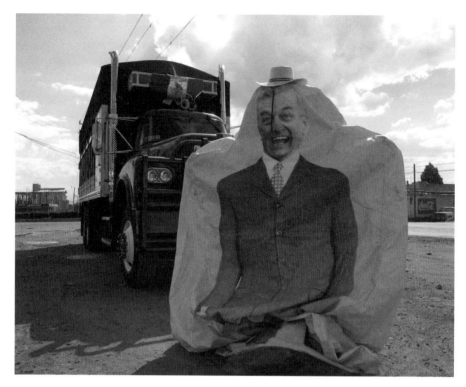

47 Of making our way across Mexico for the day of the dead

On the road from Mexico City to Patzcuaro where we were hoping to spend the night of the day of the dead.

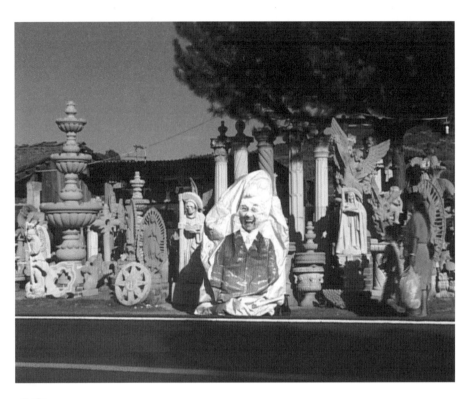

48 Of waiting for the grim reaper

The grim reaper looks on as I stand inside him trying to take in *his*
significance and everything that has led to me being
Here
At the side of a Mexican road.

49 Of our Mexican wanderlust

Passing the pyramids of Ihuatzio in order that we might satisfy our
Mexican wanderlust, deadad over my shoulder and all the life out of him.

50 Of his granddaughter carrying him across Mexico on her lap

The pyramids of Ihuatzio behind us and Patzcuaro another twenty kilometres in front.

51 Of the hotel in which he stayed for the days of the dead

Patzcuaro, Mexico and the hotel in which we stayed for the Days of the Dead. The owner was compelled to dress up and come join us in the *happening*. Apparently the garb is not an antedote to things white supremacist but some 'other' religious sect.

52 Of a Mexican graveyard on the day of the dead

Tzintzuntzan, (named after Elisa Lipkau's cat) in Mexico, with the Dead's friends and relatives pouring in throughout the day and night. Hold on tight here I go again.

53 Of witnessing the dance of the little old men on the night of the day of the dead

The dance of the *viejitos* is a very traditional and popular dance represented by small children who dress up and pretend that they are very very old.

54 Of the boat that took him to Janitzio for the night of the day of the dead

A small ferry boat and a crossing of the lake to the Island of Janitzio for the night of the day of the dead

55 Of lying down on top of him and contemplating his death

A cemetery on the Island of Janitzio, surrounded by marigolds and candles I lay down on top of my dead father and contemplated him for a very long time. My eyes open, never blinking, and just the sounds of the night of the Day of the Dead for company.

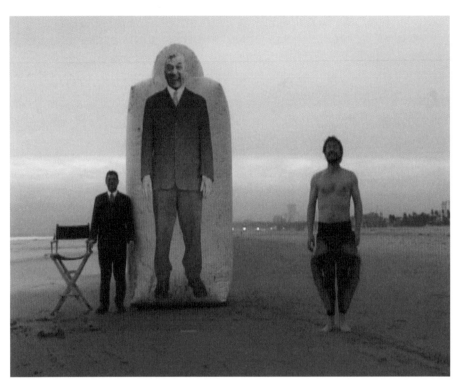

56 Of the beach on which his youngest son learnt to surf

Joey shows him the beach on which he learnt to surf.

On the way home from Mexico we stopped off in Los Angeles with the lives of his eldest and youngest sons.

Peter – Pugalugs

Joey – Josephine

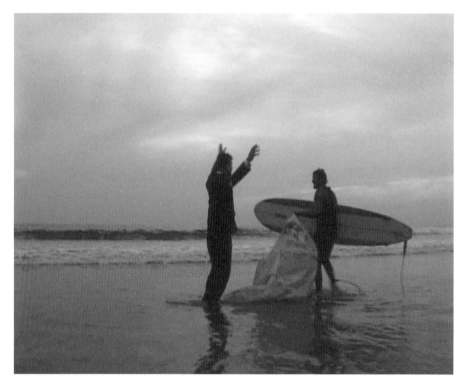

57 Of trying to teach a deadad to surf

Venice beach, Los Angeles. So that the ocean might take us all away.

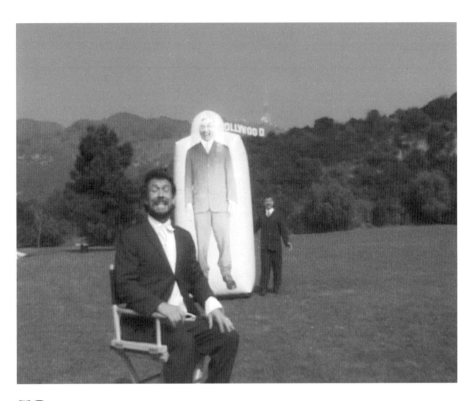

58 Of Hollywood to which he wished I'd aspired

A Mecca for the Movie Maker and an industry to which he wished
I'd aspired.

59 Of the world bearing down on top of him

Self-employed, heart attack by 42 and the pressures of life bearing down on top of him again.

60 Of bearing witness to his oldest son's birthday

Venice, California. November 5th 2005, five years after the deadad's death and we are all back together.

61 Of him being used as bouncy castle

Los Angles, America and the kid that climbed over the fence to use the
Deadad as a bouncy castle on Peter's birthday.

62 Of their last supper

Christmas Day, St Leonards on Sea. Late lunch – supper and Eden still in her skeleton costume with *'we wish you a merry christmas'* filling the room.

63 Of the flat from which his dead body was carried

Beckenham, Kent, and the struggle to get his body, vertically into a lift
and then horizontally into the back of a transit van

64 Of their ashes in the garden of rest

Their ashes buried together along with his mothers at Chevening, Kent and the omnipresent hum of the M25. Then prying questions from a gardener that *"quite frankly had never experienced anything like it"*.

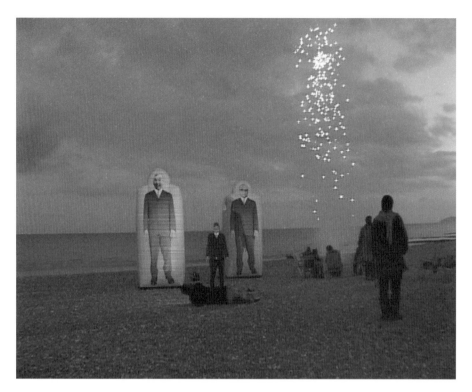

65 Of their being life after death

Cooden Beach, East Sussex, a family gathering for our wedding and a firework display to celebrate their having been.

The more you advance in life, the more you realise that you don't learn anything, you just go back in memory. It is as if we reinvent a world in which we once lived. We don't gain anything we just regain ourselves. Self-identity is reverse evolution.

EMILE CIORAN *Tears and Saints*

NB - Of being inside his very being

Inside the deadad and contemplating the inflations as a means to a life's exploration whilst travelling towards an expanded cinematic language as expressed through autobiography, psychogeography and film.

From a grave perspective, every step in life is a step into death and memory is the only sign of nothingness…naivete is the only road to salvation.

E.M.CIORAN *On the Heights of Despair*

And thus I walk about
dragging the confounded things with me.

And there are others who walked :
Aristotle
Samuel Beckett
Jeremy Bentham
John Berger
Joseph Beuys
Janet Bord
Colin Bord
John Bowmer and his boys
Bruce Chatwin
John Clare
Hamish Fulton
Werner Herzog
John Irvine (www.entrances2hell.co.uk)
Soren Kierkegaard
James Lever
Richard Long
Mark and Sean
Mike Jay
John Stuart Mill
Montaigne (17 months away walking and on horse from Bordeaux
to Rome via Germany 1580)
Friedrich Nietzsche
Nigel and Ute
Nicholas Roeg
Jean Jacques Rousseau
Harry Dean Stanton
Iain Sinclair (of course)
Ludwig Wittgenstein (around and around Bertrand Russel's rooms)
And the woman who walks, head down, from Deptford to Notting Hill
all round London and back again

**Someone said to Socrates that a certain man had grown no better by his travels.
"I should think not," he said; "he took himself along with him."**

AND
Djúpivogur
kúreyn
Seya
nadalshnúkur
2119
ekla
Vík

NEWFOU
BAS
973
ICEL
KALSOY
KUNOY
Viðareiði
FUGLOY
FAERØE
Riain og Kellingin
Gjógv
VIDOY
Tjørnu
Fenningur
SVÍNOY
Saksun
Vík
Fuglet
Klaksvík
BORDOY
STREYMOY
Vestm
Gøtu
Skálafj.
FØROYAR
VÁGAR
Sørvágur
Kollfj.
orshavn
NÓLSOY
Tindhólmur
MYKINES
HESTUR
Vellbast
Kirkjubø
KOLTUR
Skopun
SANDOY
Sandur
Húsavík
Skarvanes
SKÚVOY

STÓRA DÍMUN
LÍTLA DÍMUN
146
SUDUROY
Trøngisv.
ROSEMARY
Vágur
Sumba

SHETLAND IS
(U.K.)
erwick
RIDGE
650
ORKNEY IS
Kirkwall
North Uist
Thurso
Wick
HEBRIDES
NORTH
Stornoway
Moray Firth
HIGHLAND
Inverness
Aberdee
WEST
843
POU
GRAMPIANS
Firth of Forth
GLASGOW
EDINBURGH
NEW
North
978
LEEDS
Londonderry
Carlisle
MAN
62
BELFAST
ISLE
OF
MAN
NO
negal Bay
IRISH SEA
LIVERPOOL
R
985
Galway
DUBLIN
CAMBRIAN
BRI
way Bay
I
CARDIFF
BRIS
Limerick
R
621
Sou
Point
Cork
St George's Channel
Bristol Channel
936
Plymouth
210
V
B
E
R
S
Land's End
73
En
CHANNE
ISLAN
Equator
Brest
B
USHANT I.
PE
R
5140
N
f
676
50

CHAPTER SIX

Of a discovery, pornography and digital decoupage

Of reflecting upon the glamour of glamour magazines

You can pay a heavy price for nostalgia.
The moment is hot and frozen.
The event acts as locus and my point of reference.
It has created a moment resplendent in a semi-clothed new meaning.
A site of departure for the memory.
Thinking primarily of his pornography.
Seen by him and now by me.
Fantasised by him and now by me.
Enjoyed by him and now by me (with him in mind)
Where does it all take me?
Ultimately?

Timely, to have discovered it all those years ago and now again lately
(Thirty years in the waiting)

Of holding onto the past and never letting go

These ideas made available through my culture of the familiar.
For instance, recently,
Pornography, (glamour photography) and a discovery.
She says; *"Look what I found above me"*,
(She was painting inside a cupboard underneath a shelf),
"A bag full of pornography",
Gloriously kitsch, technicolour-filled filthy pornography.
Of course it brought back memories for me,
Of smuggling the stuff into the lavatory
The rushabout, sticky and untidy.
For a thirteen-year-old, it was more a coming-to-terms with reality
Of gaping wounds and those throbbing fit-to-burst propensities,
But eventually
And with the help of familiarity I got the hang of it,
A lot.
She says: *"I don't mind the décor, those weird curtains and that awful table lamp"*
But for me,
Suddenly,
It becomes something else.
A Mnemonic and Times Arrow,
Shooting,
Sent
Hurtled backwards and landing atop a sensuality and sexual awakening.

If pornography is part of your sexuality, then you have no right to your sexuality
CATHERINE MACKINNON

(Some musing

**It is always a naïve photograph, without intention and without calculation.
Like a shop window which shows only one illuminated piece of jewellery, it is
completely constituted by the presentation of only one thing: sex: no secondary,
untimely object ever manages to half conceal, delay or distract .**

ROLAND BARTHES *Camera Lucinda*)

And proof *a contrario*:

The Deadad porno as revelatory transporter.
Back to the wardrobe and its discovery.
A life-time ago.
An Aladdin's cave of wonder and debauchery.
A twelve year-old aspirant and a thirteen year-old masturbatory partner
Expert and older brother:
Peter is on my shoulders and our goal is Narnia
– we have been there before and we want to go again.
He reaches into the very back of the wardrobe.

And shortly after that they looked into a room that was quite empty except for one big wardrobe; the sort that has looking-glass in the door …….. This must be a simply enormous wardrobe! Thought Lucy, going still further in and pushing the soft folds of the coats aside to make room for her …….. Lucy felt a little frightened, but she felt very inquisitive and excited as well.

This is what penetrates *my* memories
and
the possibility of actually entering the past by way of the frame.

So
I select eight scenes,
The ones that pricked me
Leapt out at me and bruised me
Made me
(So long ago).
i
want to join in and partake of the fantasy

Look there's me
(and the deadad revelation)
Magic eye skulduggery surrounds me
Entertains me

And the titling is my way in
My obfuscating
My longing to be mis
Understood.

"Earliest memories can build a private Eden, a lost garden to which there is no return."

RICHARD DAWKINS *Heroes and Ancestors*

But I have returned

He went back
He went back to start all over again
(Klipperty Klopp ARK)

(NB: There should be an LCD TV screen to accompany the photographic decoupage presenting a mirror image that might move imperceptibly and beguile through the use of some sonic implausibility like Foley).

In this glum desert, suddenly a specific photograph reaches me; it animates me and I animate it. So that is how I must name the attraction which makes it exist: an animation. The photograph itself is in no way animated (I do not believe in "life-like" photographs), but it animates me: this is what creates every adventure.

ROLAND BARTHES *Camera Lucida*

ere the stored images of past experiences are projected into the future.

STUCK
(of holding onto the past and never letting go)

MALE FEMALE
(of the heart beating too fast)

SQUARE
(of tugging at the bloodline)

HANGING AROUND
(of patriachal reminisce)

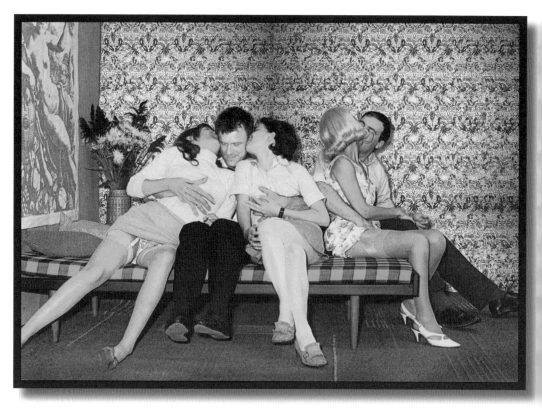

DNA
(of ancestral past times)

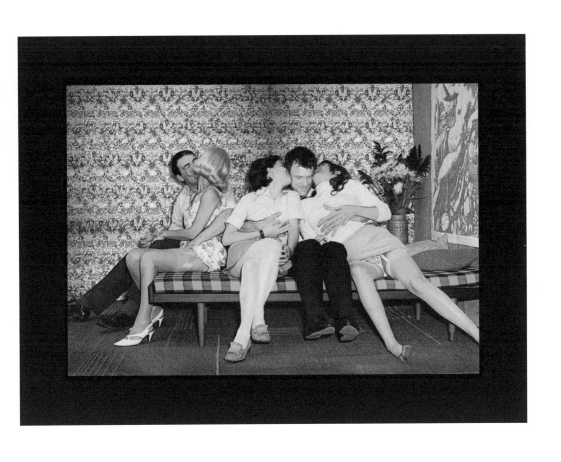

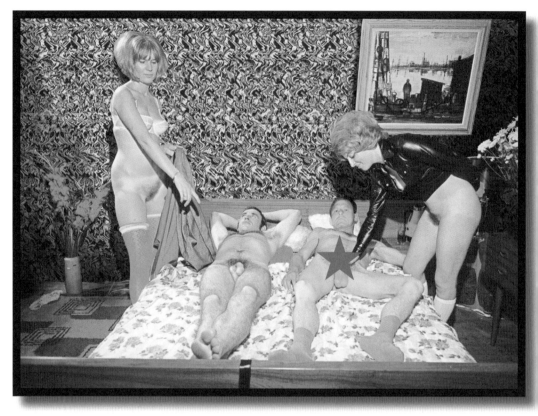

HORN BLOWER
(of pointing the finger and thus the blame)

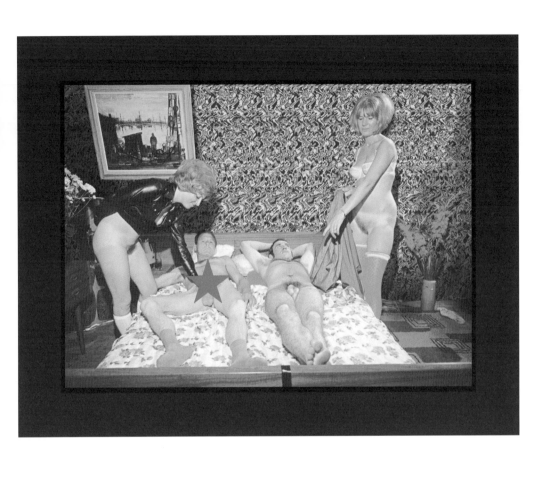

TEEING UP
(of making it all come together)

FOREVER AND EVER
(of touching the hand that fed me)

Nor is pornography's purported aim or effect – to excite the reader sexually – a defect … the physical sensations involuntarily produced in the reader carry with them something that touches upon the reader's whole experience of his humanity

SUSAN SONTAG

Digital decoupagery has got a hold of me
Another memory;
I'm at the helm of a fantasy.
Shuffling,
My trousers around the ankles,
Away from the scene of the wank.

(Him.
Nowgone.
Spent.)
I'm in Germany.
Without the Family.
But
With *Colour climax.*
Pornography.
His pornography, my memories.
His pornography, my fantasy.
Inflated memories of make believe suburban parties.
Confabulatory memory of a Wednesday afternoon spent trying to reach to the back of
the wardrobe for some debauchery….

Here I go again.

Would he have carried the pornography?
Or Sent it?
Packed it away with the samples?
(Buckles and belts and braces.)
Or boarded the plane and winged it?
Busy
It would have been when he got home to the five of us
And mummy
Then.
But now
Here
For me,
And my return will be
To just the two of them
Organic vegetables, her knitting

And a documentary about Jimi Hendrix's lost millions
(last week it was Marc Bolans')

Still there is this connection
The bloodline, the repetition
and how familiar
it all seems.
Back here and the signage:
"Warsteiner", "Frankfurter,"
spater und entshuldigung
The language too.
Comfort to the ears.

Now
Engelbert is dead,
(Deadad's best friend is dead)
And of course the Deadad is dead
and
Uncle Willy is dead
Papa
Constance
Oma
Opa
Albert
Gladys
Wally Penfold
Mark Bourne
Jack Sharp
Joan Shepherd
Monsieur Dunac
Mr and Mrs Woolford
All gone
And
The list will go on
And
On
And
On
And
on

Memory made memorable made by emotions.

The only thing pornography is known to cause directly is the solitary act of
masturbation. As for corruption, the only immediate victim is English prose.

GORE VIDAL

So you ask me why am I doing it, where does it all lead?
And I answer it is leading somewhere, it is not stuck, it is of this our liquid modernity.

In order to achieve this transcendence of distinctions, The Artist-Creator invents
a universe for himself, however illusory or fantastic, idealised or dreamed,
in which conflicts and repressions are abolished. He projects a landscape
of abhorrent, forbidden subjects, then makes it concrete, drawing from the
intensity and perverse energy of art.

GERMAN CELANT ON JOEL-PETER WITKIN *Between Flesh and Spirit*

Was he aware of the Delvauxian Pleasure?
Chaperoned through a landscape by somnambulistic and naked women
Schizophrenic dialogues with myself – a mild dalliance last night – otherwise all seems
quiet on the
Me
I
Me
I
Him, front.

The true picture of the past flits by. The past can be seized only as an
image which flashes up at the instant when it can be recognized, and
is never seen again.

WALTER BENJAMIN

Of making it all come together as digital decoupage

As inexplicable as the accidents that set it off, our imagination is a crucial privilege. I've tried my whole life simply to accept the images that present themselves to me without trying to analyze them.

LUIS BUNUEL *My Last Breath*

Reflexivity virility subordination and filth

My failure is failing to have gone far enough!
My failing is not having gone further!

SABBATH IN PHILIP ROTH'S *Sabbath's Theatre*

Pornography as trash feeling

Rather in a gutter than on a pedestal

E.M. CIORAN *The trouble with being born*

We're not
we are
and
we're not
and
I want to know why

I like thought, which preserves a whiff of flesh and blood, and I prefer a thousand times an idea rising from sexual tension or nervous depression to an empty abstraction.

E.M.CIORAN *On the heights of despair*

Sreech
or
screaming

Of course we are challenging nature itself, and it hits back, it just hits back, that's all. And that's grandiose about it and we have to accept that it is much stronger than we are. Kinski always says it's full of erotic elements. I don't see it so much as erotic, I see it more full of obscenity ...and nature here is vile and base. I wouldn't see anything erotical here. I would see fornication and asphyxiation and choking and fighting for survival and growing and just rotting away. Of course there is a lot of misery, but it is the same misery that is all around us. The trees here are in misery and the birds are in misery. I don't think they sing, they just screech in pain.

WERNER HERZOG

Of asserting
his right to live
Of sending
a message
and
Of leaving
a trace

I was born on All Soul's day in a frightful meadow amongst shells and stag-beetles

ANDRE BRETON AND PHILIPPE SOUPAULT *The Magnetic Fields*

CHAPTER SEVEN

Of pondering on hislifemylifeourlives, Madagascar,
Mexico and how the deadad became the Bigman

Of Being Dead

My Deadad as catalyst and cipher
Leads me towards notions of implied narrative within the context of a rooting around in
the mire that is memory.

> **You have to begin to lose your memory, if only in bits and pieces, to realise that
> memory is what makes our lives. Life without memory is no life at all, just as
> intelligence without the possibility of expression is not really an intelligence.
> Our memory is our coherence, our reason, our feeling, even our action. Without
> it we are nothing.**
>
> LUIS BUNUEL *My Last Breath*

Conversation as reportage of our lives

Two years before he died I gave him a Dictaphone.
It was a Christmas present and some tapes were included.
I wanted a confession.
I wanted an owning up to all those things that kept us awake at night.
All those things that still keep us up
Talking way beyond the night.
Those things that had made you mad with being alive.
And you gave me three hours of carefully remembered bus numbers and place names and
the correct spelling for your pottery, like Dalton and Derby.
But in amongst it there are some things you did tell me.
You went back into your mind:

"If I close my eyes I can see it now
you tell me.
And the horse's name was Drummer.
It is 1938 and I'm about 6 years old. And we're collecting hot shrapnel along Longlands road."

Anyway.
Now you're walking down a long garden near the A4 off towards Marlborough
and Devizes.
Over a fence and down the lane.
You are at the door of the slaughter-house and your little brother Leslie is looking in and
the animals are being shot and throats are being cut and the blood runs out and this is
the day he became a vegetarian.
Contributory factors you tell me.

**Death : Here is the great bleating square.
The sheep are arriving at full speed, on stilts.**

ANDRÉ BRETON AND PAUL ÉLUARD *The Immaculate Conception*

Faroe Islands 2004

The goal of our career is death. It is the necessary object of our aim. If it frightens us, how is it possible to go a step forward without feverishness? The remedy of the common herd is not to think about it. But from what brutish stupidity can come so gross a blindness!

MICHEL DE MONTAIGNE

Now

You are 10 years old and watching the American soldiers and there is the smell of
burning cinders and one of them makes a pass at Mama
Your mother; Constance and it was probably July 1945
and the **Deadad's Deadad**, not yet dead, (your dad), has been posted to the Faroe Islands
and it is probably now that he sets to work at having it away.
He's 'in' with one of the locals,
As close as eye balls.
The war will soon be ended and as the dance finishes
Oluva, deeply impressed,
Will be impregnated.
But do you know any of this?
You've told me nothing.
So I'm going to tell you something.

Of Childhood reminisce:

Shaking
I'm lying there
Lying that it'll be all right
And
Come morning-time mummy will be up and at it
Fresh as a daisy
Bruised
Perhaps
Even wounded
But up and at it
Breakfast for him
And then for us
The five of us
The beast departed
Then me on the bus
Remembering the monster that had caused my mother to not want to make a fuss
Shaking
Which has never warded off the danger.
HIM
Five kids
An office in Regent Street
And not the wherewithal to know where it's at
Or
Which way is up.

I must be wary of hindsight's gifts and moreover my fetid effluvia.

And your father, my contemporary, was brought up in a pre-Freudian world, where there were no models for fatherhood, or any acceptable by our contemporary world.

FAY WELDON

The Deadad is no longer the enemy
He has been.

Our fascination with death means we are left transfixed before it, clutching at its different meanings but leaving death itself unexamined.

BENJAMIN NOYS *The Culture of Death*

His dying
Here's to the memories:
On his way out I helped nurse him.
Climbed into the bath and showered him.
Sat at the other end of the room and monitored him.
Injected him.
Played with him.
Parted his hair in the wrong direction, cut his nails and pampered him.
Watched him watching match of the day with him.
Asked whether there was anything else that I could get him?
Laughed at him with two other
(my brothers)
Bits of him.
He had become the little boy that's still in me, him.
Unfocused, devoid of any clarity,
Hazy him.
The baby boy, struggling,
Muddling everything up him.
The tide come to reclaim the flotsam, wanting it back from him.
(Number 65,
Back by nine thirty?)

Then there's the commode;
What a commotion,
I lift him on, he strains to do the bit that needs to be done
And my brother waits;
Lies on the carpet

Underneath
The *goings-on*.
He gets a good angle to wipe.
Wiped out, gone.
Which didn't take very long.
A week, a weak week, but a week nevertheless.
A week at the end of many weeks.

On his way out I watched as the 'Buryman' banged my father's head against the lift.
The brown lift.
The plain lift, the lift with a number to call in the event of an emergency lift.
The horizontal to vertical lift.
The fireman's lift.
Lifted into the transit van and carried away before the break of day.
Her upstairs worrying about what the neighbours might say.
Here's the photograph as proof.
Proof of what?
Proof of the fact that out of a house was carried a Dad?
Proof of my life with him?
A life of a relationship built on *suppose*.
He must have supposed that I did whatever I did and when I was younger I supposed he did whatever he did.
We met once in the French Pyrenees and stumbled upon some talking, probably the drink but pretty soon it led to some crying, *his* crying in the upset of some desperate denying of things not being how he'd imagined I'd *supposed*.
Death is the race's chequered flag Ange
He once said
And
He really went at it that night.

There is a recent report of a Düsseldorf doctor who placed the beds of his patients on a set of extremely sensitive scales. At the moment of death, in repeated experiments, he noted a loss of weight of twenty one grammes. The weight of the human soul?

NIGEL BARLEY *Dancing on the Grave. Encounters with Death*

This work means that Ronald is with me.

The dead man has taken up all the space.

There's my Deadad's hand attached to my Deadad's arm, his thighs, his shins, his pigeon toes – he's infiltrated me and the older I get the more his physiology takes over.
Sometimes it's impossible to look without seeing him.
Seeing him in all of us.
Such is the story.

Of having staggered under the heavy load of adolescent despair
First Peter then myself and eventually Leesa, Mark and Joey.
Oh to have lived under the same roof as all of that.
No wonder my mother seems to have forgotten.
Not him, but those
things.

Of a deadad and the grief that he gives his wife whilst his
son inflates him in an attempt to get rid of him:

Amedee: I was only looking to see if he'd grown.
You'd almost think he had, a little.

Madeleine: Not since yesterday …or at least not so you'd notice.

Amedee: It may be all over, you know, perhaps he's stopped.

Madeleine: Oh you and your silly look on the bright side.

Amedee: Is he still growing?

Madeleine: Shut the door. Were you born in a barn?

Amedee: I feel quite sick!… Every time I look at him.

Madeleine: Don't look then! What did you go into his room for?

Madeleine: The dead grow old faster than the living. Everyone knows that ….

Amedee: He's growing. It's quite natural. He's branching out.

Madeleine: what do you take him for, a tree? He's just making himself at home!
Why he'll soon monopolise the whole place! Where am I going to put him? You
don't care. You don't have to do the housework!

Amedee: Of course, I know, he gives us a lot of trouble, but in spite of that
he's made a great impression on me. When I think…ah, it might have all
been so different …

Madeleine: If he'd forgiven us he would have stopped growing. As he's still
growing he must still be feeling spiteful. He still has a grudge against us. The
dead are terribly vindictive. The living forget much sooner.

Amedee: Dash it! They've got their whole lives in front of them! … Perhaps he's
not as wicked as the others. He wasn't very wicked when he was alive…

Madeleine: That's what you think!

Amedee: You see it's all right in the end.

EUGENE IONESCO *Amédée or How To Get Rid Of It*

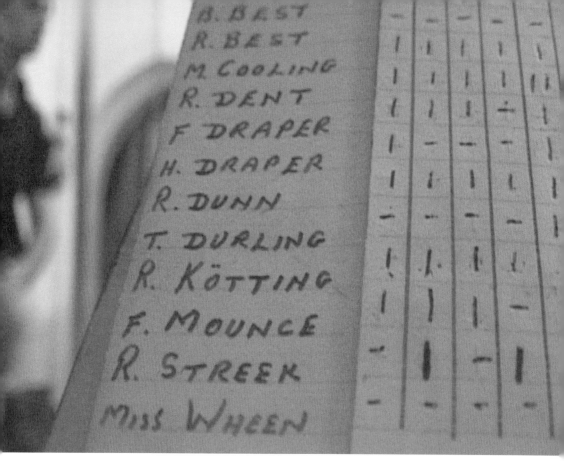

B is for bell-ringing
And hasBeen like his friend and bank manager, Roy Dent.
(He lived a life longer - and of this he was proud.)
But he pulled bells less often in Chislehurst, Kent.
Today I saw proof
In the form of a book,
Barely holding itself together;
There it was *1951: 8.45 pm, Ronald Kötting, six shillings and eight pence*
versus *Roy Dent at fourteen shillings and thru pence,*

Pointed the camera at it and I expect it will make it's way onto the page as signifier.
Somehow.

My memory is shoddy

Thus I have lived for a number of years on childhood memories the way others in days gone by lived on the income of their investments

MARCEL BÉNABOU *Why I Have Not Written Any of My Books*

And the past comes off in great unpredictable chunks

Morköt

Begot from the Mor of Morris and the Köt from Kötting.
Maiden name followed by her married name.

God Ronald! (the Deadad)
Your wife kept your house clean.

All a fidget - all a guggle
Sploshing backwards and forwards in this my puddle of historical twaddle.
Apparently The Greeks enter into Death backwards.
What they have before them is their past.
What I have before me, presently, is his past.

Life and its iron yoke of ideology
European Scanning Clinic - Harley Street
Monday 24th March 2003 - £500

Got to thinking about his heart and all the failings I might have inherited.
Got to looking inside
Through state-of-the-art-science-technology.
The data that was mine, **me**; his.

Thus this, my beating heart.

Abstract - To see whether he lives on inside of me in the shape of a dodgy heart.

Conclusion – Physiologically in this respect apparently not.

Bonus – got to see my ribs and backbone.

Of Saint Francis in meditation
(Francisco de Zurbaran – 1598-1664)

Back-dated noticings.
Then
Back to the
Devotional Deadad Pilgrimage - moving towards those intangible spiritual goals that
slip through the mind's eye - picking precariously amongst the daily indoor foreshore - a
move towards getting-off-of-the-arse and *doing* something dawdle - not for him but for
me as a testament to my memory through the contemplation of *his* legacy.

A bout of prolonged thoughtfulness.
Stood pondering,
Cameras rolling,
Posing,
Now genuflecting in deferential medievalist *look-how-meaningful-it-all-is* kneeling,
Knelt wondering

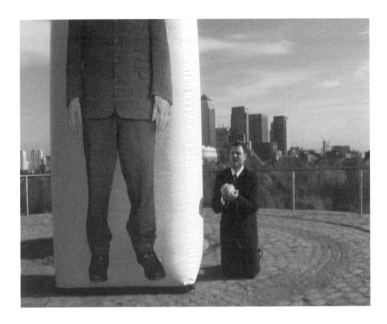

Trying to pretend that he was a saint when in *truth*?
He might beat my mother senseless and bullied and cajoled our dog and fellow
passengers on the train to Charing Cross.
(The fluidity of the remembrance and the damned imposition of autobiography.
The voice of reason versus the voices of memory.)

His yelling
His yelling would get the better of him and so he had to go to the police station

> We can and do give sense to our lives by constructing them as a story. And to
> give sense to something is to give sense not just for ourselves but for others.
>
> MARY WARNOCK *On Autobiography*

Autobiography and the work as witness to my *being*, codes for my *having been*,
traces back to what I was and therefore where I might eventually be going.
Obsessive documetarist of things pertaining to *my* life.
Also autobiography as misery and look-at-me.
Psychotherapy as a cerebral psychogeography, internalised meandering.
Walther Benjamim gadabout.

Plato is right to call memory a great and powerful Goddess – if in my part of the country they want to say a man has no sense, they say he has no memory. And when I complain of the defectiveness of mine, they argue with me and do not believe me, as if I were accusing myself of witlessness. They see no distinction between memory and understanding. This makes me look a lot worse than I am.

MICHEL DE MONTAIGNE *Of liars*

Synonyms for the Deadad
Big – Bearlike Copper
Knowledgeable – Goodatcrosswords
Middling - Middleclass
Sensible - Straight
Rover Vitesse - Buybritish
Livid – Ronald Walter Kötting

Antonyms for the Deadad
Sentimental – Mental
Happy – Furrowed
Caring – Beating
There – Elsewhere
Up and down - Asleep
Safe – Harmed
Alive – Dead

His handwriting
Delighting
Those that could read it
A window into
Hand-me-down-sayings that he had remembered his mother using
Her oral tradition expressed through him and on to me as recollector and interlocutor.

Tickle one's fancy.
Apple of ones/eye
Holy terror.
On the nevver nevver (hire purchase or credit)
Cut one's coat (or cloth)
Take the biscuit
Fly in the ointment.
Sour grapes.
Pretty as a picture
For the like of me.
Be the door of me.
Birds of a feather.
Snake in the grass
Silly old bugger.
Nice as pie.
Soft as butter
All hell let loose
Penny for your thoughts
For ever & a day.
Ants in your pants (a wriggler)
A cat on hot bricks (fidgety or a-down)
Dog in a manger (down in room)
Apple pie order.
Get stewed up.
Policemans number 9's. (large shoe size)
High as a kite.
Raining cats & dogs.
Hell & high water
Old as Methusela
Queer as a coot.

Stamps

Of *Mnemonics* and their function and the possibility of actually entering the past by way
of the frame.
His lumpen diseased riven frame,
His stamp collection.
His being at the desk, head down, organising,
Arranging.
And then waiting
The new arrivals.
Iconic paraphernalia burnt into the retina
And then I left home and now it works as memorabilia.
A legacy that no one knows what to do with.
So to my own missive by way of a book.

Dwelling on memories as a launching into the beyond.
The *studium* as a coded decipherable
But only just?

12p 12p 12p
23 JULY 1986 23 JULY 1986 23 JULY 1986

NATURE CONSERVATION
17P EUROPA
SPECIES AT RISK
BARN OWL
(TYTO ALBA)

NATURE CONSERVATION
17P EUROPA
SPECIES AT RISK
BARN OWL
(TYTO ALBA)

14P
29 July 1981

10P
10P

14 November 1973
3½p

BLACKBIRD
4d

ROBIN
4d

ROBIN
4d

Happy Christmas
2
Happy Christmas
4d

4d

4D

Happy Christmas
4d

Tarr Steps, Prehistoric
4d

Sussex
ENGLAND
4d
HARRISON AND SONS LTD

4d
World Cup 1966
HARRISON AND SONS LTD

4d
World Cup 1966
HARRISON AND SONS LTD

WORLD CUP 1966
6d

Battle of Hastings 1066
4d
HARRISON AND SONS LTD

3d

3d

Battle of Hastings 1066
4d

Battle of Hastings 1066
4d

Madagascar – *Land of man eating trees* – Victorian

And in Madagascar when a person dies, it is not the end.
It is but the very beginning. And the dead continue to live on amongst the everyday lives
of the living. And when Leila was pregnant with Eden we visited and returned safely
from the Land of Man Eating Trees to make a film called *hububinthebaobabs*.

Don't cry else I'll send the ghost after you

GLADYS MORRIS *Gallivant*

A shroud for the ancestors.
1987.
There, there was a *Lamba* cloth and it was made from different materials: cotton, silk,
tree bark and palm-tree leaves (raffia). The recipe has not changed for hundreds of years.
Lamba is a gift that symbolises friendship and it's thought that even though the cloth is
old and fades, the gesture of giving lamba will last forever.
Lamba cloths are given to the dead thanking them for their contributions to life.
(The Deadad's are made of plastic and seem to be travelling well. The scars they carry tell
of their own particular journey:

The Malagasy **dead** are given an elaborate and expensive tomb and this is the Spiritual Centre of the family. Intermittently and money permitting, bodies are taken out of the tombs and both are cleaned.

Oh joyful day.
Oh happy day.

Thus bodies or body parts of the family take part in the celebrations.
(And there they were lying on the ground partaking.)
Amongst the Malagasy this day is a day of celebration, a day of festival. They cook the best foods, sing the best songs and dance the dance of The Dead. The old *Lamba* cloth is taken off and a new one put on.
This is the gift to The Dead.
The Ancestors watch over all aspects of daily life.
There is continuity and unity of the family and community.
Ancestor spirits reside in the north-east corner of the home and in the family tomb.
There is life in bringing out the dead.

There are also the Mahafaly of southern Madagascar.
They bury their dead inside square enclosures of wood or stone decorated with the horns of their sacrificed *Zebu* cattle. There are the carved wooden memorial posts called *Aloalo* that decorate the tombs.
(The word *Alo* means 'intermediary' or 'messenger', so the memorial may help the deceased to join the community of ancestors.)

These Memorials function as commemorative sculptures, depicting scenes from the deceased's life, or desirable material possessions: the boat they dreamt of, the mountain they never climbed or the beach to which a son lost his virginity. However not everyone is entitled to a tomb or burial.

Sorcerers, pimps and devils are dumped to the west of the village, their necks are twisted so that their heads face south and they are eaten by feral dogs, worms or other wild animals. Also, in the Antaisaka tribe, twins were usually killed or abandoned to the forest and its trees.

The Victorians got wind of this and thus *The Land of Man Eating Tree*s.

Memory is recovery.
And I'm in recovery.
Not only my own memory-autobiography but some sort of collective memory.
And once they have been piled on top of each other they might reach high enough ᵘᵖ to see over

C is for Coffins

By the 17th century coffins became common for all classes, including the poor. Before that time the poor where transported in coffins to the graveyard and then removed and buried in shrouds. The coffin was then returned to the church for reuse. Some of these reusable coffins had hinges on the bottom to allow the body to be dropped out into the grave. These coffins were known as 'slip coffins'. Coffins used for cremation are a different kettle of fish and are made mostly of a light wooden material that burns easily and doesn't produce too much ash.

(Jewish coffins - Jews are buried and not cremated in order that the deceased be reunited with the soil as soon as possible. The coffins are painted wood with rope handles and wooden pegs, and are constructed without any metal. Holes are drilled in the base of the coffin to allow the body to connect with the earth. All Jews - rich or poor - are buried in the same kind of coffin.)

The coffin bearers are there to carry it all away.

And for Cremation
A pub landlord had himself converted into the contents of an egg-timer,
so that he can carry on working.
Forever

**Ashes to Ashes, funk to funky
We know Major Tom's a junkie
Strung out in heaven's high
Hitting an all time low.**
DAVID BOWIE *Ashes to Ashes*

Apparently it went like this:
(Very fast, very shouty)

1,2,3,4…. DEAD DAD DEAD DAD DEAD DAD DEAD DAD DEAD DAD DEAD DAD… DEAD DAD DEAD…DAD DAD DAD… DEAD DEAD DEAD…DAD DAD DAD… DEAD DAD DEAD DAD DEAD DAD DEAD DAD DEAD DAD DEAD DAD DEAD DAD DEAD DAD DEAD DAD DEAD DAD… DEAD DEAD DEAD…DAD DAD DAD… DEAD DEAD DEAD…DAD DAD DAD… DEAD DAD DEAD DAD DEAD DAD DEAD DAD DEAD DAD DEAD DAD DEAD DAD DEAD DAD… DEAD DEAD DEAD…DAD DAD DAD

* * * * * * * * * *

Dada - Rasta – Father
Dead as a Dodo – Who's the Daddy now?
Dada-mama – A beginners attempt at a drum roll
Daddy-bag – The testes and the scrotum
Daddy loves you best – A warning to a woman that her slip is showing
Daddy tank – An area set aside to provide protective custody for effeminate homosexuals
Daddy zoo – Prison
Daddy will beat the crap out of mummy – Dead cert
Dead as dogshit – Dead cat up a tree
Dead loss – Deadeye Dick - Deadman – Dead wood
Dead duck – Something or somebody with no chance of survival
Deadad – Day of the Deadad

So
to Mexico for the Day of the Dead.
There are festivities, which continue day and night in the graveyards, churches and villages. Special services are held honouring the dead. Marigolds (the flowers with one hundred petals) are everywhere and vendors set up booths to sell food, crafts, toys and pop song death remixes. It's a right carry on.

The Day of the Dead is a celebration of life
The dead may no longer be physically on this planet but they are still very much alive in the hearts of those that gather. (The festival is celebrated from November 1st until November 2nd. The 1st , All Saints Day, is devoted to children, and the 2nd, All Souls Day, is devoted to adults).

BEWARE
of Posada (1852) radiologist and stripper-away-of skin.
Examiner of society by way of its bones.
Cartoonist and cultural critic.

And his work:

> **I would venture that they influence Mexican's lack of nervousness and fear and sense of humour about death, and they are one of the elements of Días de muertos many enjoy most.**
>
> JUANITA GARCIAGODOY *Digging the Days of the Dead*

Death is a mirror, which reflects the vain gesticulations of the living. The whole motley confusion of acts, omissions, regrets and hopes which is the life of each one of us finds in death, not meaning or explanation, but an end. Death defines life….tell me how you die and I will tell you who you are.

OCTAVIA PAZ *The Labyrinth of Solitude*

Eden comes with me and on november 1st dons her costume.
She is dressed as the DEAD – the long gone dead.
And she refuses to take it off.
She is wearing a skin of bones and everywhere we go
The eyes are sure to follow.

Death is alive.
We wander the graveyards with
Death in our eyes
Happy as Larry
Nowhere to hide
Eden follows me
And to their surprise
Goes
Woooah!
Occasionally.

The rivers not wide
And
We're crossing it to get to get to the other side.

Photography also converts the whole world into a cemetery.
Photographers, connoisseurs of beauty are also – wittingly or unwittingly –
the recording angels of death.
SUSAN SONTAG *Portraits in life and death*

I can look at a knot of wood, William Blake once told a friend,
until I am frightened by it

Some Mexican nick names for death
Huesuda – Bony
Pelona – Baldy
Parca – Stingy
Tilica - Skinny
Flaca – Lanky
Caca – Shit head
Intrusa – Intruder
Calaca – Shit for brains

The celebrants sit by the graveside all day and all night.
I have come out from behind the wall of western sensibility.

Where are our sweethearts? They are in the grave.

GERARD DE NERVAL

To be born is only to begin to die.

JOSEÉ GOROSTIZA

A TODOS LOS VISITANTES

IHUATZIO MPIO. DE TZINTZUNTZAN, TE SALUDA Y TE DA LA BIENVENIDA A LA *NOCHE DE MUERTOS.*
TODO EL PUEBLO INDIGENA CUMPLIMOS CON LA CREENCIA DEL REGRESO DE LAS ALMAS EN ESTA NOCHE.
TE INVITAMOS HOY PRIMERO DE NOVIEMBRE A LAS 9:30 DE LA NOCHE AL PROGRAMA DE CULTURA INDIGENA EN LA PLAZA DEL COYOTE.
CONOCE Y *NO OFENDAS NUESTRA TRADICION* CONSUMIENDO BEBIDAS EMBRIAGANTES DE MANERA ESCANDALOSA.
LAS AUTORIDADES ESTAREMOS PENDIENTES.
GRACIAS POR VISITARNOS, ESPERAMOS VERTE EL PROXIMO AÑO.

To every visitor

Ihuatzio, municipality of Tzintzuntzan says hello and welcomes you to the **Night of the Dead**. The whole indigenous town preserves the belief in the return of the souls on this night. **We invite you today, 1st of November at 9.30pm to the programme of indigenous culture in the square of the coyote.**

Get to know and **do not offend our tradition** by consuming intoxicating beverages in a scandalous way. The authorities will be watching. **Thanks for visiting us**, we hope to see you next year.

She says to me:

"You can enter this fiesta by taking flowers to the grave of your dead. You can interpret this fiesta by designing painting and sculpting calaveras. You can discern some of the meanings of the fiesta while driving to Patzcuaro in your hired car, while eating *pan de muerto* and sugar calaveras. You can open yourself to a semblance of meaning while gawking at and videotaping our exotic practises and understanding something of them, although you have not bothered to learn our language. You can meditate on life and death as this fiesta expresses them whilst turning your holiday into intellectual labour. You can read *Dias de Muertos*. You can laugh at *calaveras*. But know what it is you hold in your eyebeams, know you are seeing yourself for what you are. Are you still laughing?"

And she's right
But unfortunately
And paradoxically she too has come from elsewhere.

Mourning on the contrary, tends to be preoccupied with the dead man, to dwell upon his memory and to preserve it as long as possible.

SIGMUND FREUD *The standard edition of the complete psychological works of*

Day and night death hung over me like a mournful threat. Perhaps I strove to convince myself that this minerality would enable me to elude it, forming some sort of armour, and also a hiding-place away from death's shifting but infallible attacks (rather like the one insects make out of their own bodies when they feign death in order to ward off danger). Fearing death, I loathed life (since its crowning achievement is inevitably death) – hence my horror of all those monstrous human beings from whom I was descended and who being monsters themselves, never ceased giving birth to yet more monsters, because any being, starting with myself, whose life consists in waiting for death can be nothing other than a monster.

MICHEL LEIRIS *Aurora*

No society has ever been able to abolish human sadness;
no political system can deliver us from the pain of living,
from our fear of death, our thirst for the absolute.

EUGENE IONESCO

Decay is inherent in all component things!
Work out your own salvation with Diligence.

BUDDHA

So you witnessed old age, pain, and death and told yourself that pleasure is
an illusion and that the pleasure seekers do not understand the inconstancy of
things. Then you shunned the world, persuaded that nothing will endure. "I will
not return", you proclaimed, "before I have escaped, birth, old age and death".

E.M. CIORAN *On The Heights of Despair*

Once the grave has been filled in, it must be sown with acorns so that, in the future, the ground will again be covered with vegetation, the copse will be as thick as it was before, and the traces of my tomb will disappear from the surface of the earth as I hope my memory will vanish from the memory of men.

MARQUIS DE SADE *Of his own death*

To think that for such a long time I have done nothing but concern myself with my corpse, busied myself tinkering with it instead of throwing it on the dung heap, for the greatest good of both!

E.M. CIORAN *Drawn and Quartered*

There's a strange obscenity with death, many scholars today are teaching a death education, where they take first graders or second and third graders and acquaint them with death. Not in the concept of life after death but with death itself. And kids are being taken to mortuaries and allowed to see and even touch dead bodies. There's this fascination with death, to desensitise us to death.
DEATHPROD *Treetop drive 3*

And besides

When I die, I rot
BERTRAND RUSSELL

C is for Catholicism

And its belief that All Soul's Day (November 2nd) works as Ferryman for the souls of the dead who are believed to be in purgatory undergoing the-purging-of-sins-process.

(see the Devil in Miss Jones 1973 by Gerard Damiano)

Those alive and related can still pray or offer masses in the hope that such actions will speed up the purification process.

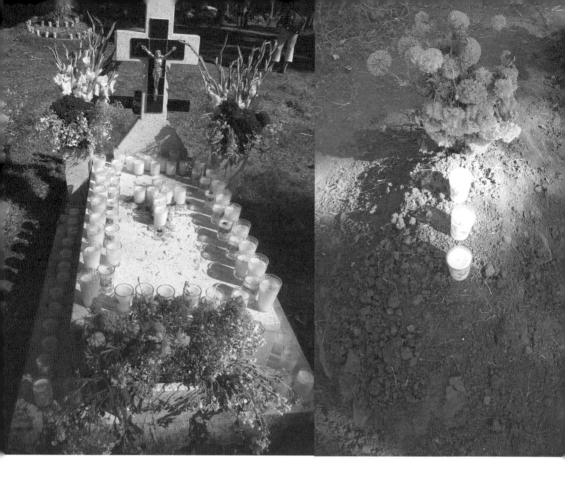

Through their commemoration those who observe Dias de Muertos produce a sociology of solidarity in oppression – solidarity with the dead, who are also marginalised by the bourgeoisie, and solidarity with those who still love their dead as they love and stand with each other and their progeny, including those who will live in future generations and whom they will never know.

JUANITA GARCIAGODOY *Digging the Days of the Dead*

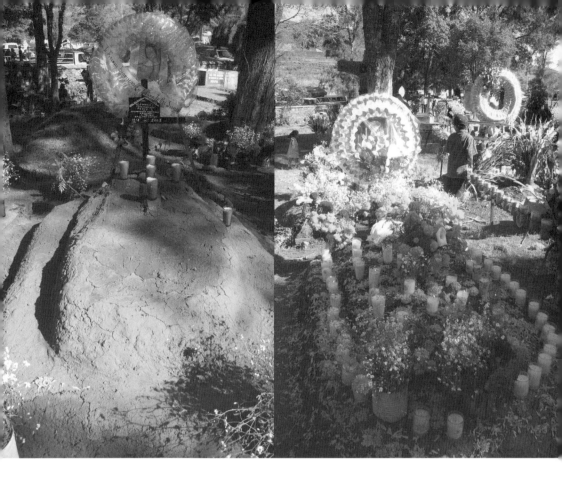

In any case, the tradition of feeding of the dead is virtually universal, with exceptions developing in this twentieth century of mass migration and immigration in which many people have lost touch with their families and communities of origin, both the living and the dead. Since the industrial revolution, the individual has been proletarianised to the point that in some cases work is more necessary and absorbing than the nurture and enjoyment of familial and communal relations, including those with the dead. Further distance between modern men and women and their predecessors is a result of their becoming more concerned with economic and political ideology than with religious and spiritual practices and traditions. The effect in many cases is the malaise of alienation.

JUANITA GARCIAGODOY *Digging the Days of the Dead*

DAY OF THE DEAD BREAD
Ingredients

1 teaspoon dry yeast
$^1/_4$ cup lukewarm water
4 cups all purpose plain flour
6 eggs
1 teaspoon salt
$^1/_2$ cup butter melted
orange-flower water
egg wash – 1 egg white plus $^1/_2$ egg yolk
sugar for sprinkling

Oh build your ship of death, your little ARK
And furnish it with food, with little cakes, and wine
For the dark flight down oblivion

D.H.LAWRENCE *The Ship of Death*

Of the mouth into which food and breath might enter the body and from which the last breath will leave

Everything in the modern world functions as if death did not exist. Nobody takes it into account, it is suppressed everywhere: in political pronouncements, commercial advertising, public morality and popular customs; in the promise of cut rate health and happiness offered to all of us by hospitals, drugstores and playing fields. But death enters into everything we undertake, and it is no longer a transition but a great gaping mouth that nothing can satisfy.

OCTAVIA PAZ *The Labyrinth of Solitude*

PS: the dead don't physically come and eat the food, they just come and kiss it and if eaten afterwards by the living they can sleep, safe in the knowledge that the dead have blessed the food.

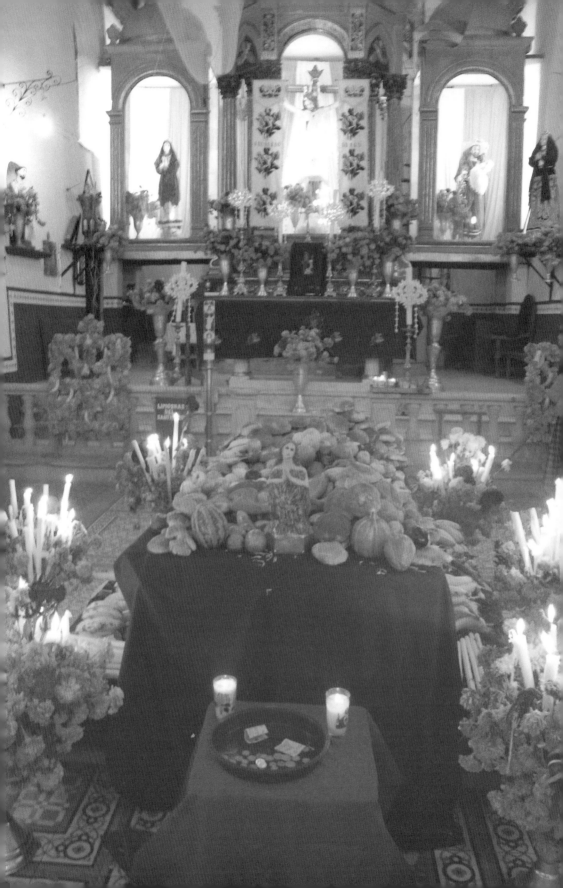

The night of the day of the dead

In front of it there was a huge offering with fruits and candles, cempoalxuchitl flowers and different kinds of bread. Almost every minute a new woman came in and contributed to the offering leaving one more element, maybe a candle or a piece of bread, a couple of bananas or pineapples, sugar canes or guayabas. I was hypnotized recording their devout performance: they came in, left their part of the offering and then sat down with the rest of the women and joined the praying. The sound of their voices rose over the offering as a luminous energy but I realized I had to go back to Andrew, Leila and Eden, who were waiting for me outside.

ELISA LIPKAU Meeting Andrew's Deadad.

No se debe temer a la muerte, al contrario, es la vida a la que se ha de temer.

One should not fear death; On the contrary, life is what one ought to fear.

JOSE CAMACHO OF COCULA

Lo que si es cierto es que cuando
Nace una persona,
Desde ese momento tambien lo
Accompaña la muerte

What is true is that when a person is born,
from that moment death also accompanies one.

CANDELARIO RIVERA

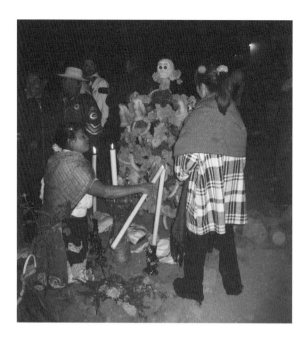

C is for Candles that illuminate paths for the spirits to follow

Incense is burned to chase away the evil spirits.
Marigolds are used to create paths for the Dead.
(In Spanish, marigolds are called "flor de los muertos" and are believed to have 400 lives.)
The flowers of the dead adorn the wreaths and the crosses.
Families get together for a right jolly up and natter.
(see Madagascar)
Stories are told and memories are shared; a problem halved is a problem solved.
All souls are turned to gold.

The bystanders look bemused, some smile. It is a comic event with much laughter and joy.
The crowd follows the parade to the cemetery.
At the cemetery, families clean and decorate the graves of their loved ones. Crosses made from the marigold flowers and candles of wax are used to guide the spirits back to their resting-places.
I hide in the far corner, dimlit, waiting for the right moment to lie down and be as one with my own deadad.
Then prayers and goodbyes are said along with promises to meet again next year.
The shenanigans are over, but memories are fresh and those we love live forever
in our heads.

Si, la muerta la traemos dentro. Lo dicen nuestros ritoss funerarios, lo dicen nuestros huesos de azúcar y cartón, lo dicen nuestras costumbres

Yes we carry death inside. Our funerary rites, our sugar and papier-mache bone, our customs all proclaim it.

ELENA PONIATOWSKA

C is for *Calvera*

Or skull.
During the Day of the Dead the word calvera takes on multiple meanings:
Rhymed and humorous pseudo epitaphs
Skeletons made of different materials ranging from lead to plastic
Pictures of loved ones depicted on various surfaces
Graphic cartoons
Scenes with skeleton characters
Or
A small monetary contribution requested by children.

Diminutive form: *Calverita*

R is for Rotulista

I have been told that
I am the *Rotulista*
The Dedadad Rotulista
A painter of pictures
Recaller and note maker
Master of scenes from the has-been life.
The Malagasy woodcarver
Joker and laughter provider.

(In Mexico, Rotulistas are the artists who paint display windows for bakeries
and other shops year-round, and not only for the Day of the Dead.
JUANITA GARCIAGODOY. *Digging the Days of the Dead*)

Ofrenda

Homes are decorated with an *ofrenda*: an altar dedicated to deceased family members and
friends. Photos and mementos of deceased loved ones are placed on the *ofrenda*.
Is this what I have achieved with the incorporation of friends and family into the
works – ongoing shrine to his passing – something that I can also share with whoever
is out there?

Eden draws her own *ofrenda*...

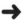

oftrendas

...And this is mine

OFRENDA TO THE DEADAD AND THEIR SIGNIFIERS:

The picture of the deceased serves to help the soul's departure from purgatory, if it resides there.

Candles symbolise mourning, especially if they are purple in colour.

Medium sized sugar skulls symbolise death, which is always present.

The Peter Styvesant ashtray is a memorial to the cigarettes the deceased smoked.

The small bottle of gin is used for the soul to wet its lips, dry after the long journey from beyond the urn.

The wax figurines a reminder of the wife and five children the deceased left behind.

The different foods are there in order that he might delight in their aroma, an ex-voto to the appetite that must surely rage.

The larger sugar skull is dedicated to the Eternal Father.

Liquor, preferably Cointreau is used to remember the wonderful, joyful events of his life and with which the soul is persuaded to return to his family again.

The paper-maché skull rattles work as mnemonic for the hours of pleasure that easy listening organ music brought to his life.

The golf trophy represents his very limited prowess as golfer and ball loser.

The football rattle is symbolic of his love of Charlton Athletic Football club and in particular The Valley.

The wedding figurines are there to honour the sacrifices that his wife would have made to *their* lives.

The wax heart is there as a reminder of the pain and grief it caused him.

The Catrina and laughing calavera is a reminder of the female dandy lurking within all of us.

The devil is there as a reminder of how badly wrong things can go if you don't breathe deeply and count to ten.

The flowers provide decoration and perfume during the soul's stay so that when it's time to leave the souls will leave us in peace.

The false teeth enable speech long after he's dead.

Of deconstructing life by means of the Day of the Dead
and Of the living taking care of the dead in exchange for
the dead taking care of the living by way of their numinous
existence in a hierarchically structured afterlife?

At my funeral
My father was dead
And laughing with scull teeth
BILLY CHILDISH *At my funeral*

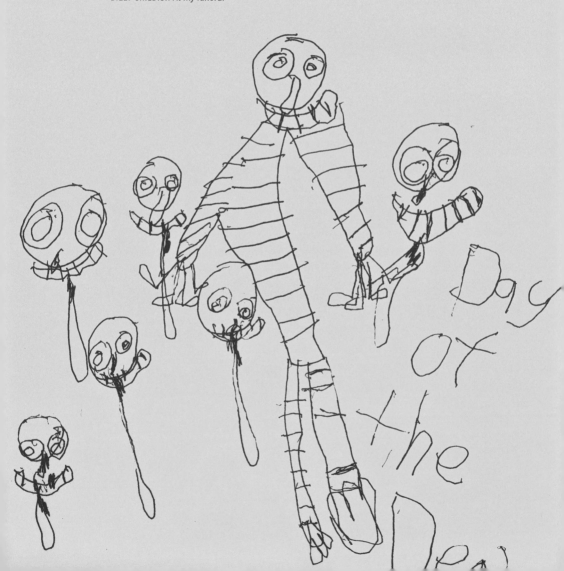

Etc

Me and my life.

Why keep reflecting upon your own 'true' story?

Obsessive documetarist of things pertaining to my life.

It's as if through reflecting on the past I have put a spanner into the works of the future,

It's as if I'm depriving myself of the time to generate any new stories, any new material.

The hasgone has become the hereandnow.

The soontocome more a matter of collating the hasgone.

But study it I do and through this process I stumbled across a Deadad.

The concept of memory has long been central, not only to the philosophy
of the mind in general, but especially to the philosophy of personal identity.
The notion of personal identity is that upon which the very possibility of
autobiography rests.

MARY WARNOCK *Imagination and Time*

So if you like there are three aspects to the work of memorialisation.

First of all - the everyday examined from every angle.

Next - the search by traditional means for my own life-story.

Then - finally this fictive memory.

There's even a fourth one, that would lie in the realm of, how shall I put it, of
the 'encrypted', of being inscribed completely in code, and that would be the
notation of elements of memories in a fiction like *Life a User's Manual,* but
practically speaking for internal use only.

GEORGES PEREC

Deadad and not forgotten

A good father and proud lover
Always in our thoughts
Peace perfect peace
In sacred memory and always in our hearts
In loving memory of the man that made us laugh
Erected in the memory of a man that never shirked from his responsibilities
To live in the hearts of those we love is not to die
A courageous gentleman worthy of everlasting love
In everlasting memory
Sacred to the memory of someone that never deserved to live
We are the clay you were the potter
Cherished memories and a lost treasure
Remembered with love the love you gave
For the love of Christ
He kicked the bucket

Eden's dead grandad and my deadad have become the big man

Eden has made the journey with me.
She has witnessed the growth of the deadad.
For her he has become The Bigman and it is The Bigman
and not The Deadad she draws.

418

Daddy and the Bigmen

Eden and the Bigman

Eden loves the Bigman

Eden and the Bigman

Bigman at Eden's party

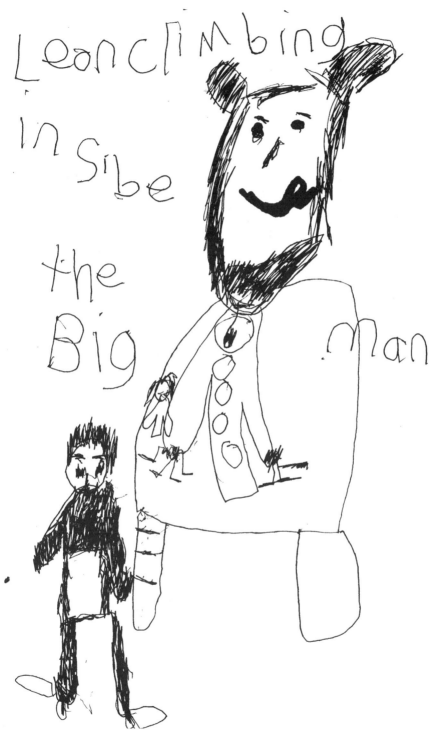

Leon climbing inside the Bigman

the big man on the Day of the Dead

I do not know just how in childhood we arrive at certain images, images of crucial significance to us. They are like filaments in a solution around which the sense of the world crystallizes for us. They are meanings that seem predestined for us, ready and waiting at the very entrance of our life and such images constitute a programme, establish our soul's fixed capital, which is allotted to us very early in the form of inklings and half-conscious feelings. It seems to me that the rest of our life passes in the interpretation of those insights, in the attempt to master them with all the range of intellect we have in our possession. These early images mark the boundaries of an artist's creativity. His creativity is a deduction from assumptions already made. He cannot now discover anything new, he learns only to understand more and more the secret entrusted to him at

the beginning, and his art is a constant exegesis, a commentary on that single verse that was assigned him. But art will never unravel that knot completely. The secret remains insoluble. The knot in which the soul was bound is no trick knot, coming apart with a tug at its end. On the contrary, it grows tighter and tighter. We work at it, untying, tracing the path of the string, seeking the end and, out of this manipulating, comes art.

BRUNO SCHULZ

Bigman party

Mummy and Daddy marry with the Bigmen

"Memento mori can exorcise morbidity as effectively as they evoke
its sweet poetry and its panic."
SUSAN SONTAG

Solitude

Let me alone to have my solitude and then let me back at it

I have set out to imbue the work with literary and philosophical references, invariably
they are obtuse, corrupt, subverted, misremembered and irritated by the mind of this
approximationist.
On that I can agree
But nevertheless

The Bigman

makes his presence felt – laid out in made up splendour
I've invaded the chapel of rest with my candour.
Now to the death mask and remarks he might have made to me:

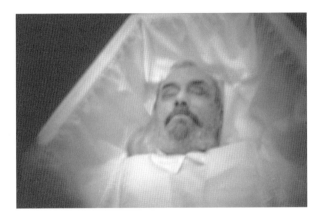

Bury me in all my finery in the hope that somebody might dig me up and 'discover' me.
Bury me deep in the hope that someone might want to investigate the memory of me.
But don't bury me so deep that nobody can get to me.

I know nothing more disgusting than death, nothing more serious and sinister!
How could some poets find beautiful this ultimate negation, which cannot even
wear the mask of the grotesque? It is ironic that one fears it the more one
admires it ...it's grandeur and infinity impress me, but my despair is so vast
that I don't even harbour the hope of death.

E.M.CIORAN *On the Heights of Despair*

Correct your parents.
Speak according to the madness that has seduced you.
You have nothing to do before dying.

ANDRÉ BRETON AND PAUL ÉLUARD

My Mother
Where is she in all of this?
She lives on
Safe in her thinking
An edited remembering
Perhaps her undoing.
She carries on navigating
A life without him
Beautiful but befuddled
A life of having held the family together
At all costs

CHAPTER EIGHT

Of the made plain
(conclusion)

432 In which nothing is concluded...

Yes, I am lying in the ground, but my lips are moving.
OSIP MANDELSTAM

Ancient Egyptians believed that upon death they would be asked two questions and their answers would determine whether they could continue their journey in the afterlife. The first question was, 'did you bring joy?' the second was, 'did you find joy?'
LEO BUSCAGLIA

Deadad Variations: Notes on Life

Write this: the day is clamped as tight as a coffin or a skull. A grey seal on all things. Just when thought craves a lifting into higher air, when the mind wants to blossom straight through the bone.

Gauguin was right. The questions that need to be asked. The right questions. 'Where Do We Come From? What Are We? Where Are We Going?' The journey is one of implications constantly slipping beyond even tentative grasp. Of a baton passed, a sense of place and degrees of belonging. A sense of origins that work or don't, or sometimes. From livedad to liveson, deadad to liveson, livedad to us and on. If we are touched, it is often by storm, by light, always by a weather that turns the brain like a thinking globe towards further questions. However, regardless of answers or their lack, what matters is the movement towards... towards a speaking, a response. A gathering of the tribes of thought and emotion, relation and solitude. Being alone with memory as it was when it was beating in a person like a hammer on an anvil's face. An attempt, briefly, to hold the elements in a single palm. Lifelines on skin and paper. This is the book as repository, casket, urn, headstone. Memory as its own headstone. What weighs us down, what fuels us to endure.

Always, as with sleep, as with the door of a wardrobe, the approaching coast, as with the moment of her skin and the casting of the last breath to the wind, we are on the threshold of a revelation.

Death borders upon our birth, and our cradle stands in the grave. Our birth is nothing but our death begun.
BISHOP HALL

The book as still-life.

Death is a matter of language, of signifiers that circle around death as absence. In this way death itself is lost to us, and it is left as ungraspable.
BENJAMIN NOYS, from *The Culture of Death*

The journey becomes a thread of mantras. A chorus of inflations, of places and positions. Dates and rendezvous. Diary's meat. Life's ordnance survey. Mapping the weapons deployed. Mapping the means to explosions of auto/biography. The words grow, his and others. Many others. As mortality spells, chants towards an exorcism. The naming and renaming of the site; where the passing passed.

What has no shadow has no strength to live.
CESAR VALLEJO

Still, life.

This talk is like stamping coins. They pile up. While the real work is done outside by someone digging the ground.
RUMI

It is the documentation of a collapse, the measurement of a dad-shaped hole, the voyage around this absence that is more present than most presences. Small deaths between each word. Where the light gets through.

The darkness of every infinite fall and the shivering blaze of every step up.
RAINER MARIA RILKE

It is the negotiation of a violence, of a series of assaults, life's blows. Was it Vallejo who said, 'there are blows in life, so hard...' This book is a blow against death because it is driven by desire (porn desire, son desire, world desire). Degrees of yearning, versions, but always a longing to know more. To feel more. To feel. Not to go under. It is desire as permanent becoming.

As the single body breaks into earth or flame, so the single version of the man takes certain flight towards its multiples. The fragments. All the voices singing their own song. What is a father but a receptacle for failing?

For life in the present there is no death. Death is not an event in life. It is not a fact in the world.
LUDWIG WITTGENSTEIN

To become other. To become the father. To wear his suit. Even, to step inside the inflated father as a ghost in the machine. Closer. The plan: to occupy the father with the same vigour as he has been occupied by him. Not just for this project's process time, but always. *What has no shadow has no strength to live.*

It is about taking on the skin of animals to become them, to be accepted by them for their hunting. About asking their forgiveness for the act of running them into the ground, into the hole that awaits them, the arrival at their own absence, their own no-more, no-longer...

Remember you must die.

It is against death-in-life, the sleepwalkers. It is against life as a more expensive version of death. It is against death as black (our culture) and white (other people's). It is in favour of life as a multi-screen experience.

Remember you must live.

ALI SMITH

live dadeadad live...

My father emails to tell me that he has become disillusioned with crematoria and has decided to purchase a plot with a new green burial initiative in the home counties. The field is secure, some miles from settlement. There will be trees (he favours oak) and a wicker casket. He is concerned about the distance to hospitality after the funeral. He will do all the paperwork in advance. He wants our input on the operation. He has startled me on so many strata that I have to find a glass.

Life (laif) n. 2. the period between birth and death; 6. the amount of time that something is active or functioning; 12. a source of strength, animation or vitality.

...And who has remembered them, who remembers them at all? To remember, to retain and preserve, Pierre Bertaux wrote of the mutation of mankind even thirty years ago, was vitally important only when population density was low, we manufactured few items and space was present in abundance. You could not do without anyone then, not even after death. In the urban societies of the late twentieth century, on the other hand, where everyone is instantly replaceable and is really superfluous from birth, we have to keep throwing ballast overboard, forgetting everything that we might otherwise remember: youth, childhood, our origins, our forebears and ancestors.

W.G. SEBALD, from *Campo Santo*

We die everywhere and become all of the earth.

Only connect! That was the whole of her sermon. Only connect the prose and the passion, and both will be exalted, and human love will be seen at its height. Live in fragments no longer. Only connect, and the beast and the monk, robbed of the isolation that is life to either, will die.

E.M. FORSTER, from *Howard's End*

The journey is across water. To the isle of the dead (and sometimes - with the Faroes - to a double helix with the new and secret life). Always across water. From *Gilgamesh* to *Dead Man*. In Hastings, we drove to the edge and looked at the sea in its night, a splashing darkness beyond form. Waves broke out of it into vision like the plough of a field under snow. Against the lights of the shoreline parking, the dark took on a totemic depth. It wrote itself into us with the blackest ink. And the couples knotted in the several solitary vehicles seemed like markers, tests, laboratory fodder, with unseen cameras measuring their urgency to see if, like a dam, it could withstand the pressure of the reachless space.

Men fear Death as children fear to go in the dark; and as that natural fear in children is increased with tales, so is the other.

FRANCIS BACON

For Thomas

The miracle of you is in its mystery an exquisite pain in my eyes and heart. It is good that I cannot understand your origins and being, how you are, there, here. No facts or explanations will ever reach the edge of what you are. How life finds itself new, with a unique face. How you find yourself in the mirror's window, how you make yourself in flesh, like clay working from itself a vessel with every wheel of breath. You tap your name on your chest as we older children might touch wood for ancient good journeys and a kind of trust, a hope. But you know. You seem so at ease in the world as you meet it.

I pray perhaps a hand's worth of prayers for you. That you strive for and receive justice, that you swim in the ocean of a true and inexhaustible love, that you find work you can believe in and wake for, that you understand what the light in the trees means – not because you *should*, but because you are part of the light – and that you do not suffer in the silent storm of real isolation, but that you know the rewards of solitude.

I pray therefore that you do not find life takes you into the too late streets, into the darker corners, the poorly lit arcades and alleys of the mind, that you do not become one of the broken men who tremble at the edge of our street-time consciousness. You are infinitely loved, and you spill over with the good fruits. Be yourself in joy and gratitude, sow and harvest experience, tell others that you love them. Do unto them as you would they do unto you, as the old book says.

Do not be shy before the truth. We walk on the sand, our footprints are sand and then water and then gone. Live inside the moment and know it is joined to other moments by a thread of blood that is yours alone. Believe in your life and its awe. Look to the sky and to the soil. Watch the world for signs. Make of your hands a cup and a balm, not a fist. All things are sacred and you will be well. Few words more from me. You are the word that anchors me to all that is good. When I hold you as you climb into sleep on my shoulder, I doubt nothing except my ability to help you become yourself.

You found us in the solstice morning and decided to stay awhile. Thank you. Nothing is the same again and I am glad. Thank you for the greatest gift anyone can offer. Yourself as unconditional as the sun. You are the deep clock and its reason. The fifth season is love.

Learn as if you were going to live forever.
Live as if you were going to die tomorrow.

ANONYMOUS

Love is spoken, sometimes with words. But if love is not spoken, is it still love?

What reconciles me to my own death more than anything else is the image of a place: a place where your bones and mine are buried, thrown, uncovered, together. They are strewn there pell mell. One of your ribs leans against my skull. A metacarpal of my left hand lies inside your pelvis. (Against my broken ribs your breast like a flower.) The hundred bones of our feet are scattered like gravel. It is strange that this image of our proximity, concerning as it does mere phosphate of calcium, should bestow a sense of peace. Yet it does. With you I can imagine a place where to be phosphate of calcium is enough.

JOHN BERGER

The journey has been towards a hand. We are made human in the palm. Our purpose there like a map of the seas we must cross, together and alone. The hand open then, is a field of paths. Write this: the hand writes this. Look at hands in prayer; how, clasped, they make a fragile roof beneath which our hopes shelter like weary travellers. *Any* two hands bought together become a prayer and, briefly, its answer. Become the oldest song, the call for some communion within the ceaseless night.

The mystery of love is greater than the mystery of death.

OSCAR WILDE

**Wake, butterfly -
it's late, we've miles
to go together.**

BASHO

Gareth Evans is a writer and independent film / arts curator. He works on the film pages of Time Out London and edits the moving image journal Vertigo (www.vertigomagazine.co.uk). He has one son, Thomas, and lives in Clapton, North East London.

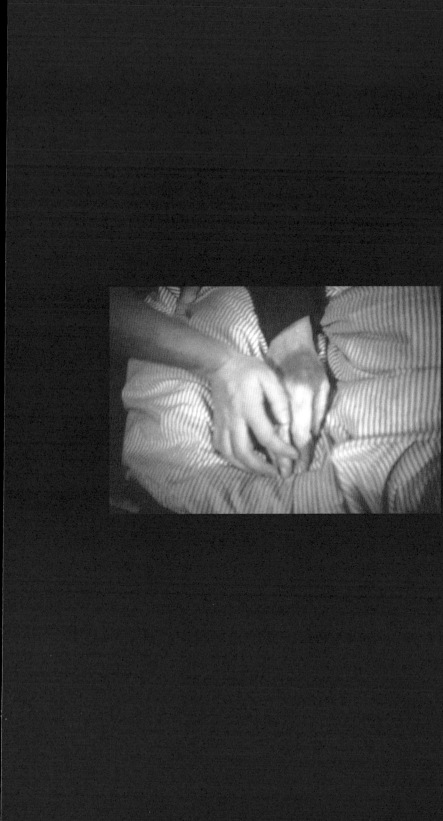

Acknowledgements

440

Most of all:
Rita, my mother, for talking to me as best she could
Leila McMillan for her animations and continued adorations
Eden and her drawings

Pam Owen's découpage

AHRC
KIAD Maidstone now University College for the Creative Arts
Dazed and Confused
Egg Bank
The Herbert Read Gallery
Dilston Grove
The Café Gallery
Badbloodandsibyl

Julien Lesage
Gareth Evans

Sophia Phoca for her continued interest and inspiration
Joanna Lowry
David Hawkins
JJ Charlesworth
David Calhoun
The Plight Club
Leslie and Margaret Kötting
Ron Henocq
Silke Dettmers
Lois Keiden and her Mexican paraphernalia

All those that responded to the invitation to write and those that joined in
because they were moved to do so

Walther and Marjun Thomassen
Lena, Kari and the boys
Bogi, Ola-Jalup and Zacharias and the rest of the Faroese 'family'

Chris Wright
Elisa Lipkau
Sarah Tisdall, Arturo and all those that helped in Mexico

Nigel Hudson, Ute Benfeldt, John McCulloch and all those
hiding in the French Pyrenees

Kate Adams for her rigorous and intelligent conversations

Technical support and suffering
Darren Kayley
Ken Woods
Alnoor Dewshi
Nick Gordon Smith
Fergus Malone
Gareth

Installation Inflations edited using *Final Cut Pro*
Sounds digitised using *Audacity* and *Peak*

THE LOCATIONS:
Chevening Cemetery - Kent
Onslow Gardens - Highgate London
Regents Street – London
Charlton Athletic Football Club - London
Stave Hill - London
The Pepys Estate - Deptford
Bence House - Deptford
Morköt – Elmstead Woods
St Nicholas Church - Chislehurst, Kent
196 Longlands Road - Sidcup Kent
Hastings Beach – East Sussex
Cooden Beach – East Sussex
The Esplanade – St Leonards on Sea
Oak Passage Studio - Hastings Old Town East Sussex
Gensing Road – St Leonards on Sea
Louyre – 09300 France
The Ariege - French Pyrenees
The Forest of Belesta - France
Montségur - France
Les Moureous – Benaix Ariege
The Montagne de La Frau - France
Wuppertal - Germany
Bruch – Germany
Huppertsburg Factory – Germany
Smyril Line Ferries and the North Sea
The Faroe Islands
Venice Beach LA California
Hollywood LA California
Mexico City
Patzcuaro - Mexico
The Island of Janitzio - Mexico

Books

442

Mary J Andrade, *Day of the Dead in Mexico*, La Oferta Review

Guillaume Appolinaire, *Selected Writings*, A New Directions Book

Niels Juel Arge, *Stridsarini*, Forlagid Hvessingur

Margaret Atwood, *Negotiating with the Dead*, Virago Press

Roland Barthes, *Camera Lucinda*, Vintage Classics

Georges Bataille, *Literature and Evil*, Marion Boyars

Zygmunt Bauman, *Liquid Modernity*, polity

Nigel Barley, *Dancing on the Grave*, Abacus

Samuel Beckett, *The Expelled and Other Novellas*,
Penguin 20th Century Classics

Marcel Bénabou, *Why I Have Not Written Any of My Books*, Bison Books

John Berger, *Selected Essays*, Bloomsbury

Agnès Birebent et Yves Le Pestipon, *Samuel Beckett a Fougax et Barrineuf*,
Editions Clapotements

Andre Breton and Philippe Soupault, *The Magnetic Fields*

Luis Buñuel, *My Last Breath*, Flamingo

Billy Childish, *Chatham Town Welcomes Desperate Men*, Tahoma Books

Billy Childish, *I'd rather you lied, selected poems 1980-1998*, Codex

E.M. Cioran, *A Short History of Decay*, Arcade Publishing

E.M. Cioran, *The Trouble with Being Born*, Arcade Publishing

E.M. Cioran, *On the height of Despair*, The University of Chicago Press

E.M. Cioran, *Tears and Saints*, The University of Chicago Press

E.M. Cioran, *Drawn and Quartered*, Arcade Publishing

Douglas Coupland, *Life After God*, Touchstone Books

Mark Cousins, *The Story of Film*, Pavilion

Edited by Paul Cronin, *Herzog on Herzog,* Faber and Faber

Jonathan Culler, *Barthes*, Fontana Paperbacks

Mark Z. Danielewski, *House of Leaves*, Pantheon Books

Richard Dawkins, *A Devil's Chaplain*, Weindenfeld & Nicolson

Juanita Garciagodoy, *Digging The Days of The Dead*,
University Press of Colorado

Germaine Greer, *Daddy we hardly knew you*, Penguin

Martin Heidegger, *Being and Time*, SCM Press Ltd

Robert Irwin, *Exquisite Corpse*, The Overlook Press

Peter Hujar, *Portraits in Life and Death*, DaCapo Press

Eugene Ionesco, *Amédée,* John Calder Publishers

Mike Jay, *The Air Loom Gang*, Bantam Press

Emma Kay, *Worldview*, Book Works

Danilo Kis, *The Encyclopedia of the Dead*, Northwestern University Press

Michel de Montagne, *The Complete Works*, Everyman's Library

Tom Nauerby, *No Nation is an Island*, SNAI North Atlantic

Barbara P. Norfleet, *Looking at Death*, David. R Godine

Benjamin Noys, *The Culture of Death*, Berg

Philippe Oberlé, *Provinces Malagaches,* Diffusion

George Orwell, *Essays*, Penguin Classics

Octavia Paz, *The Labyrinth of Solitude*, Grove Press

Georges Perec, *Species of Spaces and Other Pieces*,
Penguin 20th Century Classics

Fernando Pessoa, *The Book of Disquiet*, Allen Lane, The Penguin Press

Frederick G. Richford, *Seeing the Unseen, the Cult of the Insignificant*,
The Mitre Press

Philip Roth, *Sabbath's Theatre*, Vintage

Richard Rorty, *Contingency Irony and Solidarity*, Cambridge University Press

W.G. Sebald, *Austerlitz*,Penguin

Iain Sinclair, *The Kodak Mantra Diaries*, Albion Village Press

Iain Sinclair, *Dining on Stones*, Hamish Hamilton

Susan Sontag, *Against Interpretation*, Vintage

Andrey Tarkovsky, *Sculpting in Time*, University of Texas Press

Mary Warnock, *Imagination and Time*, Blackwell

Kenneth Williamson, Collins, *The Atlantic Islands, The Faroe Life and Scene*,
Publications Aarhus University Press

Joel-Peter Witkin, *Centre National de la Photographie Palais de Tokyo*, Paris

'The dark march'

TENNESSE WILLIAMS